CU00926466

Jane Barnwell

Production Design & the Cinematic Home

palgrave
macmillan

Jane Barnwell
Harrow Campus
University of Westminster
Middlesex, UK

ISBN 978-3-030-90448-7 ISBN 978-3-030-90449-4 (eBook)
https://doi.org/10.1007/978-3-030-90449-4

Cover illustration: Gëzim Fazliu / EyeEm

This Palgrave Macmillan imprint is published by the registered company Springer Nature
Switzerland AG.
The registered company address is: Gewerbestrasse 11, 6330 Cham, Switzerland

In loving memory of Mavis Barnwell

ACKNOWLEDGEMENTS

I would like to thank the many production designers, set decorators, art directors and art department who have been so generous with their time and insights. I am grateful for the depth and detail, wit and wisdom regarding design in general and the home in particular:

Moira Tait, Stuart Craig, Hugo Luczyc-Wyhowski, Anna Pritchard, Mimi Gramatky, Alex McDowell, Tatiana Macdonald, Jim Bissell, Malcolm Thornton, Gemma Jackson, Jim Clay, Martin Childs, Ronald Gow, Christopher Hobbs, Kave Quinn, Rusty Smith, Sarah Greenwood, Maria Djurkovic, Gary Williamson, Jon Hutman, Peter Lamont and Inbal Weinberg.

The publishers, Palgrave Macmillan, Julia Brockley, Lina Aboujieb, Emily Wood and Esther Rani for guidance, patience and support over the course of the project.

My gratitude to friends, colleagues and students who discussed the subject of the cinematic home with me—you know who you are (special thanks to Des Brady for in-depth notes).

Rob and Ruby for being my home and the Barnwells and Napoletanis for expanding it on a regular basis.

Parts of Chap. 4 of this book were originally published as "Returning Home: Set Design and Visual Storytelling in the Cult World of Stranger Things" in Tracey Mollett and Lindsey Scott (eds) 2021, *Investigating Stranger Things. Upside Down in the World of Mainstream Cult Entertainment.* Palgrave Macmillan. My sincere thanks to the editors for kind permission to reprint it here. Parts of Chap. 6 were originally included in my 2017 article 'Spies at Home: the role of the domestic interior in

Tinker Tailor Soldier Spy', *Kosmorama journal* 268. Parts of Chap. 8 were originally included in "How does the design of the prison in Paddington 2 convey character, story and visual concept?" in Marcus, Meredith and Barbara Harmes (eds) 2020, *The Palgrave Handbook of Incarceration in Popular Culture*. Palgrave Macmillan. Many thanks to the editors.

CONTENTS

LIST OF FIGURES

xii LIST OF FIGURES

Introduction: Production Design and the Cinematic Home

There is something about the medium of film that enables it to implant images in the mind that are more real than the real world; to stage-manage our perception of the facts of everyday life. Southern plantation houses look like Tara; airports look like the last scene in Casablanca; motels look like the Bates motel. (David Sylvester, 2000)

How are these film worlds constructed? As audience members, we often forget that the spaces we see on screen are mostly an illusion, created for the sole purpose of serving a cinematic narrative. Behind the scenes is the production designer, in charge of imagining and creating this fictional universe with the help of a large team including drafts people, carpenters, painters and graphic designers who are supervised by the art director. Film architecture involves traditional skills such as drafting, rendering and model-making and unconventional challenges unique to each project.

The private environment of the home is a significant setting in film, often providing the key to character, where ideas can be distilled and accentuated. Personal space can mirror a character's psychology, the interior décor reflecting inner landscape and layers of backstory. Character and story are closely entwined in the domestic setting, which is often the place that undergoes transformation to signify transition in the narrative arc. The house has also been cultivated as a site of anxiety and disturbance in the tradition of the Victorian novel and appropriated by filmmakers such

J. Barnwell, *Production Design & the Cinematic Home*, https://doi.org/10.1007/978-3-030-90449-4_1

1

Fig. 1.1 Screen homes externalise the interior landscapes of our dreams, desires and fears

as Hitchcock who was fascinated by the domestic space as a place of secrets and concealment (Jacobs 2013, 33).

This chapter frames the notion of home and its importance in the design and subsequent visual storytelling in film and television, from the perspective of production design, offering a methodology for its analysis that stems from the professional practice thereby linking practice and critical thinking (Fig. 1.1).

PERSPECTIVES ON PRODUCTION DESIGN

The term production designer was created by David O Selznick to acknowledge the extent of the contribution made by William Cameron Menzies on *Gone with the Wind* (1939).[1] Menzies drew a thousand detailed sketches, shot by shot, visualising the script to guide the camerawork. The title was indicative of the partnership between the designer and the director and begins to appreciate the overlap between the two roles.

The job of the production designer (PD) from that point encompassed the creative collaboration with other heads of department and the planning of the film's visual style to achieve a coherent look. Often directors and PDs form partnerships that span several films and even lifetimes, leading the Affrons to suggest binomials like those used in music authorship to include the director and PD.[2] The process varies on every production depending on the individuals and the nature of the project.

The literature on production design tends to be divided between the practical and the theoretical with little crossover relating the process to the end product.

Practitioners complain that film theory tends to invent meaning to fit preconceived theses. While there are established approaches to reading a screen text there is value to be gained in the inclusion of process. Costume designer and film professor Deborah Nadoolman Landis's work on costume design identifies the lack of practitioner evidence to verify or deny design intentions,[3] an absence that applies across screen studies which would benefit from a greater understanding of the production roles and process.

The early writing by Robert Mallet Stevens (*Le décor au cinema*, 1928), Edward Carrick (*Designing for Motion Pictures,* 1941 and *Art and Design in the British Film,* 1948) and Leon Barsacq (*Caligari's Cabinet and Other Grand Illusions: A History of Film Design,* 1976) are among the first texts to compile a genealogy of cinematic design across the different cultural contexts and historical periods from early cinema to 1950s Hollywood.

Followed by art historian Juan Antonio Ramirez's 1986 study *Architecture for the Screen: A Critical Study of Set Design in Hollywood's Golden Age* between 1915 and 1955. Art Deco design and the influence of architectural movements on Hollywood set design during the 1920s and 1930s are the focus of *Screen Deco: A Celebration of High Style in Hollywood Film* (1985, Howard Mandelbaum and Eric Myers) and *Designing Dreams: Modern Architecture in the Movies* (1986, Donald Albrecht).

During the 1990s momentum gained in this area with two publications by Beverly Heisner, *Hollywood Art: Art Direction in the Days of the Great Studios* (1990) and *Production Design in the Contemporary Film: A Critical Study of 23 Movies and Their Designers* (1997). Robert S. Sennett's *Setting the Scene: The Great Hollywood Art Directors* (1994) and Vincent LoBrutto's *By Design: Interviews with Film Production Designers* (1991) continued to bring the art and insights of the art department to prominence, while *Film Architecture: Set Designs from Metropolis to Blade Runner* (1996) edited by Dietrich Neumann explores the relationship between film and architecture.

Also, during this time two interesting approaches to the analysis of production design were published. Firstly, Charles and Mirella Joan Affron's *Sets in Motion: Art Direction and Film Narrative* (1995) considers the different ways a setting can function in degrees of narrativity, devising criteria for determining the extent to which a set engages with narrative, followed by Charles Tashiro (1998) who builds on the taxonomy of Norberg-Schulz in *Pretty Pictures: Production Design and The History Film*.

In May 2005, *The Journal of British Cinema and Television* published a volume dedicated to visual style, in which the editors Sue Harper and Vincent Porter make the point,

> The failure of media historians to address issues of visual style may lie in part with the difficulty in finding an appropriate verbal language with which to discuss it. The truth of the matter, however is that in order to appreciate the visual style of a film the scholar probably requires not merely the analytical abilities of the historian but the visual eye of the painter or photographer and the structural sensibility of the architect. (2005, 15)

This quote acknowledges the difficulty surrounding the study of the subject and points to the absence of an appropriate language with which to discuss it. Scholarship in the field has continued to evolve in the form of practitioner accounts, historical overviews and critical interpretation.

Production designers Heidi and Toni Ludi published *Movie Worlds: Production Design in Film* in 2000, which outlines the creative process and considers a range of case studies. The work of production designers is examined through interviews in *Production Design & Art Direction* (Ettedgui, Peter ed. 1999) and similarly in *Filmcraft: Production Design* (2013, Fionnnuala Halligan). Cathy Whitlock, *Design on Film: A Century of Hollywood Art Direction* (2010) illustrates the process through artwork and documentation. Individual production designers are focused on in several books, including Ken Adam's *Moonraker, Strangelove and Other Celluloid Dreams: The Visionary Art of Ken Adam* (Sylvester, David 2000) and again in Christopher Frayling's *Ken Adam and the Art of Production Design* (2005) and *Ken Adam Designs the Movies: James Bond and Beyond* (2008). *Designing Movies: Portrait of a Hollywood Artist* (2006) surveys designer Richard Sylbert's work and Ian Christie's 2008 book analyses the work of designer John Box in *The Art of Film: John Box and Production Design*, providing a wealth of historical context. PD Peter Lamont outlines his work on 18 of the *Bond* films in *The Man with the Golden Eye: Designing the James Bond Films* (2016).

Laurie Ede's *History of British Film Design* charts significant movements and filmmakers beginning in the silent era and concluding in the 1990s (2010). In *Accent on Design: Four European Art Directors* (1992) Catherine A Surowiec, deals with Alfred Junge, Hein Heckroth, Vincent Korda and Lazare Meerson. *Film Architecture and the Transnational Imagination: Set Design in 1930s European Cinema* (2007) is a study indicating the need to conceptualise the designer as a significant stylistic force within the collaborative context of filmmaking by Tim Bergfelder, Sue Harris and Sarah Street. *Art Direction & Production Design* edited by Lucy Fischer (2015) works through key periods in film history from the silent era to contemporary practice, including key figures, design styles, studios and technology. Ben McCann explores the expressive nature of French film design in *Ripping Open the Set: French Film Design 1930–1939* (2013). *Critical Approaches to TV and Film Set Design* (2019) by Geraint D'Arcy employs semiotics, history and concepts drawn from art, architecture and theatre to read set design. Recent contribution from Piers D. Britton, *Design for Doctor Who. Vision and Revision in Science Fiction Television* (2021), is a book-length study of Doctor Who's costumes, sets and graphics, exploring theoretical frameworks for evaluating the design using detailed case studies.

My own work, *Production Design: Architects of the Screen* (2004), begins with a historical overview and the evolution of the role. Followed by chapters on the practical process and creation of place and historical period, my second book on the subject *Production Design for Screen: Visual Storytelling in Film and Television* (2017) maps out the visual concept methodology through distinct chapters devoted to each aspect of the fivefold model using PD sources drawn from interviews, process documentation and artwork.

These texts open up the area and deliver solid insight into a range of PDs in terms of filmographies and working practices of specific designers framed within the context of production. This body of work can be built on using a model such as the one I propose which furthers understanding of the ways in which the conceptual process of designing results in the images we subsequently see on the screen, enhancing and making visible the underpinning elements that are at work across the production design of a film in a universal sense.

Visual Concept Analysis

The case studies in this book use a methodology I have developed for the analysis of production design called visual concept analysis. This approach can usefully be applied to a production as an analytical tool for supporting

a greater appreciation of the filmmaking process. I would like to emphasise that this approach may be utilised by anyone wishing to deconstruct the production design of any screen production. Intended as a universal key with which to decode and gain a greater appreciation of the design.

The visual concept augments the narrative of a production and is usually established collaboratively by the PD with the director through closely scrutinising the script and related research. This methodology works through five key ways that the script is visualised by the PD:

1. Space[4]

Space includes architectural details such as height, length, depth, shape, angle, levels, layers, scale, proportions and the ways in which these are organised. As PD Stuart Craig has stated, 'The designer's job is to provide a space that *tells the story*', making explicit the role of space in expounding story.

2. In and Out[5]

The way in which interior and exterior settings and the movement between them is designed. Windows and doorways create borders between the inside and outside and these physical transitions can be crafted to enhance ideas, character development or stages in the narrative. Thus, boundaries and transitions can be designed to reveal or conceal, linking or disconnecting the interior and exterior spaces. Doors, stairs, corridors and lifts offer particular movement through and between space.

PD Gemma Jackson states, 'I think very much about how to get people from A to B. How to get them to arrive at a good place ... movement first, light second' (2004).

3. Light[6]

Light refers to the choice of light source, natural or artificial, position, intensity and direction. Often early PD sketches include key light positions as a fundamental consideration. Decisions are made in dialogue with the Director of Photography (DP) to ensure a coherent vision. Stuart Craig says, 'It's the most important decision really. Where you put the window or practical lamp. We discuss it, make sketches and models and talk to the DP as early as possible. You block the scene with that in mind. I always start with

a window. You know when you draw a face you start with the oval of the head and then the next thing you put in are the eyes and its exactly the same with the set. My first doodle will be a rectangle of a window' (2001).

4. Colour[7]

The psychological effects of colour can be employed to evoke atmosphere, time, place, character and plot development. The selection and combination of colours can influence opinions, feelings and even create physical responses in the audience. As Stuart Craig says, 'Colour does have a temperature and an emotional temperature that we respond to. The colours that are used should be motivated by the psychology of the scene.'

5. Set Decoration[8]

The set decoration is achieved in collaboration with the set decorator, who is a key partner in the production design process. The PD and set decorator work closely to ensure that the concept translates into specific choices of furniture, textiles, colours, patterns and shapes chosen. Decisions such as size, style and texture and the arrangement of these in a setting combine to create mood and further enhance the concept. PD Maria Djurkovic states, 'Dressing any set is hugely important to me, I am very involved in it, it is crucial to storytelling' (2015).

The case studies illustrate how decisions about the five elements are linked and return to the logic of the central visual concept driving the design.

PD Stuart Craig states, 'In the real world there is too much conflicting information every time you pick a real location you better make sure it is saying what you want it to say and you better try to eliminate anything extraneous because the real world is confusing, it sends out conflicting signals all the time. The designer's job is to simplify down to the essentials and make its meaning absolutely clear' (2004).

This is where the visual concept helps create coherence, with all of the elements working in unison to build the same visual story. Through the strategic use of these five tools, the chapters will explore how story is visualised for the screen. This approach builds on *mise en scène* theory in that it textually analyses the image but identifies key areas that the PD is responsible for and separates these out for further scrutiny from the larger grouping of elements implied by *mise en scène*. It is distinct in that it uses

the five tools listed above in order to comprehend the practical and conceptual solutions the PD has employed to design problems posed by the script. (*Production Design for Screen*, 2017, expands on the methodology through PD interviews and a chapter devoted to each of the five categories/tools with examples.)

The deployment of screen space is often physically and emotionally essential in order to underpin concepts of character and narrative. As professor Ben McCann explains, décor is never a silent shell detached from the action, as the design speaks to the audience and paraphrases the narrative's concerns by architecturally reflecting the emotions and mental states of the individuals inhabiting them (2004, 375).

The approach is based on a dataset of interviews with leading contemporary production designers. Methodologically stemming from the creative process, beginning with the professional practices of PDs in visualising a script whereas other critical literature tends to start with the finished product and use film theory subsequently to form an understanding/analysis of the work.

The PD is the person responsible for the overall look of a film, working in close collaboration with the director, DP and other heads of department. They create the environment and visual style for the story to take place in. As head of the art department they oversee the realisation of their designs creating real and imagined worlds for the screen.

The chapters in the book draw widely upon the PD's professional perspective and particular creative point of view, elaborating and expanding on themes of authorship, visibility, authenticity, acknowledgement, professional practice and codes of realism and visual storytelling. The success of the PD is often tied to ideas around invisible design—environments that appear plausible and do not draw attention to their artificiality. The PD is usually key in the creation of the visual story as it appears on the screen and one of the aims of my writing is to render them visible in our reading of those images.

The aim of the research has been to establish a new approach to understanding production design, drawing upon in depth and sustained research into their practice and contribution. Through interviews carried out since 2000, my research illustrates the fundamental contribution of the PD. Although each designer embodies an individual approach to their craft, they follow a similar creative process, seeking a visual concept and finding ways to realise it on screen. Their responses to the script will vary enormously depending on their background and influences.

Initially the study sample for the interviews was chosen in relation to the PDs I had access to, thus the majority belong to British cinema between the years 1970 and 2021. More recent research broadens the study to US, Australian and Korean designers. The work spans cult and arthouse independent cinema with films such as *Caravaggio* (1986), *Trainspotting* (1996) and *My Beautiful Laundrette* (1985) to mainstream romantic comedies such as *Notting Hill* (1999), *About A Boy* (2002) and *Bridget Jones's Diary* (2001) and comedy *Paddington 2* (2017). More recently the horror genre is explored in *Get Out* (2017) and the dream homes created in *Something's Gotta Give* (2003), *The Holiday* (2006) and *It's Complicated* (2009).

When interviewing Peter Lamont, who designed *Bond* from the 1980s to 2006, it was interesting to hear his strong pragmatic approach with an emphasis on realism in relation to using real locations and materials wherever possible. While Alex McDowell, PD and academic, believes in the designer as World Builder where he conceives the design in conjunction with the writer. On *Minority Report* for example McDowell started on the project the same day as writer Scott Frank, both beginning with the concept of 'future reality' whereby a script evolved six months later. Jim Bissell's strong conceptual approach is beautifully illustrated in films spanning *ET* (1982), *Good Night and Good Luck* (2005) to the *Mission Impossible* film series.

The interviews with PDs Christopher Hobbs, Stuart Craig and Peter Lamont exemplify the tension that exists in any project between realism and expressionism. Whereby Peter Lamont aligns his work with realism, Craig strives for what he terms 'poetic truth' and Hobbs wishes to create emotional authenticity.

Within the conversations the points that re-occurred began to form a narrative, a shared language voicing the mutual concerns of designers, which revolved around five key strands that have provided the core elements of my model. The results illustrate a new perspective with which to appreciate the conceptual nature of the designer's work and make visible their creative presence.

The fact that production design is usually at the service of the story and the work should not upstage the characters or narrative is a recurring issue for an understanding of the subject. Production design provides the physical environment required for the script but also enhances this with layers of psychological and emotional nuance. PDs utilise the environment as a

storytelling device through the adept use of the visual language identified in this fivefold model.

Examples of visual concepts include

> *Caravaggio* (1986), art transcends time
> *Do the Right Thing* (1989), a desert in the city
> *From Hell* (2001), the East End of London as Hell

Some PDs rely on a contrast, for example Stuart Craig likes to simplify his design down to one or two key ideas, to the extent that the visual concept for *The English Patient* (1996) is the contrast between pre-war opulence and post war austerity, and in *Notting Hill* (1999) the contrast between the impersonal world of celebrity and close community of Notting Hill. Similarly, Bo Welch set the gothic mansion on the hill against the sea of uniform suburban houses in the town below for *Edward Scissorhands* (1990) and in *Black Narcissus* (1947) Alfred Junge established an orderly world in the convent, disrupted by the chaos of natural forces in the Himalayan Mountains.

PD Richard MacDonald states, 'without the concept its anyone's game ... you work to prevent that, to keep all the visual elements together so they add up to a whole' (in Mills, 1982).

This approach stems from a practitioner's point of view and an understanding of the process of interpreting and collaborating on the way a script is realised for the screen. By incorporating the intentions of the PD into a discussion of the finished project, a consideration of the ways in which their work impacts on the end product is possible, adding a valuable perspective to screen studies. The examples include the practical and conceptual process of production design.

THE HOME

The house has been the subject of growing interest across a range of disciplines.[9]

'Domestic space as an increasingly pertinent subject of inquiry is obviously linked to the mid 20th century spatial turn in critical thinking. For as Foucault contended, our era seems to be that of space. ... We see this turn in the writings of Walter Benjamin, Martin Heidegger, Gaston Bachelard, Henri Lefebvre and Michel Foucault' (Briganti and Mezei, 2012, 5). The home implies a space, a feeling, an idea, not necessarily

located in a fixed place. The concept of home is ambiguous, belonging, exile, longing, loneliness, homesickness. It is adaptive and resilient functioning in turns as shelter, labyrinth, vessel of desire and terror. The house and the home are frequently perceived as symbols of the self, the psyche and the body (Briganti and Mezei, 8). As Margaret Davies states, 'It is impossible to leave home because the home is not only our physical location … but also our interior architecture, our own psychology, home is in this sense who we are' (Davies, 2015, 153).

On a fundamental functional level we expect houses to provide shelter, warmth and comfort. Conceptually the home is often considered a reflection or expression of self, closely entwined with identity and belonging leading to distinctions between inside and outside, dirt and cleanliness safety and danger that have shaped the built environment.

Yi-fu Tian's study of human geography *Space and Place* (1977) defines 'place' as embodying stability and security, somewhere we settle and call a dwelling. While a 'space' is associated with freedom and potential, somewhere we temporarily move through. The home can mean family and shelter, but also a claustrophobic prison, and a place of exclusion, space and place at the same time, a dwelling where multiple perspectives co-exist, and where boundaries can be blurred and redefined.

In *Nomadland* (2020), for example, the protagonist is seen to make the road, or journey and landscape itself her home. She is aligned with the exterior space and is seen to feel uncomfortable inside conventional domestic spaces usually associated with home comfort. Thus, spaces and places are reconfigured to create new meanings from shifting perspectives.

The houses of our childhood continue to resonate through our lives, as French phenomenologist, Bachelard, has said, our house is our corner of the world, our first universe. First, we reside in a house then it resides in us. The physical features of the homes we have occupied and the memories and atmospherics converge in our consciousness. The image of a particular house can be powerfully evocative in suggesting a lifestyle and future trajectory.

For Walter Benjamin writing about nineteenth-century Paris the privacy of the bourgeois urban private citizen is facilitated by the separation of work and living spaces. These phantasmagorias of the interior are evidence of the increasing desire for individuation and perpetuation of the self that the nineteenth century expressed (exemplified in the use of first names, portrait visiting cards, individual burials). The rapid industrialisation and urbanisation during the nineteenth century have been identified

as significantly shifting cultural ideas and practices of the home. The walls of a dwelling define the house as a separate entity dividing the inside and outside; however, the walls are inextricably linked to the exterior they purportedly work to segregate. Thinkers like Baudrillard and Adorno refer to the domestic setting as constructing a binary opposition between the home and the other. The idea of the home as a closed container in Western culture separated from the outside world prevails: a notion relevant to each of the case studies in this book to varying degrees.

However, the division between interior and exterior is challenged by psychoanalytic knowledge around the connection between our interior mind and exterior environment. Freud's discovery of the unconscious opened up a new dimension within the self, the interior landscape of the individual was subsequently perceived to be reflected in the home interior and its decoration. Thus, exterior home and the internal environment are seen to be linked enabling the crossing of boundaries between real and dream worlds.

English professor Charlotte Grant suggests that in the novel, interiors operate as a means for the writer to articulate the characters' thoughts and feelings and the boundary becomes blurred between self and things to the extent that the objects are integral to the characters interior landscape. The link between self and domestic interior is sustained and its potential as powerfully expressive site acknowledged (2006, 136).

Many significant screen homes stem initially from literature, including Laura Ingalls Wilder's *Little House on the Prairie*, Bag End in *The Hobbit* (Tolkein), Mole End in *The Wind in the Willows* (Kenneth Grahame), *Mansfield Park* (Jane Austen), *Brideshead Revisited* (Evelyn Waugh), *Howards End* (E.M. Forster), *Bleak House* (Dickens), *Wuthering Heights* (Bronte) Manderley in *Rebecca* (Daphne du Maurier) and *Gormenghast* (Mervyn Peake). These fictional homes can be seen to fulfil many functions such as guardian, inspiration, anchor, catalyst, prison or trap, gateway, ghost, the self and the shadow. The richness of ideas in circulation about the home are harnessed in the conceptualisation of screen houses, where they may be heightened, subverted or exploded. PDs knit these notions into the design of the home and the stories it tells us about ourselves and our place in the world.

The relative invisibility of setting considered by art historian Frances Borzello in art (2006) can also be observed in film and TV where it has gradually gained acknowledgement as a pivotal storytelling device with the potential ability to communicate layers of conceptual nuance and detail.

THE HOME ON SCREEN

According to Renee Tobe, When we watch a film, we suspend our disbelief to get caught up in a world that must be familiar enough to be recognised by us and into which we can situate ourselves in our imaginations. Spatial perception combines with diegesis to help us connect the visuals into a narrative combining haptic with the optic through mimesis. This is she states, the essence of Plato's shadow play. As our focus narrows we both find and lose ourselves in another world. We look at the screen as if we are looking through a window frame into another world … in fact looking at the projections on the back of Plato's cave (2017, 5).

Elisabeth Bronfen has written on the home and nostalgia in Hollywood cinema, Pamela Robertson Wojcik considers the apartment plots of mid-century New York, Merril Schleier on the gendered tensions of the high rise and John David Rhodes on the spectacle of the cinematic home. In *Spaces of the Cinematic Home: Behind the Screen Door*,[10] and *Film and Domestic Space: Architectures, Representations, Dispositif*,[11] the relative significance of spaces within the home are explored. *The Wrong House: The Architecture of Alfred Hitchcock* (2013) by Steven Jacobs examines the architecture of the houses in a range of Hitchcock films. My work benefits from these fascinating contributions, while providing another perspective on the cinematic home from the point of view of the production design, whereby the design is analysed in relation to the ways it has built layers of visual concept in to the narrative.

Myths have been cultivated around the home as a safe and secure structure embodying traditional family values. Signalling a yearning for community and something that never truly existed according to Elisabeth Bronfen, who frames the home as fictive, an image of belonging, a fantasy of order and stability in a transient world. The mythical place called home is constructed for audiences on the screen (Bronfen, 2004, 50). Screen homes can appear as familiar as our own, especially those we return to regularly in the form of television series. In these recognisable spaces, we are reassured by the familiarity, continuing plot lines and a set of characters we know and love. A sense of belonging also comes with the knowledge of genre expectations, character and setting. We feel *at home* in the constructed world we immerse ourselves in. These ideas can also be fruitfully subverted where the home is used to trap characters and function as a site of anxiety and disturbance, which is often the case during periods of social and political upheaval or when constructs such as the American nuclear family are questioned.

The detached, single family home is one of the most powerful metonymic signifiers of American cultural life—of dreams of privacy, enclosure, freedom, autonomy, independence, stability and prosperity that animate national life in the United States (Rhodes, 2017). Rhodes explores the inherent instability of property and the questions this raises around the tenuous boundaries between public and private space. This is the story cinema has been mutely telling all along—a story about the house, the security and ease it promises and the horrible anxieties produced when we try and force the house to deliver on those promises. The homes in the chapters that follow may be considered in dialogue with this notion, where fluctuations around belonging, identity success and failure pivot.

A number of theorists have projected spiritual space onto that of the home (Bachelard, 1994; Freud, 1953; Jung, 2012; Pile, 1996; Vidler, 1992). Whereby the domestic interior can be seen as a symbolic reflection of the human interior landscape. This resonance of the home in the personal and collective consciousness is explored and cultivated in the creation of screen homes. Screen space plays on the ways attics, basements and bedrooms hold different roles in our daily imaginary lives. The physical realm and abstract notions of space cannot be disconnected from our memories, dreams, fears, desires and everyday existence (Jacobs, 2013, 10). Freud's theory of the uncanny relates closely to a discussion of a home that is familiar yet 'unhomely' (unheimlich). The uncanny home is a familiar aspect of the gothic and horror genres, where the sense of unease created in the domestic environment can be so integral to the narrative that it becomes a character in itself. For Freud, this combination of strangeness and familiarity resonates most strongly in relation to the mother's body, the original home, which is a 'forgotten place' (through repression of the trauma of childbirth) but still familiar. Such connections point to the importance of the relative locations of rooms within houses in the construction of meanings and pleasures, for example the uterine connotations of dark enclosed spaces (Andrews et al., 2016, 8). Issues around the uncanny home recur and are threaded through several of the chapters in this book.

The impetus to return home for characters expelled or journeying away from home is harnessed in film narrative. Describing the importance of 'getting back home' in relation to setting, PD Richard Sylbert argues, 'That's the way Mozart structured music. You always went back home […] now home and getting back home are very serious ideas […] it satisfies the mind and closes the circle' (1989, 22).

The term nostalgia, partially stemming from *nostos* (return/homecoming) in ancient Greek, refers to the epic hero who, having undergone trials and tribulations, achieves the ultimate level of heroism by successfully returning home. In Homer's *The Odyssey*, Odysseus's drive to return home establishes the notion of nostalgia in narrative. Seventeenth-century Swiss physician Johannes Hofer joined the Greek *nostos* with *algos*, meaning suffering or affliction, as a term originally used to describe the melancholy that stems from the desire to return to one's homeland. However, nostalgia, once regarded as a disorder inhibiting the afflicted from engaging in the present, can now be considered as a more positive tool aiding wellbeing, with nostalgic reminiscence recruiting positive experiences from our past in order to assist us in the present (Routledge, 2015, 4–6). Recent research into nostalgia has found it to be beneficial both mentally and physically, thus reversing some of the previously considered negative effects of 'wallowing in the past', or the futile search for a lost 'object' that can never be retrieved. Thus, the positive emotional benefits of remembering a time of belonging can help to produce wellbeing in the present.

The hero's quest is one of the most fundamental mythic narratives (Joseph Campbell, Homer's *Odyssey*, Aldous Huxley, Carl Jung). Susan Mackey-Kallis argues that the hero quest is not limited to the discovery of some boon or Holy Grail but also involves finding oneself and finding a home in the universe. The home that is sought is simultaneously the literal home from which the hero sets out and the terminus of the personal growth he or she undergoes during the return journey. The hero's quest then is a double quest that often requires a journey home not only to the place from whence the hero departed but to a state of being or consciousness that was within the hero's heart all along (Mackey-Kallis 2010, 1).

According to Jung, the journey homewards is to a home that we have never known. To truly reach individuation as individuals and as a culture we must go home fully prepared to face our collective Shadow and to fashion a new home in the universe.

And such a return is never regressive or simply nostalgic; although home is the place we have 'always been' it remains a place that we could not have either recognised or attained before our 'departure' or journey outwards (Mackey-Kallis, 4–5).

Returning home is a preoccupation for the protagonists in several of the chapters that follow, including The Kims in Chap. 2 (*Parasite*), Chris Washington in 3 (*Get Out*), Will Byers in 4 (*Stranger Things*), George Smiley in 6 (*Tinker*), Winston Churchill in 7 (*Darkest Hour*) and Paddington in 8 (*Paddington 2*).

The home as we have seen is multifunctional and has been cast in a diversity of roles. For example, in *Fight Club* (1999) the house functions as the fractured personality of the protagonist, *Home Alone* (1990) the home becomes a weapon to deter burglars, the house swap in *The Holiday* (2006) enables both characters to move past life obstacles, in *The Others (2001)* the site of trauma and 'forever after home', *Mother* (2017) uses the home to represent the Earth's natural resources as it is progressively misused by guests. The homes in both *It's a Wonderful Life* (1946) and *Sunset Boulevard* (1950) may be viewed as similar in that they coil around the characters refusing to allow them to move forward. However, in the first case this is framed as a positive where the protagonist is reminded that everything of value is already in his reach within his own home. While the second example reveals a woman frozen in time, stuck in the past in a self-destructive pattern resulting in a psychological breakdown. In both instances a different facet of the forever home is depicted.

This book is primarily concerned with the way design helps convey story, character, atmosphere and theme through the use of a visual concept. Thus, revealing the design intentions that underpin the creation of each screen home discussed in the chosen case studies. The script requires a place to tell story and houses are often fundamental in this enterprise. The ways in which houses are designed involves the distillation of character and story to enable the visual story to work effectively.

The powerful resonance of the home has been realised on screen in innumerable ways making the choice of case studies particularly difficult, ultimately my selection was based on a combination of enthusiasm, perceived significance of the home in question and access to the relevant PDs (where this was not possible I have studied interviews and articles featuring the PD from other sources). A range of genres are considered, including horror, comedy, spy, thriller and romantic comedy. The protagonists are equally varied; a bear, spy, prime minister, single woman and man are featured in addition to a diversity of families. Inclusions which help illustrate the universal relevance and significance of the cinematic home.

The Chapters

In the chapters that follow the design of the home on screen is explored, considering spaces that have impacted on the notion of what this can be. Whether it is the nurturing warmth of the Browns' home in *Paddington*, the ambiguous boundaries of secret service agent homes in *Tinker Tailor Soldier Spy* or the multi-faceted space occupied by singleton *Bridget Jones*,

the domestic interior has played a key role. Issues of class, gender, race and national identity are all bound up in the notion of home and these are teased out through the chapters. Recurring themes include the quest to return home, the home as reflection of self, ideal, uncanny, labyrinth, nation, unconscious, dream and portal to other physical places or mental states.

Parasite (2019) is the focus of Chap. 2, where the home is designed to convey the divisions in South Korean society based on the visual concept of vertical hierarchy. The home is central to the real and metaphorical struggle over belonging in a capitalist society that no longer values humanity. The two key homes in the film are metaphors for the characters' situation but also the wider social collapse of a hierarchical system that fails to work for anyone. The production design visually displays and examines the gap between those with economic power and those without.

In Chap. 3, *Get Out* (2017) explores the spatialisation of social divisions, through the design of a suburban white home as trap for African Americans. The distance between contemporary safe spaces and dangerous places that continue to reverberate with the threat of violence covertly is examined.

In Chap. 4 the Byers' home in *Stranger Things* (Netflix series, 2016–ongoing) is designed as a transition space physically and metaphorically, situated on the edge of the woods on the outskirts of town, a liminal place between the town of Hawkins and the 'Upside Down'. It is in this house that traditional boundaries are broken and temporary ones created, rupturing and subverting conventional entrance and exit points.

Chapter 5 examines the home of Bridget Jones and considers how her single status is reflected in the design of her private space. Bridget's attic apartment plays with the iconography of fairy tale turrets while also positioning her as the pro-active heroine of her own story.

Chapter 6 turns to the spy genre ambiguous creation of agents' homes in the film *Tinker Tailor Soldier Spy* (2011) where the issue of visibility and the lack of clear division between interior and exterior combine to create a provocative screen image. The boundaries between public and private space are designed to accentuate themes around espionage. The notion of returning home is fundamental in the film, enhancing character and story. Home in this instance incorporates the additional nuance of country and empire folding in nostalgia for a lost myth of Englishness. Illusions around national security are reflected in the vulnerability of characters privacy and the difficulty in defining who should be included (us) and excluded (them) during the cold war.

In Chap. 7, *Darkest Hour* (2017) the home is also recruited to communicate wider notions around nation, belonging and democracy. PD Sarah Greenwood used the real exterior of 10 Downing Street combined with built interiors to convey the sense of struggle and lack of clarity during the tense period in British history portrayed in the film. Downing Street does not stand apart from the other settings in the film blending as it does with the dreary lacklustre London of the period. Functional stripped back to the bone interiors in need of repair hint at failure. In spite of the uninspiring appearance and peeling paintwork the sense that we are all in it together is echoed repeatedly in the design.

The domestic interior of Winston Churchill blends with the public government interiors and functions in the joining of public and private worlds and indicates a democratic flow in spite of existing hierarchical structures. This stands in deliberate contrast to the fascist ideology that is being fought against. A maze ultimately leads us to the democratic space at the centre of wartime Britain and reflects the strong sense of unity at the core of the story.

Chapter 8 explores the role of the home and the prison environment in the representation of character and narrative in the film *Paddington 2* (2017). The Browns' home, Paddington's family home, is established as warm and welcoming, which Paddington is forcibly removed from when he is wrongly sent to prison. On arrival, the prison appears to be a classic hostile place of incarceration where Paddington is intimidated and alone. However, Paddington's presence is slowly seen to transform the place into a warm and inviting world full of friendship and hope. The prison effectively forms a transition space linking Paddington's journey away from home and back again. The design is crucial in conveying key themes in the script that reflect Paddington's character and the positive impact he has on people's lives.

The notion of home is poignant in a wider sense, as Paddington can be understood as an outsider story, having migrated from Peru and made London his home, while also being an anthropomorphic bear interacting with humans. The film contains messages of tolerance towards difference and diversity, particularly in that Paddington's marginal status is foregrounded and his differences identified as strengths.

Whether used as a transition space, an ideal, a catalyst for change or a place to return to the case studies in the book examine the pivotal role of the home in storytelling and the production designers' significance in its creation.

Where are we? It is the PDs job to answer that question, visualise the environment and transport us there. The paradox in this is that the setting will often remain unnoticed as it is usually a vehicle for the conveyance of

story and character. Wherever we are the PD has been there first, ensuring that the setting is not only appropriate to the character and story but is infused with information regarding the emotion and psychology of a scene. Profoundly resonant with the construction of the home, which as we have seen is loaded with personal, collective and cultural significance.

NOTES

1. Prior to this title the role of the designer was not fully acknowledged. The title technical director was replaced by interior decorator then art director. The art director is now the person working directly for the production designer, project managing the art department and overseeing the drawing of plans by the drafts people.
2. In my writing I attempt to include the PD wherever possible.
3. Landis, Deborah Nadoolman, June 2003, PhD dissertation, *Scene and not heard: the role of costume in the cinematic storytelling process*. Royal College of Art.
4. Please see Chap. 3, *Production Design for Screen*, 2017, Bloomsbury for a more expansive discussion of space in the design process.
5. Please see Chap. 4, *Production Design for Screen*, 2017, Bloomsbury for a more expansive discussion of the in and out in the design process.
6. Please see Chap. 5, *Production Design for Screen*, 2017, Bloomsbury for a more expansive discussion of light in the design process.
7. Please see Chap. 6, *Production Design for Screen*, 2017, Bloomsbury for a more expansive discussion of colour in the design process.
8. Please see Chap. 7, *Production Design for Screen*, 2017, Bloomsbury for a more expansive discussion of set decoration in the design process.
9. Events during the COVID-19 pandemic impacted on our sense of home, whereby we spent more time in our own homes and saw inside others homes via Zoom calls.
10. Andrews, Eleanor, Stella Hockenhull, and Fran Pheasant-Kelly, editors. 2016, *Spaces of the Cinematic Home: Behind the Screen Door*. London, Routledge.
11. Eds. Baschiera, Stefano and Miriam De Rosa (2020).

FURTHER READING

Almogi, Sigal Eden, Fenster, Tovi, 'The psychogeographical home', in *Home Cultures, The Journal of Architecture, Design and Domestic Space*, Vol 17, Issue 1, p. 45–68, 25 Oct 2020.
Bachelard, G, 1994, 'The Poetics of Space'.
Campbell, Joseph, *The Power of Myth*, p. 59.

Cooper Marcus, C. 1995. *House as a Mirror of Self: Exploring the Deeper Meaning of Home*. California: Conari.

Craig, S, 2004, Author interview.

Curtis, Barry. *Dark Places: The Haunted House in Film*. Reaktion Books, 2008.

Freud, S, 1953, 'The Interpretation of Dreams and On Dreams. The Standard Edition of the Complete Psychological Works of Sigmund Freud.' Vol 5.

Gitai, Amos. *Architectures of Memory*. 4 Nov. 2011–8 Jan. 2012. Mole Antonelliana e Cinema Massimo, Torino.

Gledhill, Christine, editor. *Home Is Where the Heart Is: Studies in Melodrama and the Woman's Film*. British Film Institute, 1987.

Jung, C, 2012, 'Memories, Dreams, Reflections' in C Briganti and K Mezei (eds) 'The Domestic Space Reader' Toronto Press, 135–138.

Lefebvre, Henri. *The Urban Revolution*. Translated by Robert Bononno, U of Minnesota P, 2003.

Massey, Doreen. *Space, Place and Gender*. U of Minnesota P, 1994.

Pallasmaa, Juhani, 1999, *The Architecture of image: Existential Space in Cinema*. Rakennustieto Publishing.

Pile, S, 1996, 'The Body and the City: Psychoanalysis, Space and Subjectivity' London, Routledge.

Schaal, Hans Dieter. 2010. *Learning from Hollywood: Architecture and Film*. Stuttgart: Axel Menges.

WORKS CITED

Adam, Ken and Frayling, Christopher, 2008, *Ken Adam Designs the Movies: James Bond and Beyond*. London: Thames and Hudson.

Affron, Charles and Mirella Joan. 1995. *Sets in Motion: Art Direction and Film Narrative*. New Brunswick: Rutgers University Press.

Albrecht, Donald, 1986. *Designing Dreams: Modern Architecture in the Movies*. London: Thames and Hudson.

Andrews, Eleanor, Stella Hockenhull, and Fran Pheasant-Kelly, editors. 2016, *Spaces of the Cinematic Home: Behind the Screen Door*. London, Routledge.

Aynsley, Jeremy and Grant Charlotte, 2006, *Imagined Interiors*, London, V&A.

Barnwell, Jane, 2004. *Production Design: Architects of the Screen*. London: Wallflower Press.

Barnwell, Jane, 2017. *Production Design for Screen: Visual Storytelling in Film and Television*. London: Bloomsbury.

Barsacq, Leon, 1976. *Caligari's Cabinet and other Grand Illusions: A History of Film Design*. Boston: New York Graphic Society.

Baschiera, Stefano and Miriam De Rosa, editors, 2020, Film and Domestic Space: Architectures, Representations, Dispositif, Edinburgh UP.

Bergfelder, Tim, Harris, Sue, Street, Sarah, 2007. *Film Architecture and the Transnational Imagination: Set Design in 1930s European Cinema*. Amsterdam: Amsterdam University Press.

Borzello, Frances, 2006, At Home: The Domestic Interior in Art. London, Thames and Hudson.

Briganti, Chiara, Mezei, Kathy, 2012, *The Domestic Space Reader,* Toronto University Press, Toronto.

Britton, Piers D, 2021, *Design for Doctor Who. Vision and Revision in Science Fiction Television.* London: Bloomsbury.

Bronfen, Elizabeth, 2004, *Home in Hollywood: The Imaginary Geography of Cinema.* Columbia UP.

Carrick, Edward, 1941. *Designing for Moving Pictures.* London: The Studio Publications.

Carrick, Edward, 1948. *Art and Design in the British Film.* London: Dennis Dobson.

Christie, Ian, 2008. *The Art of Film: John Box and Production Design.* London: Wallflower Press.

Craig, Stuart, Author interview, 2001, 2004.

D'Arcy, Geraint, 2019. *Critical Approaches to TV and Film Set Design.* New York: Routledge.

Davies, Margaret, 'Home and State: reflections on metaphor and practice.' *Griffith Law Review,* Taylor and Francis, 12 Feb 2015, p.153–175.

Djurkovic, Maria, 2015, Author interview.

Ede, Laurie, 2010. *History of British Film Design.* London, New York: I. B. Tauris.

Ettedgui, Peter, ed, 1999. *Production Design & Art Direction.* Switzerland: Rotovision.

Fischer, Lucy, ed. 2015. *Art Direction & Production Design.* London, New York: I. B. Tauris.

Frayling, Christopher, 2005. *Ken Adam and the Art of Production Design.* London: Faber and Faber.

Halligan, Fionnuala, 2013. *Filmcraft: Production Design.* Lewes: Ilex Press.

Harper, Sue and Porter, Vincent, 'Beyond Media History: The Challenge of Visual Style', *Journal of British Cinema and Television,* Vol 2.1 pp1–17, 2005.

Heisner, Beverly, 1990. *Hollywood Art: Art Direction in the Days of the Great Studios.* McFarland.

Heisner, Beverly, 1997. *Production Design in the Contemporary American Film: A Critical Study of 23 Movies and Their Designers.* London: McFarland.

Jacobs, Steven, 2013, *The Wrong House: the Architecture of Alfred Hitchcock,* NAI Publishers.

Jackson, Gemma, 2004. Author interview.

Lamont, Peter, 2016. *The Man with the Golden Eye: Designing the James Bond Films.* Signum Books.

Landis, Deborah, 2003, *Scene and Not Heard: the role of costume in the cinematic storytelling process.*

LoBrutto, Vincent, 1991. *By Design: Interviews with Film Production Designers.* Wesport, CT: Praeger.

Ludi, Heidi and Toni, 2000. *Movie Worlds: Production Design in Film.* London: Axel Menges.

Mackey-Kallis, Susan, 2010, *The hero and the perennial journey home in American film*. University of Pennsylvania Press.

Mallet Stevens, Robert, 1928. *Le Décor au cinema*. Paris: Charles Massin.

Mandelbaum, Howard and Myers, Eric, 1986. *Screen Deco: A Celebration of High Style in Hollywood*. Santa Monica: Hennessy & Ingalls.

McCann, Ben, 2004, 'A discreet character? Action spaces and architectural specificity in French poetic realist cinema.' *Screen*, 45 (4) p 375–382.

McCann, Ben, 2013. *Ripping Open the Set: French Film Design 1930–1939*. Oxford: Peter Lang.

Mills, Bart, 1982, 'The Brave New Worlds of Production Design.' *American Film*, p 46.

Neumann, Dietrich. ed. 1996. *Film Architecture: Set Design from Metropolis to Blade Runner*. Munich and New York: Prestel.

Ramirez, Juan Antonio, 1986, Architecture for the Screen: A critical study of set design in Hollywood's Golden Age. London, McFarland & Company.

Ramirez, Juan Antonio, 2004. *Architecture for the Screen: A Critical Study of Set Design in Hollywood's Golden Age*. London: McFarland & Company.

Renee, Tobe, 2017, *Film, Architecture and Spatial Imagination*, London, Routledge.

Rhodes, John David. 2017, *Spectacle of property: The House in American Film*, University of Minnesota Press.

Robertson-Wojcik, Pamela. 2010, *The Apartment Plot: Urban Living in American Film and Popular Culture, 1945 to 1975*. Duke UP.

Schleier, Merrill. 2008, *Skyscraper Cinema: Architecture and Gender in American Film*. University of Minnesota Press.

Sennett, Robert S, 1994. *Setting the Scene: The Great Hollywood Art Directors*. New York: Harry N. Abrams.

Surowiec, Catherine A, 1992. *Accent on Design: Four European Art Directors*. London: British Film Institute.

Sylbert, Richard, 1989, 'Production designer is his title. Creating realities is his job' *American Screen*, 15, 3, p. 22–26.

Sylbert, Richard, Townsend, Sylvia, Sylbert, Sharmagne. 2006. *Designing Movies: Portrait of a Hollywood Artist*. Westport: Praeger.

Sylvester, David, 2000, *Moonraker, Strangelove and Other Celluloid Dreams: The Visionary Art of Ken Adam*. London: Serpentine Gallery.

Tashiro, Charles, 1998. *Pretty Pictures: Production Design and the History Film*. Austin: University of Texas Press.

Vidler, A. 1992. *The Architectural Uncanny: Essays in the Modern Unhomely*. London: The MIT Press.

Whitlock, Cathy, 2010. *Designs on Film: A Century of Hollywood Art Direction*. New York: Harper Collins.

Vertical Hierarchy and the Home in *Parasite* (2019, Dir. Bong Joon Ho, PD Lee Ha-Jun)

In the film *Parasite*, the Kim family struggle for survival, manipulating their way into the wealthy home of the Park family. The hierarchical structure of capitalist society is reflected eloquently in the duality of the two respective homes. Social inequality is represented and questioned through the inescapable spatial design.

This chapter examines the ways in which the home is central to the real and the metaphorical struggle over belonging in a capitalist society that no longer values humanity. The architect-designed home of the wealthy family (the Parks) is spacious and speaks of entitlement and emptiness at the same time. The paradox is apparent in that this family has accumulated wealth and achieved the capitalist dream; however, a void remains that they seek to fill with paid for services of those less well-off members of society. Namely an English tutor, an art tutor, a driver and a housekeeper who are all essential for this family to function. An architectural void echoes this absence in the form of the bunker-style basement that reveals hidden occupants and further complexities.

In contrast the Kim family dwell in a 'semi basement', down an alleyway where drunken people come to urinate on a frequent basis. There is no space available to them in their semi subterranean home, which is eventually flooded and filled with sewage.

The two homes in this film are metaphors for the characters' situation but also the wider social collapse of a hierarchical system that fails to work for anyone. The home is designed to convey the divisions in South Korean

© The Author(s), under exclusive license to Springer Nature Switzerland AG 2022
J. Barnwell, *Production Design & the Cinematic Home*,
https://doi.org/10.1007/978-3-030-90449-4_2

society based on the visual concept of vertical hierarchy. The production design visually displays and examines the gap between those with economic power and those without.

The home is often a catalyst for change; in this instance, the father of the Kim family can no longer return to his semi-basement as he becomes a fugitive. He finds a place to survive while in hiding—in the secret bunker of the Parks' house. The design transition is clear; he has shifted from a semi-basement to a hidden space beneath the basement where he is now concealed below ground at the very bottom of the vertical and social hierarchy.

FILM SYNOPSIS

Set in Seoul, South Korea the film portrays two families as they navigate the hierarchical socioeconomic structure. The Kim family are struggling to survive when son Ki Woo (Woo-sik Choi) is given the opportunity to tutor the daughter (Da Hye, Ji-so Jung) of the wealthy Park family. Ki Woo and his sister Ki Jung (So-dam Park) devise a plan to manipulate the Parks into employing their whole family. The father Ki Taek (Kang-ho Song) is hired as a replacement chauffeur, the mother Chung Sook (Jang Hye-jin) replaces the old housekeeper and daughter Ki Jung as an art therapist for Da Song (Hyun-jun Jung). The family celebrate in the Parks' home while they are away however are visited by the former housekeeper Moon Gwang (whose husband Geun Se is secretly living in the basement) who confronts and threatens them. During a birthday party for the Parks' son, Geun Se emerges from the basement and stabs Ki Jung. Da Song faints and it is when Mr Park expects Mr Kim to drive to hospital even though his own daughter is bleeding to death that he snaps and stabs Mr Park. Mr Kim then replaces Geun Se as the secret bunker resident. In a poignant voiceover Ki Woo explains his plan to go to college, get a job and make a lot of money so that he can eventually buy the house and allow his father to leave the basement and return home to his family.

The film was the first non-English language film to win an Academy Award for Best Picture in 2020. It was also nominated for best production design. The director Bong Joon Ho has commented, 'we all live in the same country now: that of capitalism' (Mintzer, 2019) suggesting that in spite of differences in language the problem explored is an international one.

Visual Concept

The film weaves a tale of class stratification and the human psyche into the architecture of each family home. The visual concept is vertical hierarchy, which is used to signal each family's access to wealth and opportunity through spatial relations. The two homes are central to the narrative visualising the class structure, inequity and unhappiness that results from the capitalist system. The poverty gap is illustrated through the extreme contrast of these two disparate homes.

The Kim family gradually infiltrate the Park home however are expelled and repressed by the end. Water flows between the two worlds of privilege and under-privilege, connecting them fluidly in spite of their apparent dislocation. They are part of the same overarching structure expressed through the spatial layers knitting them together. The secret bunker accentuates the underbelly, the flipside of the capitalist coin in the extreme wealth of the Parks and the shadow that creates of invisible casualties of wage inequality dwelling unseen, underground.

Social hierarchy based on access to economic power is visualised through the spatial design of the two homes. The rigid boundaries of spatial stratification are challenged by the audacious actions of the Kim family; however, this is ultimately punished with the death of the daughter, hospitalisation and long-term brain damage of the son and the exile of the father further beneath the ground. The design initially echoes the apparent insulation wealth provides; however, on closer inspection this is revealed as an illusion whereby rich and poor are inextricably linked.

Economic Inequality and Spatial Stratification

According to film professor Kate E Taylor, the nature of home in South Korean cinema has always been heavily influenced by ideas of class.[1] The Korean War and partition destroyed homes and families. South Korean rapid industrialisation saw a decline of rural communities and rise of vast urban areas like Seoul. South Korea is currently a nation that operates one of the most concentrated forms of free market capitalism and as a result contains one of the most stratified class systems. Income inequality is the worst in the Asia Pacific region. With over 85% of the Korean population living in urban areas it has become dominated by apartments rather than houses (Taylor, 2020).

According to psychiatrist Julia Ridgeway-Diaz, psychotherapy and cinema have long been regarded as kindred spirits by psychoanalytic scholars. She says that a psychodynamic interpretation of *Parasite* provides a heuristic approach to understanding the psychological dilemmas faced in a capitalist society that are often deeply repressed. When not challenged or reflected on these issues fester in the unconscious. The yearning for transformation is part of our developmental journey and capitalism is sold as the means to that end (2020). However, dominant ideologies tend to appear invisible, or natural and often require radical means to reveal and uncover social contradictions that govern behaviour. In the example of class, produced by exploitation where a tiny elite possess the majority of wealth and power, middle-class privilege relies on the oppression of the workers (Marx, 1981). Marx states that the unequal distribution of wealth alienates the worker from their home and the basement apartment of the poor man is a hostile dwelling that can never feel like home (in Robertson Wojcik, 144).

From a Marxist perspective the nuclear family may be perceived as a product of capitalism whereby it functions as a unit of consumption teaching acceptance of the hierarchical structure. The concept of the division between productive and personal life in which the contradictions inherent in the alienated labour of capitalist production are supposed to be compensated for within the family are however merely displaced (Kleinhans, 1978). The Kim family are not sentimentalised or demonised but portrayed as complex characters (Hoggart, 1958) whose struggle we empathise with.

Class, money and prejudice in contemporary South Korea and the ever-increasing gap between the rich and poor is reflected through the layering of characters in the levels of the architectural space. Other examples of social and spatial stratification in film and television include: Akira Kurosawa's *High and Low* (1963, Japanese title, *Heaven and Hell*), *Metropolis* (1927, Fritz Lang, Otto Hunte, Erich Kettelhut), *Minority Report* (2002, Steven Spielberg, PD Alex McDowell), *Cloud Atlas* (2012, the Wachowskis, Tom Twyker, PD Hugh Bateup and Uli Hanisch), *High Rise* (2016, Ben Wheatley, PD Mark Tildesley) and *Us* (2019, Jordan Peele, PD, Ruth De Jong).[2]

This spatial hierarchy was a reality in British homes during the Victorian era when servants' quarters were separated from the families they served with discrete narrower staircases and entry and exit points used. However,

although the servants' working areas were traditionally *downstairs* (below the living areas of the family) their bedrooms were often in the attics, at the top of the house. Although this vertical positioning is interesting, it is also worth noting that the rooms were tiny with small windows allowing relatively little daylight in. Servants were expected to be invisible to a certain extent, working without disturbing the families while undertaking their duties. Popular historical drama TV series, such as *Upstairs Downstairs* (1971–75, LWT) and *Downton Abbey* (2010–15, ITV), foreground these settings. The final series of *Downton Abbey* indicates the rise of the working class during the 1930s and a shift in the British aristocracy. Although the Kim and Park houses are separate structures they still haunt the same spaces above and below stairs mirroring this Victorian-era hierarchy.

British film, *The Servant* (1963, Joseph Losey, PD Richard Macdonald), also explores social hierarchy through spatial design in the home of Tony (James Fox). Cited as a critique of British fears of impending social upheaval during the sixties (Weedman, 2019) and 'a savage indictment of the English class system and its waning hold over all aspects of working and cultural life' (Millar, 2003–2014). The servant, Barrett (Dirk Bogarde), takes over the home of Tony through coercive control; he infiltrates and transgresses physical, class and moral boundaries. Barrett's subversive intentions result in his taking over the power in the home. Staircases feature prominently, initially delineating the spaces of master and servant. According to Weedman, the film represents the ideological threat of working-class individuals who do not know their place, mirroring the Morlocks (underground workers), cannibalistic consumption of the Eloi (the degenerating capitalists) in HG Wells's 1895 novel, *The Time Machine*. Barrett is a proletarian monster coming back to destroy the capitalist class which for too long appropriated its 'use value' for its 'useless' lifestyle of leisure. His presence is aligned with the Freudian concept of the return of the repressed, where unpleasant or difficult to deal with thoughts and experiences are blocked from the conscious mind only to reappear, bubbling up in different forms (Weedman, 2019, 106).

In *Parasite* the return of the repressed is expressed through the foregrounding of the toilet and the flood, which brings everything to the surface including the explosive emergence of Geun Se from underground.

INTERPRETING THE VISUAL CONCEPT

In and Out

Both houses are set builds, constructed on outdoor lots in order to use natural lighting. The Kim family semi-basement is, half above and half below ground level, designed to be in the middle to suggest it is possible to go lower or higher from that position.

The film opens with a long static shot from inside the Kim home, looking out of the window. The window is long and thin stretching across the upper area of the wall, a grid pattern can be seen on the exterior, a form of bars. Inside a semi-opaque covering provides a modicum of privacy. Through the window the street and street life can be observed, cars drive past, children ride bikes and play, shoppers and shop workers come and go. The exterior is cluttered with boxes, wires, air con units and rubbish. The reverse shot looking in from the outside frames Mr Kim through the bars with the dirty ledge sprouting weeds beneath (Fig. 2.1).

At dusk out of the window neon lights twinkle, the wires criss-cross above the road. Someone begins urinating near the Kims' window as they contemplate the best course of action, Ki Woo's friend Min arrives on his moped and tells the person to stop insisting, 'this is not a toilet'. In a later

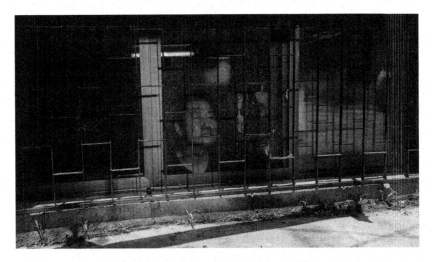

Fig. 2.1 Mr Kim looking out of the window in his semi-basement home

scene it is Ki Woo and his father who confront another offender, throwing water on them. Ki Jung films this on her phone saying, 'it's a deluge', foreshadowing the flood that is to come and the eventual transformation of their home into a giant toilet.

The Kim front door opens out onto concrete steps leading up to street level, where weeds and washing proliferate. Their connection to the street is visible which contrasts with the Park home, which is disconnected from the exterior in an affluent part of the city, at the top of a quiet hill, devoid of people or traffic. Steps up to the gate and a buzzer entry system create the sense of a protective shield, maintaining privacy, sealed off from uninvited guests. Once through this boundary, there are more steps up to the garden and a path to the wooden front door of the house. The modernist architecture emphasises the horizontal lines of the deep wide structure and minimal form of two rectangular blocks. The position on the top of a hill without any close neighbours reinforces the sense of seclusion and exclusivity, concealed, from the street it is not possible to gain access or see in. This creates a solid boundary between private and public space, with only those invited granted access. Ironically these apparently rigid borders are infiltrated by the people who work for them to varying degrees (Fig. 2.2).

The living room features a generous use of glass, with a floor to ceiling window connecting the exterior garden with the interior space. Although

Fig. 2.2 The Parks' home exterior appears serenely secluded, concealed from street view

the interior and exterior are entwined through the expansive windows in this way the exterior view does not extend further than the garden, which acts as a protective buffer from the outside world beyond their home. Wealthy homes in Korea often include twisting pine trees but director, Bong didn't want that, instead they used Chinese junipers to encircle the space (Lee Ha-Jun, 2019).

This lack of views beyond the garden continues the secluded sense of disconnection from the street and wider city. On its own, individual, the barrier around the house contains the family (also prisoners of the economic system) inside, away from the messy confusion of the wider environment, while also disconnecting them from the benefits of community and everyday neighbourly social interaction. None of the detritus of the system is visible, however, within their own home the debris is buried, invisible to them deep beneath the smooth shiny surfaces of their existence. The sewer-like secret bunker connects with the highly visible toilet that is such a prominent feature in the Kim home.

Relative connections to the exterior are reinforced when the storm comes; in the Parks' house this is something beautiful to be enjoyed from the comfort of the living room. Meanwhile the Kims' house is being flooded; the water infiltrates their home the way they have infiltrated the Parks' home.

Ki Woo enters the Park front door and moves through the open plan space to the kitchen area with ease; there are no restrictive walls containing his movement. He sits at the long dining table to meet with Mrs Park before going upstairs to Da Hye's room. The stairs and the first-floor landing are spacious and wide.

When former housekeeper Moon Gwang appears and persuades the Kims to let her in because she has left something in the basement another physical level to the house is revealed. Down in the basement she pushes a wall cabinet aside that has become stuck to reveal a secret door leading to a hidden bunker. Down two further flights of stairs is her husband Geun Se, who is hiding because he is being threatened by loan sharks. This underground space illustrates it is possible to go lower than the semi-basement and it is a shocking revelation. The dark damp hidden space with a floor curved like a sewer underneath a manhole is home to an economic prisoner of the capitalist system he is no longer valued by. This is the lowest space in the Park home, a secret unknown to the family, reflecting the fact they are oblivious to the plight of those less well off than themselves having repressed the fact they are complicit in an exploitative system.

Underground spaces often signify abjection (Andrews and Kelly 2016, 8); in this instance the connection becomes literal through the highly visible toilet and sewer design.

The PD Lee Ha-Jun says, 'This has been called a *stairway movie*' (2019). There are numerous staircases in the film facilitating the performance of vertical movement through space (taking characters from top to bottom physically) and signifying relative position in the economic structure. The design of the stairs in each setting were carefully considered in relation to details such as size, shape, incline and style. This resulted in the Park home steps being wide and flat; easy to walk up and down, while at the Kims' they are steep and irregular; more difficult to traverse.

After a violent struggle the Kim family tie up Moon Gwang and Geun Se pushing them back down into the bunker while rushing to clear away the evidence as they discover the Parks are on their way home earlier than expected.

On their return Da Song brings the tepee from his bedroom into the garden and decides he will sleep out there. His parents watch from the living room window remaining inside the house. The Kims' eventually escape via the garage, walking all the way home in the torrential rain; they follow the flow of water down the hill, down a series of exterior metal stairs eventually reaching their neighbourhood which is flooded and spewing sewage. The prolific use of stairways evokes those of artists such as Bosch, Escher and Piranesi, presenting endless and futile journeys.

The boundaries in the Kim home are open; they are directly connected to the street via a short stairway, which leaves them vulnerable. Their open windows allow the flood water in freely, which they attempt to close to minimise the damage. Mr Kim and the children wade into the water filled home to rescue key items including the mother's Olympic medal from the wall. In the bathroom the toilet spews sewage out of it, human waste floats through their home (which is now a giant toilet).[3]

After spending time in prison Chung Sook and the Ki Woo return to their semi-basement. Ki Jung is dead and the father is missing. Ki Woo goes for walks in the forest up in the mountains, where he can see the Parks' old house with binoculars and notices a light flashing a Morse code message. His father is hiding in the secret bunker and sends the message out in the hope that his son will see it one day. He explains that the Parks sold the house and moved after the deaths, he was able to bury the body of the housekeeper in the garden and a new family eventually moved in.

He has replaced Geun Se in the bunker, sneaking upstairs for food when everyone sleeps.

At the end of the film Ki Woo describes in voiceover his plan to free his father from the secret bunker. He says he will work hard and earn enough money to enable him to buy the house. On the day that he moves in he tells his father 'all you will have to do is walk up the stairs and out into the garden'. The stairs are hugely prominent in the crossing of this dreamscape interior/exterior boundary in which the son dreams of helping free his father from underground but it is wage inequality and class hierarchy that have worked to position him there and it is the same method by which the son hopes to free him. It is the dream of exceptionalism, work hard and rise above your social status that the director has said traps people in the system.

Space

We thought of the space as another character. (PD Lee Ha-Jun, 2019)

Space is designed to convey the vertical hierarchy of layers from top to bottom through the Kim and Park family homes. Space is very cramped and constricted in the Kim family semi-basement. A central corridor opens onto a small kitchen/living area. Doors lead off the corridor to the bedrooms and bathroom which features an unusually positioned toilet, central to the underpinning themes of the narrative. The low ceiling furthers the sense of compression of space in their home; however, this also creates a strong family unit; they are close physically and emotionally, supporting and helping each other with warmth and intimacy in their interactions.

The kitchen/living area and corridor form an L shape, without a door, they are the key spaces featuring lots of activity and movement. When the family are paid for their joint enterprise of folding takeaway pizza boxes, they sit together around their small kitchen table drinking beer in an intimate scene of family togetherness (Fig. 2.3).

This is contrast with the Park family who appear distant and often disengaged from what is going on in each other's lives. For example, the children are cared for by hired help and when Mr and Mrs Park have sex it is not as themselves, they role play pretending to be different, lower class people having an illicit get together.

There is a cold, clinical atmosphere and absence of joy or warmth in the home. The surface of the interior has been tidied and sanitised; it seems emotion and genuine human interaction have been removed in this process (Fig. 2.4).

Fig. 2.3 The cramped Kims' kitchen reflects the close-knit family

Fig. 2.4 The spacious Parks' kitchen appears empty

The Park house is designed by a fictional architect Nampong Hyeonja in a modernist style: spacious and serene. PD Lee Ha-Jun states that the modernist architecture was inspired by the relative blocks of Lego and tofu; he designed the structure to be wide and deep to suit the 2.35:1 aspect ratio. The open plan ground floor includes the living room, dining room and kitchen with the bedrooms and bathroom on the first floor.[4]

The secret bunker in the Parks' home was not included in the blueprints thus may be viewed as signifying the unconscious that festers unseen

desires unacknowledged by the conscious mind. 'The Parks oblivious to their unconscious, fall victim to its destructive force because its contents were hidden and unknown' (Ridgeway-Diaz et al. 2020). An uncanny space[5] that is present without the occupants having knowledge and therefore access to it. Geun Se survives hidden deep beneath the surface, a personification of the repression, eventually bursting out in an explosion of violence.

The original housekeeper, Moon Gwang, is the oldest resident having lived there with the first owner and architect; she was subsequently kept on by the Parks when they bought the house. This is an example of the 'belt of trust' that Mrs Park refers to as being an illusion. Although she has been recommended via the previous owner Moon Gwang is in fact harbouring another occupant unknown to the Parks. This uninvited guest eats their food and lives gratefully in the dark forgotten place deep beneath the family. Moon Gwang occupies the space, the only one aware of the bunker, moving around all levels and rooms while other characters do not move as freely, staying in their separate spheres fragmented and isolated from each other. The generous spatial proportions of the house allow for this separation of character; they are rarely all together. Da Hye doesn't want to go on the family camping trip to celebrate Da Song's birthday, she is reluctant to spend family time like this. Mr Park says, 'Even your busy father is taking time off', he is usually at work and the children in their respective rooms. Thus, there is a lack of communal family activity, bonding or intimacy displayed. The fragmentation of the family illustrates another broken promise of the capitalist dream. Without the consolation of family, there is just further alienation as individuals who are isolated by a system based on consumption and exploitation, leading separate lives. This makes them more vulnerable to manipulation by the Kims as they do not communicate honestly or authentically with each other.

In contrast the Kims are compressed into the small space of their semi-basement and are seen to spend time together enjoying each other's company, helping each other, plan and collaborating in order to gain employment from the Parks as a team. The family rehearse scenes such as Mr Kim telling Mrs Park that the housekeeper has TB. They offer feedback and advice to each other in terms of the delivery, tone and so forth in order to achieve the most believable result. There are no secrets between them, not only do they care for and look after each other, they work together as an effective team.

When Mr Park believes his driver has had sex in the back seat of the car he says, 'Why cross the line like that?' to his wife. This is a recurring issue for him, concern over his employees crossing the line physically and metaphorically. He is acutely aware of his social space and where others should be situated in relation to him; he likes people to stay in their place. This line becomes visible when he first meets Mr Kim who comes to his office for an interview whereby both men are visible yet separated by a glass partition defining the distinct spheres they occupy.

These visible and invisible lines are also at work with the system of recommendation that the Parks favour over other more transparent methods of hiring staff. Mrs Park confides in Ki Jung saying she doesn't trust anyone anymore and she prefers to have a personal recommendation from someone she knows. This hierarchical system usually maintains divisions in society creating an invisible barrier between those without the cultural capital or connections to receive a personal recommendation. However, in this case the Kims have cleverly circumnavigated the system manipulating it to benefit rather than discriminate against them.

Driving in the car Mr Park tells Mr Kim that it is a shame the housekeeper quit because she was excellent and she knew never to cross the line. 'I can't stand people who cross the line.' He states his only criticism is that she ate enough for two, we discover later that she was in fact taking the food to her husband hidden in the secret bunker.

When the Parks are away on a camping trip the space is used differently by the Kims. Firstly, they each explore and enjoy the different areas, with Ki Woo lying on the grass reading and Ki Jung in the bath after which they come together in the garden and watch their mother practice her shot putting. Later in the open plan living room enjoying a feast of food and drink, appreciating the view out into the garden. In spite of the vast space they are physically close reflecting their family intimacy. This reinforces the fact that the Parks do not come together as a family in this space and are rarely united.

Ki Woo day dreams about the house becoming theirs one day and marrying Da Hye, he asks which room his sister would like. However, his mother says that if the Parks walked in the father would run and hide like a cockroach. The discussion about the different occupation of space reflects on the relative sense of belonging and 'knowing your place' in terms of wealth and class. The notion that Mr Kim would hide like this comes true soon afterwards when the Parks return home early unexpectedly. The

father and children are forced to hide under the living room table until they are able to escape unseen.

While the Kims hide under the table Mr Park confides in his wife that Mr Kim seems like he is going to cross the line but he never does, however his unpleasant smell ('like an old radish or a boiled rag') does. The hierarchical structure is emphasised here in terms of the less privileged literally getting up the nose of the privileged and causing offence by their very existence. While this conversation takes place the Kims are physically beneath the Parks, compressed in a small space below the table. Ki Jung observes that the only way to lose the smell is to leave the semi-basement, which is a physical reality and a metaphor for the wider situation. The importance of the home is highlighted in Ki Woo's dreaming of one day occupying those spaces in pursuit of a better future.

Light

Situated partially below ground, natural light is limited in the Kim semi-basement, the key source being a long, thin horizontal window in their kitchen/living area.

There is also a small square window in the bathroom. Artificial light predominates including fluorescent overhead strip lighting in the corridor.

In contrast the Park home is positioned on a hill with plenty of large windows and light shiny reflective surfaces bathed in ample natural light. The first-floor living room has a wall-to-wall window (designed in accordance with the 2.35:1 aspect ratio) with a view of the back garden. The production used natural light as a significant aspect of the visual story whereby the relative wealth of the characters equates with the amount of light they have access to. There is no natural light in the secret bunker, where Geun Se hides, fluorescent strip lights and a single light bulb accentuate the dingy mouldy atmosphere. The direction of the sun was considered in detail when planning the best location to build and positions and sizes of windows were designed accordingly.[6]

When Mr Park arrives home, he walks up a flight of stairs from the garage and as he ascends the lights come on one by one as if activated by a motion sensor. However, it becomes apparent that Geun Se carries out the ritual of turning these lights on from his secret bunker out of respect and gratitude to his unwitting host.

Later he uses the same controls to send a Morse code message upstairs in the hope that Da Song, a boy scout will be able to decode it and alert

the Parks to the Kims' deception. The flickering lights communicate across physical boundaries and social class. Lighting is often used in this way to create a sense of unease in the horror genre where it can suggest a paranormal presence. As an attempt to cross borders and dimensions it is traditionally harnessed to the dead making contact with the living in this instance it enables contact between the co-existing worlds of above and below ground. (Please see Chap. 4 where light is also used as a communication device between two worlds in *Stranger Things*.) Flickering lights also feature in the Kim home, when overflowing with water and sewage.

The sense of haunting is furthered by Geun Se's sighting by Da Song when he was younger which has been explained as having been a ghost. The invisible poor underclass are the ghosts of the capitalist structure that has rendered them without use, without capital they have no spending power, hence invisible and outside of the system. He says he feels comfortable in the bunker, like he was born there, it has become his home.

According to Carl Jung, positive personal growth takes place from venturing into the dark unknown places of our unconscious enabling reflection; however, this can only occur when we emerge again from the darkness (1991). Freud's theory of the return of the repressed considers what happens when instead of looking and reflecting on an issue it is repressed only to resurface in the conscious in different forms (2001). Thus, the haunting can be viewed as the repressed ghosts reminding the characters of something they have pushed deep underground and don't want to look at. Without contemplation the repressed will resurface in dreams and memories or more volatile destructive forms.

Colour

The colour palettes of the two homes contrast and build another layer of the visual story, where the colourful environment of the Kims and the monochrome world of the Parks reveal further societal difference and division. The Kim home is awash with colour, a multitude of household items provide an array of colours, much of which come from cheap plastic props with vibrant unnatural colours. This adds to the sense of confusion and clutter but also a lively quality.

The Park home has an absence of colour, monochrome shades of neutral create a restricted palette that conveys a bland sense of uniformity. Dark wood and pale grey toned materials accentuate the contrast with the natural greenery from the exterior. Although this appears zen it also

suggests something is missing, the sanitised surface has lost the vibrancy of humanity in exchange for the accumulation of wealth through capitalism and conformity. This notion is further emphasised in the secret bunker which is festering, mouldy and mildewed with green and yellow, the flip-side of the sterile home above ground. The lack of colour results in a soul-less, loveless habitat where the joy has been drained away from their home.

Set Decoration

The set decorator Won-Woo Cho worked closely with Lee Ha-Jun to cre-ate a cluttered and cramped interior for the Kim home, whereby all avail-able surfaces are covered, there is insufficient space for their belongings and boxes line the hallway further hemming them in. The bathroom fea-tures an unusually positioned toilet that is raised from the rest of the room on a platform, which explodes in the flood allowing the waste to spill out. A tangle of wires and washing drying add to the confusion. On the wall there is a framed photo of Mrs Kim shot putting and another frame for her Olympic medal. The wall cabinets and tiles are ingrained with grease and grime the debris of everyday life is on display. The place is infested with insects, a stink bug is on the kitchen table as Mr Kim eats some mouldy bread from a plastic bag. An organic approach to set decoration meant that old and used props were sourced and real food waste recycled during shooting to attract flies and create an authentic rough texture and dense space.

The kitchen becomes even fuller when the family are employed to fold cardboard pizza boxes. While making the boxes, pest control start spray-ing the street outside to fumigate the area. The family choose to leave their windows open to get free extermination of the stink bugs; the inte-rior slowly fills with the cloudy gas.

The Parks' mansion appears empty as a reflection of the dehumanising effect of wealth on the family. The interior consists of clean lines, with clutter hidden away beneath the surface. Minimalist interior design uses shiny smooth textures such as marble and other natural materials includ-ing wood and stone. The exterior is a constant presence in the interior as most spaces on the ground floor have large windows from which the greenery of the garden can be seen. The living room is furnished with bespoke items including a large modern sofa and coffee table. One of the walls is entirely taken up with an artwork by Korean artist Seung Mo Park. Rather than using known brands for furniture, designer Bahk Jong Sun

Fig. 2.5 The Parks' living room features minimal interior decor with large statement pieces of furniture especially designed for the film

was commissioned to build the key pieces including the coffee table that the Kim family are forced to hide under (Fig. 2.5).

There are very few personal objects on the ground floor; these include some formal framed photographic portraits of the family on the hallway wall, a framed piece of Da Song's artwork and a small number of family snapshots stuck on the fridge door. The photos on the fridge appear to be the only informal personal evidence of family life as the other items are carefully curated and lack any sense of spontaneity or intimacy. Unlike the Kim home there are no lived-in layers or textures, further accentuating the impersonal qualities that create a veneer of perfect domestic order. This treatment suggests the occupants have lost their identity outside of their role as consumers.

The kitchen is empty, clean minimal lines, everything is either tidied away in cupboards or deliberately displayed in cabinets in the feature wall full of glass and ceramic ware, lit behind glass doors. Beyond this is access to the basement which has shelving stacked full of supplies. The basement leads to the secret bunker where rusty pipes, peeling plaster and damp mouldy surfaces flourish. There is a central corridor that echoes the Kims' leading to the toilet (another example of repression, the toilet is pushed underground along with uncomfortable truths) and a living area which has a small camp bed and desk. It is dressed with Geun Se's few possessions, some books and photographs.

Upstairs on the first floor are the bedrooms and bathroom. Mr and Mrs Park's bedroom resembles a boutique hotel; generic luxury, sparsely furnished with a large bed, cold and clinical greys and blues. Clothing and accessories have a separate area in the form of a walk-in wardrobe, a shrine to consumerism. The children's bedrooms are more characterful with some personal items on display. For example, Da Song's room contains a Native American tepee, shelves full of books and art materials while Da Hye's room foregrounds the desk that she and Ki Woo work at, dressed with books and personal objects. Beneath her bed is a box where she keeps secret diaries. The spacious bathroom includes an oversized luxurious bathtub, sleek fixtures and fittings of wood and natural materials (there is no toilet visible).

The garden becomes the site of Da Song's birthday BBQ, Mrs Kim is told to arrange tables in a semi-circle formation around the tepee and a lavish feast is prepared for the party guests. As Ki Jung brings the birthday cake out for Da Song, Geun Se emerges from the bunker and stabs her. Blood splatters over the guests and tables of food and drink. Mrs Kim uses an axe and BBQ skewer to fight and eventually kill Geun Se. His body lies on top of the car keys which Mr Park needs to drive his son (who has passed out) to hospital. It is when he lifts the body holding his nose with disgust at the smell, that Mr Kim reaches breaking point and finally 'crosses the line' picking up the knife and stabbing him through the heart.

Several action props[7] were pivotal aspects of the narrative, including food, small hand props and ornaments that become weapons. The food was carefully considered and continues the contrast between the two worlds of rich and poor: nicely presented and nourishing in the Park home (beautifully cut and arranged fruit), while greasy and mouldy in the Kims'. The art department had a pork belly party in the space to dress it with real grease from real food (Lee Ha-Jun, 2019). Initially, there is a lack of food in the Kims' followed by several scenes of them eating outside of their home—first in a taxi driver's canteen buffet, a pizza place and in the Parks' home while they are away. In the pizza place, as the Kims scheme to replace the current housekeeper, a sachet of hot sauce is squeezed into the centre of the pizza splashing blood red and foreshadowing the dismissal of the housekeeper and subsequent bloodshed at the BBQ.

The business card for the invented service 'The Care' (veteran grade help for VIP customers) is well designed leading Mr Park to believe it is a high-class exclusive organisation. The Kims understand the cultural cues and utilise them effectively in gaining Mr Park's confidence to hire a new

housekeeper. The importance of appearance is made clear; a small piece of card can be read as highly significant in this way indicating the value placed in the elite status of himself and the imaginary organisation.

This believing surface appearance rather than deep truth connects to the visual concept in that in spite of the separate spheres created by vertical hierarchy the two worlds are connected. As a child Da Song is not deceived and makes observations that rupture the false consciousness including noticing that the Kims all smell the same and seeing Geun Se is a person and not a ghost.

When Ki Woo's friend, Min, visits he brings an unusual gift, a large piece of rock in a wooden box, from his grandpa who collects 'scholar's rocks'. The rock is another action prop, a gift that was supposed to bestow material wealth on the family. Ki Woo clings to it and brings it to the emergency shelter in the school gym when their home is flooded and to the Parks house the next morning when it becomes the weapon with which Geun Se attacks him. The rock is a symbol of the ideology that Ki Woo clings to in the hope of a better life and an escape from poverty and hardship that has positioned him at the bottom of the hierarchy. When Ki Woo is hit with the rock a pool of blood from his head merges on the floor with a pool of plum wine. This was intended to create another connection between the two worlds of rich and poor illustrating their physical mingling and conflation. At the end of the film Ki Woo places the rock back in the river in its natural environment.

Conclusion

Although the Kim family manipulate the Parks their actions do not appear malicious, harnessing survival techniques in a system stacked against them. The chain of recommendations that Mrs Park relies on ('belt of trust') is a form of nepotistic gatekeeping that discriminates against the less privileged being able to access better paid employment. The fact that the Kims have crossed this line/boundary without alerting the Parks to the deception is testament to their abilities, resilience and intelligence. Mr Kim has tried many jobs but due to the economic climate in South Korea has suffered difficulties. When the whole family are employed by the Parks Mr Kim offers a prayer of gratitude to Mr Park and shows concern over the driver who got fired. In a similar way Mrs Kim comments about Da Hye saying she likes her, 'she is a good kid'. Thus, illustrating the Kim family retain their humanity in spite of being subject to systemic discrimination,

while the Park family exhibit no such qualities in their disdain and lack of empathy for those less fortunate.

Family relations within each of the homes indicate that in spite of economic wealth, the Parks are dysfunctional, lacking family bonds of intimacy and trust. Da Hye was having a relationship with Min and very quickly becomes involved with Ki Woo, she is looking for intimacy and love outside of the family, attempting to fill the void that exists in their home.

In the end Mrs Kim and Ki Woo go back to their semi-basement; however, Ki Woo visualises a future where they are able to return to the Parks' house. He says in a letter to his father, 'On the day we move in all you will need to do is walk up the stairs'. The poignancy of his wish to free his father from the prison of poverty is felt in the impossibility of his dream. However, the film ends visualising Ki Woo's dream and we see the family reunited in the empty house, the father walks up the stairs, out into the garden and they embrace. The return home remains a fantasy currently beyond the characters' control, Mr Kim does not emerge from the darkness. Contained, the repressed has returned underground so that society does not have to deal with the ghosts created by a defective system. The dream, like the dream house, is a flawed fantasy built on exploitation that on closer inspection includes the nightmare produced by social inequality.

Notes

1. For example, *Angels on the Street* (1941, Choi In-Kyu), explored poverty of children and a local teacher, *Housemaid* (1960, Kim Ki Yong), the aspirational hiring of a maid destroys the family and *Taste of Others* (Im Sang-soon), class and corruption in Korean elite.
2. In *Metropolis (1927)* a futuristic city is divided between an apparent utopia above ground fuelled by an exploited working class below ground.
 Minority Report (2002) initially appears utopian but also visualises the relative access to power and economic inequality through the spatial stratification where the privileged live at the heights and the underclass below.
 Cloud Atlas (2012, the Wachowskis, Tom Twyker, PD Hugh Bateup and Uli Hanisch) interprets this idea with a division between *pure bloods* who live as consumers above ground and fabricants born in tanks working in the underground malls without human rights.
 Us (2019, Jordan Peele) explores the flipside of American privilege with the underground clones, the 'tethered' who rise up and murder their above ground counterparts.

3. The Kim home has built in a water tank to enable the flood scene to be shot in a built environment rather than constructed using CGI in post-production.
4. The ground floor was built in the exterior and the first-floor exterior was created in CGI with four separate built interiors.
5. Freud's theory of the uncanny applies when something familiar is 'unhomely' unheimlich. The uncanny home is a recurring feature in the horror genre where the domestic environment is haunted and dangerous. Please see Chaps. 3, 4 and 6 for a discussion of other uncanny spaces within the home.
6. The DP Hong Kyung Pyo used indirect lighting and warm tungsten light sources.
7. Properties that don't remain in the background but are actively used, usually handheld and form part of the action in some way.

FURTHER READING

Benjamin, Walter, 1999, *The Arcades Project*. Translated by Howard Eiland and Kevin McLaughlin. Cambridge, Mass: Belknap.
Freud, Sigmund, 1913, *The interpretation of dreams*, Macmillan
Freud, Sigmund, 1955, 'The Uncanny' in *Complete Psychological Works: Standard Edition* Vol 17. London: Hogarth, 219–52.
O'Fait, Chris, 2019, 'Building the Parasite House: How Bong Joon Ho and His Team Made the Year's Best Set.' *Indiewire*, Oct 29. https://www.indiewire.com/2019/10/parasite-house-set-design-bong-joon-ho-1202185829/
Thompson, EP, 1963, *The Making of The English Working Class, Vintage Books*
Todd, Selina, 2014, *The People. The Rise and Fall of the Working Class*. John Murray, London.
Wagner, Peter. 2016. 'Modernity, Capitalism and Crisis: Understanding the New Great Transformation' in *Global Policy*, Vol 7, Issue 1

WORKS CITED

Andrews, Hockenhull and Pheasant Kelly, 2016, *Spaces of the Cinematic Home: Behind the Screen Door*, New York, Routledge.
Hoggart, Richard, 1958. *The Uses of Literacy*, Harmondsworth, Penguin.
Jung, Carl, 1956, '*The Collected Works of C G Jung*' editors Herbert Read, Michael Fordham and Gerhard Adler, London: Routledge.
Jung, Carl, 1991, *The Archetypes and the Collective Unconscious* London, Routledge.
Kleinhans, C 1978 in Cook, P, *The Cinema Book* 1985, London, BFI.
Lee Ha-Jun, 2019 'Inside the production design of Bong Joon Ho's Parasite', 27 Nov, https://www.youtube.com/watch?v=WplhYy4iUWQ

Marx, Karl, 1981, *Capital,* Volume 3, trans. D Fernbach. Harmondsworth: Penguin
Millar, Caroline, 'The Servant' BFI Screenonline, 2003–2014, http://www.scree-
nonline.org.uk/film/id/450491/index.html
Mintzer, Jordan, 2019, 'Bong Joon Ho Talks True Crime, Steve Buscemi, Unlikely
Success of Parasite', *Hollywood Reporter,* Oct 18.
Ridgeway-Diaz, J., Truong, T.T. & Gabbard, G.O. 'Return of the Repressed:
Bong Joon-Ho's *Parasite.*' *Academic Psychiatry* 44, 792–794 (2020). https://
doi.org/10.1007/s40596-020-01309-7
Strachey, James translation, 2001, 'The Standard Edition of The Complete
Psychological Works of Sigmund Freud.' Vintage, London.
Taylor, Kate E. 2020. 'Home, Class and Murder in South Korean Cinema.' in
Viewfinder magazine, issue 116
Weedman, Christopher, 2019. 'A Dark Exilic Vision of 1960s Britain. Gothic
Horror and Film Noir pervading Losey and Pinter's The Servant.' (1963),
Journal of Cinema and Media Studies, Uni of Texas Press, Vol 58,
No 3. P 93–117.

Racial Prejudice, the Ghosts of Colonialism and Spatial Segregation in *Get Out* (2017, Jordan Peele, PD Rusty Smith)

Get Out follows cool young couple Rose (Allison Williams) and Chris (Daniel Kaluuya) from the city to the suburbs for a 'meet the parents' weekend with a difference.[1] When Chris asks if Rose's parents know he is black she insists there is no cause for concern as they are liberal Obama-loving middle-class white people. However, the Armitage family home is a trap that ensnares Chris with potentially fatal consequences.

The trip is framed by Chris's friend Rod's (Lil Rel Howey) warning not to go to the white house. The majority of the film takes place in the Armitage home, the spaces of which are fundamental in the unfolding horror. Rod's healthy sense of paranoia is informed by racial tension and discrimination in the contemporary United States. The white home as a site of racial discomfort and terror conjures images from the past of former plantation houses. The presence of black hired help, groundskeeper Walter (Marcus Henderson) and housekeeper Georgina (Betty Gabriel), furthers this haunting sense of historical enslavement. References including *Guess Who's Coming to Dinner* (1967), *The Stepford Wives* (1975) and *Night of the Living Dead* (1968) have been related to the film.

Chris's apartment and the Armitage home are fundamental in describing the distance travelled between contemporary safe spaces and the dangerous places of the past that still reverberate and resonate in post-racial America. The contrast between the city and the suburb further helps convey the physical and psychological shift between the two. The journey

© The Author(s), under exclusive license to Springer Nature Switzerland AG 2022
J. Barnwell, *Production Design & the Cinematic Home*,
https://doi.org/10.1007/978-3-030-90449-4_3

between settings takes them through wooded areas and suggests they are moving away from safety and into the unknown where potential danger resides. It is on this journey that the car collides with a deer and kills it foreshadowing what is to come.

FILM SYNOPSIS

Chris a young African American living in Brooklyn agrees to meet his white girlfriend Rose's parents for the first time at their home in a northern suburb. Concerned at whether the family know he is black or not Rose reassures him that Missy (Catherine Keener) and Dean (Bradley Whitford) are liberal. When he arrives the family and friends exhibit varying degrees of bizarre behaviour towards him. Missy hypnotises Chris under the guise of helping him stop smoking which sends him into the *sunken place*, a dark void where he is immobilised and powerless. When Chris takes a photo of the only other black guest at the party the flash jolts him and he shouts at Chris to 'get out'. Horror emerges as the façade of normality is replaced by reality. The family sedate African Americans with hypnosis and perform a surgical transplantation procedure called the Coagula (developed by Rose's grandfather) auctioning their bodies to white people. The white person's consciousness is transplanted into the black body.

The film won the Oscar for best original screenplay in 2018 and has been a box office success, grossing over $250 million worldwide.

VISUAL CONCEPT

The visual concept of the home as a trap is crafted whereby racial prejudice lurking beneath the surface of post-racial America is visualised in the duality of the Armitage house. The film makes visible the invisible inequity of the racial landscape. Rose tells Chris that her parents are not racist, when he questions whether she has told them that he is black. Chris jokes he doesn't want to be chased off by shotgun referencing the spatially segregated States of the past, when African Americans were barred access from certain spaces by whites. During this time guides such as the *Green Book*[2] were used to avoid physical and psychological danger. As the PD of the film Rusty Smith explains, 'The Armitage estate should feel incredibly normal, liberal and not reveal the sinister presence beneath the exterior' (Author interview, 2021). According to media professor Elizabeth Patton, *Get Out* challenges neoliberal racism by undermining the strategy of

colour blindness, which obscures the colonial roots of violence towards people of colour and the lingering impact of structural racism (2019).

The suburban house and city apartment are contrasted effectively to convey the dualism of modernity and tradition. The white house, a dangerous place with a façade of normality, actually becomes the site of terror. Rod's warning not to go in to the house is based on the racial discrimination he anticipates his friend will be subject to once inside. However, the house becomes much more than the container for racial prejudice, it becomes the site of horror and murder, where Chris is disempowered and rendered subservient to the wishes of the white community who want to exploit him.

When it appears that a police car arrives at the end we are fearful that it may result in further discrimination towards Chris. In the original edit Chris is arrested for killing the Armitage family. However, Peele changed the ending: 'It was very clear that the ending needed to transform into something that gives us a hero, that gives us an escape, gives us a positive feeling when we leave this movie. There's nothing more satisfying than seeing the audience go crazy when Rod shows up.' Chris is not arrested and does not suffer reprisal for defending himself against a violent white family' (Desta, 2017).

RACE

In response to some genre confusion around the film including it being called a comedy Peele said, 'we are still living in a time in which African American cries for justice aren't being taken seriously ... the systemic racism that the movie is about is very real' (Morris, 2017).

The film uses the genre conventions of horror to highlight the invisibility of racial exploitation among liberal white people. This representation has a political dimension when what is being made visible are the lived realities that many in society refuse to see. Cultural historian Alison Landsberg terms the film 'horror verité' because it uses the mechanics of the horror genre to expose actually existing racism to render newly visible the real but often masked racial landscape of a professedly liberal post-racial America. According to Landsberg in horror verité the terrifying nightmare is everyday reality. As a form of politically inflected horror it has the potential to perform the kind of materialist history that Walter Benjamin theorises in which the historical materialist 'appropriates a memory as it flashes up in a moment of danger' in order to recast the present (2018).

The notion of *colour blindness* based on the belief in equal opportunity that everyone in the United States is now treated equally is states Elizabeth Patton keeping the historical causes of racial disparity hidden obscuring the persistence of racial prejudice in contemporary US and masking the racism in neoliberalism.[3] Patton argues that *Get Out* uses a politicised form of memory to undermine neoliberal racism by connecting newer practices of racism to older forms of racism that have been historically erased (2019).

The film connects the colonial roots of racial segregation with racist practices of spatial exclusion in the suburbs as site of contemporary danger. When Chris spots another black guest in the otherwise all-white gathering, he is confused to find that he is culturally white and old but appears young and black (wearing a straw boater and blazer) and accompanied by a much older white woman. When Chris confides in Georgina the housemaid that he feels uncomfortable in the presence of so many white people she tells Chris, 'They treat us like family' alluding to the historical narrative associated with household slaves of the past and the history of white dependence on black labour while simultaneously reversing the dependency to suggest the slaves need their masters.

When Rod reports Chris missing, he finds himself explaining to three police officers of colour his theories about abduction and possible sex slavery by white people. The police find it highly amusing and fail to listen or take any of what he is saying seriously. This may be viewed as an example of racial minorities failing to realise the dangers that continue to exist in post-racial America. As Paul Gilroy states race and racisms change over time and are not a fixed entity, 'Racism does not, of course move tidily and unchanged through time and history. It assumes new forms and articulates new antagonisms in different situations' (Gilroy, 1987, 11). Jordan Peele has said, 'I wanted this film to explore the false sense of security one can have with the, sort of, New York liberal type' (Butler, 2017).

Get Out depicts the racist stranglehold perpetuated by whites, whether covertly or overtly towards people of colour in contemporary society and their attempts towards psychic freedom (Powell, 2020). According to psychiatrist Dionne Powell, *Get Out* imaginatively captures issues of white privilege, black emancipation and the ongoing psychic vestiges of racism in our presumed colour-blind society. Getting out refers to the physical escape but also a mental awakening in terms of recapturing racial identity in the post-racial landscape of the United States.

The legacy of slavery has Powell states made marks on the American unconscious, making everyone by-products of a racist system and

therefore capable of regression, envy, hate and murderous rage. 'The film *Get Out* allows us to viscerally experience the trauma and terror of racism when left unexamined and unchallenged' (2020).

Healthy cultural paranoia is present in the form of best friend Rod Williams, TSA agent (Transportation Safety Administration) who provides the vital connection to a safe psychic space, the collective experience and memories of African Americans. He becomes his North Star, Underground Railroad and Harriet Tubman motivating him back to freedom (Powell, 2020).

The idea that whites want to own the black body and mind is explored whereby the *sunken place* spatialises black paralysis, imprisonment that exists within white liberalism under the banner of post-racialism (Landsberg, 2018). Being a part of society while prevented from experiencing those advantages that most whites take for granted is says Landsberg the history of the African American. In order to escape Chris needs to acknowledge how systemic racism traps African Americans in the sunken place and the paralysing effects of paranoia.[4]

Interpreting the Visual Concept

In and Out

The exterior streets of the white suburb in the opening scene (where Jeremy Armitage abducts Andre (Lakeith Stanfield)) are presented as a scary unsafe place. This contradicts the traditional representation of the suburbs as safe spaces in comparison to dangerous cities (see *Stranger Things* chapter for further discussion of the suburbs) and recalls the racial segregation and discrimination that white suburbs enforced historically in the states.[5]

The majority of the film takes place in the Armitage home, 'The detached, single family home is one of the most powerful metonymic signifiers of American cultural life—of dreams of privacy, enclosure, freedom, autonomy, independence, stability and prosperity that animate national life in the United States' (Rhodes, 2017). PDs utilise these notions regarding the house and the stories it tells us about ourselves and our place in the world. The resonance of the house is harnessed as a recurrent trope in horror, where the haunted home becomes a familiar figure as seen in *Amityville Horror* (1979), *Poltergeist* (1982), *Rosemary's Baby* (1968), *Hammer House of Horror* (1980), *House on Haunted Hill*

(1959), *The Haunting* (1963), *The Others* (2001), *The Grudge* (2002), *The Woman in Black* (1914, 2012), *Beetlejuice* (1988), *Crimson Peak* (2015), *Hereditary* (2018) and *Psycho* (1960). The architecture employed for the haunted house is often from the 1800s helping suggest it is old, dark, creaky, large, unknown and prone to containing malevolent energy from the past. The Armitage house may be viewed as such with the additional history of slavery and racial segregation making it a threatening trap for people of colour.

The white home is welcoming on a superficial level; however, it reverberates with ties to the colonial past apparent in the physical architecture, interiors and decoration. Chris does not feel that he belongs here, a historical sense of spatial segregation becomes apparent making him uncomfortable. He is made aware of his outsider status in this all white setting through a series of race related comments. Although on the surface he is an invited guest there is a disjuncture between what people say and what is going on beneath the observable surface. This is a metaphor for covert racial discrimination, more difficult to identify but just as real as earlier forms of exploitation. In fact, the contradiction lies in that they do want him to stay but on their terms which involve their intended domination and control.

As the title of the film suggests escaping is key and the entry and exit points are prominent in the design. Chris has to navigate his way out of the Armitage house to escape the horrific plans the family have for him. Foreshadowing issues of access we do not see Chris come in or out of his own apartment. His movement from interior to exterior is not mapped, instead the camera follows Rose gaining entry from a lift to Chris's second floor apartment, opening onto a nicely kept hallway and his front door. Inside the open plan space there is only one door which divides the living space and bathroom, large windows connect the interior with the exterior street.

The in between space of the woods is used to segue the city and the suburb. The car journey creates a sense of unease at leaving the relative safety of the city behind and the incident with the police officer further compounds this notion.[6] Recalling a time when black people required a specific guidebook travelling across America to stay safe.

A long driveway leads up to the secluded Armitage house surrounded by gardens and woods.[7] The architecture of the house nods to the antebellum plantation style and features a centred entrance, long slim steps, wide-covered front porch, evenly spaced windows and Greek-type columns that were popular in the South in the first half of the nineteenth century

(recalling the plantation house, Tara in *Gone With The Wind*, 1939).[8] Inside the wooden front door there is a hallway connecting the ground floor rooms and a staircase leading up to the bedrooms on the first floor. Nets are closed on windows preventing views in or out, subtly enclosing characters in the interior space. The rooms are often framed from the doorway/entrance of another room, for example when they first sit down in the living room, we watch from a distance in Missy's study. We look in from the next room on the scene, distancing and adding depth. The technique of shooting through doorways and creating deep staging is reminiscent of seventeenth-century Dutch interior painting.[9] The relative openness of doorways suggests fluid boundaries to enhance the illusion of freedom in the liberal white home. The only closed door being the basement which initially Dean says is sealed up due to black mould. Later the basement is revealed as the heart of operations and the site of captivity and surgical procedures.[10]

The family have a drink on an outdoor patio, where they ask about Chris's family and discover that his mother was killed by a hit-and-run driver. Linking to the earlier deer incident and later when Georgina/grandma is hit accidently by Chris while escaping.

In the middle of the night Chris walks downstairs and out in to the garden for a cigarette when he can't sleep. It is when he re-enters the house that Missy is waiting in her study (another open door connected to the entrance hall) and hypnotises him without consent on the premise of helping him stop smoking, she instructs Chris to sink and he falls into the *sunken place*.

The next day a cavalcade of cars enter the driveway signalling the start of the party and a series of bizarre interactions where Chris is treated like a commodity to be purchased, which it turns out he is. The elderly and middle-aged white guests move freely between the interior and exterior spaces through open doors at the front and back of the house leading to the grounds including the gazebo.

During the party Chris also moves through the house upstairs and downstairs, with apparent freedom, through open doors out into the garden and later further afield to the lake with Rose. When they are down by the lake he tells Rose, 'the man got in my head and now I'm thinking all this fucked up shit that I don't want to think about'. His awakening from the façade of liberal post-racial discourse is painful and unwelcome. However instead of capitalising on this moment of rupture and potentially escaping Chris tells Rose, 'You're all I've got. I'm not going to abandon you here.' Rose replies, 'Let's go home' however, the concept of home in

this instance is ambiguous depending on the individual. It signifies return-
ing to somewhere they feel comfortable and at ease, not threatened or
endangered physically or mentally. At this stage Chris doesn't know that
Rose's ideological position is aligned with her family and wider white
community and that she is already at home amongst these people and their
belief systems.

Meanwhile Chris is being auctioned in a macabre scene where he is
eventually bought by the gallery owner who 'wants his eyes' (Fig. 3.1).
This takes place outside in the gazebo, not hidden away or underground
but in the open with everyone present and complicit in the conspiracy
heightening the tension and fear.[11] There is a large framed photo of Chris
displayed during the auction objectifying him and recalling slave auctions
and the treatment of the non-white as subhuman. According to Landsberg
the film performs a radical form of history writing, bringing the present
into contact with the past to interrupt and serve as a wake-up call (Benjamin,
1999). The contemporary slave auction forces us to reinterpret the present
more urgently. History holds a utopian potential in this way to reframe the
present and potentially transform the future. By the time Chris and Rose
return to the house from the lake it is night, the house is illuminated in the
darkness as the last of the guests depart.

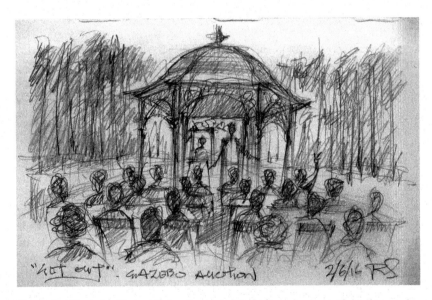

Fig. 3.1 Rusty Smith pencil sketch, the auction takes place outside in the gazebo

Although Rod occupies another physical space (usually Chris's apartment where he is dog sitting or his work environment at the airport) to Chris they are connected through their frequent phone conversations and racial identity/experience. Rod is woven in to Chris's interior landscape as he tries to make sense of his situation. Rod tells Chris right from the start not to go into the Armitage house, he occupies a different psychological space in that he has a healthy distrust of the white people anchoring Chris in relation to his blackness. This connection enables Chris to be heard and not disempowered by internalising the problem as paranoia or insanity. When Rod tells him he should leave, Chris tries to placate him, normalising the situation and refusing to listen to his own intuition. Rod says, 'all I'm doing is connecting the dots'. This becomes more urgent when he recognises the photo of Logan as Andre.

Finally, as Chris is packing to go, he sees a small door in the eaves of Rose's bedroom is open and looks inside, where he finds a red box full of photographs of Rose with previous black partners (when she told him he was the first). This is a shocking revelation as it implicates her as part of the deception. They walk downstairs to the front door which is now closed. The whole family are lurking nearby around the hallway and connecting rooms closing in on him, Chris drops to the floor powerless when Missy initiates the hypnotic state he is carried down to the basement and tied to a leather chair in the windowless games room.

The uncanny has been related to the home as something familiar yet unhomely, that class of the frightening which leads back to what is known of old and long familiar (Freud, 1955, 219). The Armitage house leads back to the roots of slavery, racial segregation and discrimination. Zizek's analysis of the house in *Psycho* aligns the basement with the id, the id being the unconscious instinctive aspects of personality. According to Freud this contains desires and primal drives mediated by the ego. It is in the basement that the Armitage's imprison Chris and this is where their horrific surgery is undertaken. This is the suggested site of unconscious desires that continue to harm people of colour in spite of protestations on the surface of being Obama-loving liberals. The basement beneath the surface houses racist ideology in a different form in spite of post-racial discourse to the contrary. (Please see Chap. 2 for a basement that becomes the hidden home of the dispossessed in *Parasite*.)

Rod persists in trying to locate Chris by phone eventually Rose answers and lies while sitting in the dark of the kitchen, which now looks a cold and unhomely environment. Meanwhile Rod is in Chris's apartment framed by the window and views of the street, warm and inviting lit by the street light and table lamps. He implicitly knows she is lying. Rod is reliable and consistent; he does not allow others to deter him from his solid sense of self.

When Chris awakes the gallery owner explains to him through the television screen the process of coagulation further, saying 'Your existence will be as a passenger. ... I'll control the motor functions so I'll be you.' When Chris asks why he says 'I want your eye', making literal the attitude of entitlement and appropriation of the black body and mind. Chris manages to block his ears with stuffing from the chair closing the entrance/boundary to his unconscious and preventing Missy from re-entering and controlling him.

A long corridor covered in artwork and photos spanning hundreds of years connects the operating theatre and the games room. When Jeremy brings a wheelchair in to take Chris to the theatre, Chris knocks him out with a hard bocce ball and proceeds to take the stag head from the wall and use it to kill Mr Armitage. One of the candles falls over setting the room on fire. During Chris's escape he is attacked and manages to kill Missy and Jeremy eventually wrestling the door open and exiting the house. Upstairs Rose is oblivious to the activity downstairs, sitting on her bed, with earphones in listening to music she appears childlike with a glass of milk and a small glass bowl of Froot Loops she scans the internet for her next victim.

Chris starts driving away in Jeremy's car while calling the police, he is distracted and Georgina/grandma collides with the car. Mirroring the deer from the beginning and the way his mother was killed he is compelled to go and pick her up. Alerted by the noise of the crash, Rose appears at the door with a shotgun and fires at the car, which crashes. Grandpa attacks Chris who uses his camera phone flash to awaken Walter from inside grandpa, who turns the gun on Rose then himself. The three lie in the driveway in a triangle as a police siren sounds and a car pulls up. We fear the worst for Chris until Rod steps out of the vehicle and rescues Chris after a moment of stunned silence they set off and Rod says, 'I told you not to go in the house'.

This very complex and messy 'get out' escape physically reflects the psychological confusion of the terrain around racial politics.

Space

The spaces of the two homes create a design contrast between the relative simplicity of Chris's and the hidden depth and complexity of the Armitage house. Two further spaces are explored, the photographic and interior psychological dimension.

Chris's New York apartment[12] is one big open plan loft with high ceilings and exposed beams. Everything is on one level, no layers or stairs, we can see his whole world in that space his bed at one end, kitchen and living room at the other. The bathroom is the only separate room, which is glimpsed when he is shaving in the mirror.

Chris is a successful photographer and his work and the camera itself are foregrounded in the narrative and the visual story. The camera becomes the tool that breaks the coagulated African Americans out of their *sunken place* and allows Chris to discover the truth. The camera makes visible the reality of the ideology underpinning the Armitage house and more widely post-racial America (Benjamin, 2008, 294). Walter Benjamin described what he called the optical unconscious of photography, whereby it might function as a tool to enable people to see the crimes of capitalism. The radical potential of film and photography to awaken people to the dominant ideologies that appear invisible (natural/normal) but govern our lives (Benjamin 1999, 463). The role of the camera in rupturing the status quo and bringing the past into dialectical relationship with the present, rendering visible the material conditions and social relations that are masked by ideology. This potential tool for consciousness raising may also render visible the real but often masked realities around racial hierarchies.

The camera reveals the truth about racial exploitation through a series of observations and ruptures including; the flash that breaks Andre's trance, the photo of Andre sent to Rod that reveals his true identity, the box of photos in Rose's cupboard exposing her complicity, the flash that breaks Walter's trance.

In the Armitage house there are several levels, basement, ground and first floor. The ground floor consists of a living room, study, dining room and kitchen. The rooms all connect onto each other in a circle, Rusty Smith states, 'We had to play the ground floor as it was, which led the tour of the family history in a circle. It was intended to intimidate but we had to be crafty about how we introduced the scale of the family in cuts and close ups' (2021). The stairs lead up to a landing and hallway to the bedrooms, including Rose's bedroom, where the couple stay, which has an en

suite bathroom. We don't see inside the other family bedrooms which helps distance Chris and the audience from the truth. The multi-layered house echoes the layers of racial discrimination that co-exist in the space, from micro aggressions to overt violence. Initially the basement appears to be sealed off and out of use; however, this is where the real brutality of capture and coagulation takes place and represents the deeply imbedded heritage of racial exploitation.

The space appears welcoming and open but once inside it becomes a trap. The real danger lies within the individual, where another dimension exists, a room within a room. The home ensnares the physical body and the process of hypnosis subsequently controls the mind within a meta-physical space that seems boundless. The control of the consciousness appears spatially limitless and it is this prison that is truly terrifying. The chains of enslavement are no longer visible but the body is appropriated by others, imprisoned in their own bodies unable to act independently of the white master the host becomes an instrument for their conscious-ness/wishes.

A further space becomes apparent within the body itself, a dark void of isolation and paralysis. This other dimension, the *sunken place*, opens up when Chris is hypnotised, although this is an interior space it is visualised as if it is beneath ground level and the sense of falling deeper and deeper into a vast infinity is created. When Chris is instructed to sink into the floor he looks tiny and insignificant. Missy can be seen above him in a small television screen-like rectangle of light. According to Patton, *Get Out* interlinks references to old forms of racism with current neoliberal forms. 'The film depicts palimpsest spaces that contain an aggregation of historical narratives and memories of mental and physical violence experi-enced by people of colour underneath the layer of our contemporary moment of Black Lives Matter' (Patton, 2019).

Georgina and Walter's bodies are occupied by grandma and grandpa, hosting their consciousness in a reconfiguration of slavery, 'despite the Armitages protestations to the contrary, race as a matter of significance erupts again and again always catalysed by black bodies' (Landsberg, 2018).

The legacy of racism as a social spatial practice defines spaces of white-ness as dangerous and to be avoided, particularly after sundown. Notions of the home as a trap in horror terms where the home has been harnessed to conceptualise fear in the form of ghosts and monsters is employed. The Armitages embody monstrous ideologies that are often invisible therefore difficult to attack/destroy. Satisfaction comes in the film through the

systematic dispensing with each of the family members who has brought suffering to Chris and previous victims. Connecting with the white suburb from the opening scene we are reminded of the spatial segregation that was enforced in so called 'sundown towns' during Jim Crow laws (1890–1940) in the states. During this period signs that warned people of colour not to remain in the town after sundown sent a clear message they were not only unwelcome but in physical danger if they transgressed these arbitrary white boundaries. The enforcement of these laws contributed to keeping many suburbs white during the post war era. According to Patton, the suburbs came to represent a contradictory space of potential threat and violence and missed socioeconomic opportunity to African Americans. Falsely framing suburban whiteness as natural when in fact the result of violence and discriminatory policies.

Light

Chris's apartment is well lit and includes natural sources from several large windows and artificial light from a selection of table lamps. Wooden venetian blinds hang in varying stages of openness at the windows.

There is plenty of natural daylight initially at the Armitage house from windows although this is diffused through nets. Artificial sources used in the evening include a chandelier over the dining table and two candelabra. There is no natural light in the basement as there are no windows; it is lit by entirely artificial sources. The ceiling of the games room has a surreal quality reminiscent of a casino or disco floor, a luminant grid. This highly stylised lighting feature adds to the sense of unease and disorientation[13] (Fig. 3.2).

It is when Chris takes a photo using a flash of Logan/Andre that he is awoken from his trance state and screams 'Get out' to Chris, who initially thinks he is offended by the photo. Later we understand that this is Andre trying to warn Chris of the danger he is in. Thus, the light is used to illuminate and raise consciousness to enable breakthroughs from the *sunken place* which is dark except for a small television screen rectangle of light at the top.

The lighting of the homes does not follow classic horror conventions, as the naturalistic light tends to serve the sense of normality in denying there is anything sinister going on. This adds to the shock as it is the everyday quality that enables the sickening realisation to be so powerful. The

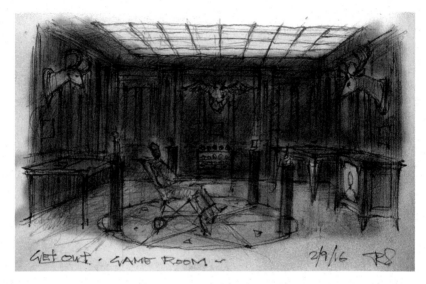

Fig. 3.2 Rusty Smith sketch, the basement game room where Chris is imprisoned

darkness of night is used to accentuate the horror when the façade is dropped and Chris is imprisoned, echoing the white suburban threat from the past warning people of colour not be caught in town after sundown. In the basement the light becomes more disturbing, entirely artificial sources help create an alienating claustrophobic environment. The chiaroscuro links to the horror tradition where shadows of the past haunt the present. The candles from the dinner table earlier acquire new and sinister implications in for example the peculiar use of candlelight in the operating theatre where they assume a ritualistic air recalling the gothic horror of surgical experimentation in Frankenstein's monster (Fig. 3.3).

The flashing lights of the patrol car are initially ambiguous until it is revealed that this is Rod coming to the rescue.

Chris enters the darkness and emerges more whole having faced some uncomfortable realities that he was not looking at previously. Although we don't see him return home, his journey with trusted friend Rod reassures us that he will arrive safely. Rod is his home in a racial, cultural sense and has been closely connected with Chris's physical home throughout while dog sitting.

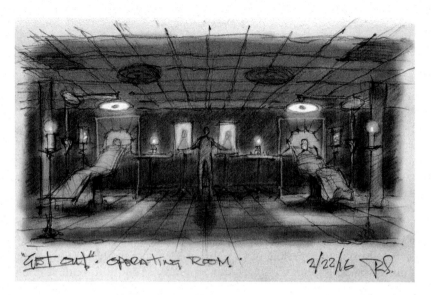

Fig. 3.3 Rusty Smith sketch, Operating Room including ritualistic candle light

Colour

The colour palette of the film is naturalistic with the two key homes using primarily neutral colours. The hallway leading to Chris's apartment is painted pistachio green and cream which appears a little sanitised and hospital like in comparison to the warm rich wooden tones inside where there are also some pops of colour, such as lime green chairs and an orange lampshade. Chris and Rose drive out of the city in Rose's red car which is evocative of her malicious intent and the bloodshed to come.

The exterior woodwork of the Armitage house is white and the interior predominantly neutral with cream and yellow painted walls and furnishings in the living room. Rose's bedroom has pale green walls that echo the sterility of Chris's apartment hallway. In the basement colour becomes denser in the absence of daylight. When Chris is in the sunken place there is a contrast between the cold blues and blacks and the warm yellow glow that comes from the rectangular form. Neither palette is ideal, one is desaturated and the other saturated, representing two extremes rather than the full spectrum of colour.

Set Decoration

The contrasting décor of the two homes can be understood on the surface as belonging to a younger and older generation. However, they also suggest ideological beliefs which attach themselves to these different styles and periods of furnishing. Chris's apartment is alive with artistic energy while the Armitage house is filled with antiques and literally dead things.

Chris's apartment is furnished with contemporary pieces, including leather sofas, a wooden table and set of chairs, three black metal high stools at the breakfast bar. The natural materials, wooden floors and exposed brickwork create a warm inviting space. The simple and uncluttered chic is given character through the large black and white photographic works (Chris's photos) on the walls and several cameras and props like superhero action figures. There is also a small travel alarm clock by his bedside which may be tied to the notion of his need to wake up metaphorically. It is an appealing place to be, houseplants and his dog promote a nurturing atmosphere of social interaction; Rose and Rod both visit his home at different times.

One of Chris's photos is of a bird in flight, wings open an energetic image of freedom. Rather than the contemporary art on Chris's walls there are traditional oil paintings in golden frames in the Armitage house. The set decoration includes layers of history to look like it has evolved over time creating density and texture. Set decorator Leonard R Spears collaborated with PD Rusty Smith who says, 'The painting above the fireplace is representative of the ancestral mythology Jordan wanted to create for the Armitage family. It is set during medieval times and one of the members of the family is being burned at the stake, a sacrificial martyr for their heretical philosophy and science' (Author interview, 2021).[14] Deer heads are a recurring motif of ornamentation, one of which becomes an action prop when Chris uses it to impale Mr Armitage. The poetic justice is apparent as Mr Armitage made his dislike of deer clear saying, 'they've taken over, they're like rats' aligning with slurs used against migrant communities. The contrast in chosen animal imagery also provides a commentary on notions regarding freedom; Chris has a bird in flight while the Armitages surround themselves with animals that have been hunted and killed for sport and subsequently used for decoration.

The Armitage house is decorated with furniture from another era which suggests traditional views including a grandfather clock in the hallway and a globe in the living room hinting at a colonial past.[15] The living room features a cream sofa and armchairs, an oval glass coffee table with a bowl

of green apples in the centre. Wooden panelling and period furniture, traditional fireplaces and ornate overhead lighting all promote a classic conservative look. The hallway is lined with framed family photos leading to the kitchen which is dressed with lots of copper pots and pans and a dried flower arrangement.

In Missy's study two chairs face each other in the centre for her hypnotherapy, one brown leather chair for the patient and another covered in floral fabric. A small round wooden table and table lamps create a cosy atmosphere. She holds a china blue willow pattern tea cup and saucer and stirs the silver spoon in it to make Chris fall into the *sunken place*, when she tells him to sink into the floor. Smith says they wanted the office to feel warm and safe; however, even the epitome of comfort—a cup of tea— becomes an instrument of control.

Rose's bedroom is initially decorated to suggest she no longer lives there, a wooden four poster bed, with remnants from her childhood such as old posters haphazardly pinned on the wall, a cluttered dressing table and a cuddly toy on the bedside. (Chris's phone is found disconnected on the bedside table twice.) Later when the façade of normality is over the space transforms with the addition of a collection of framed photos of her victims on the wall at the head of the bed (the cuddly toy remains on the bedside table) (Fig. 3.4).

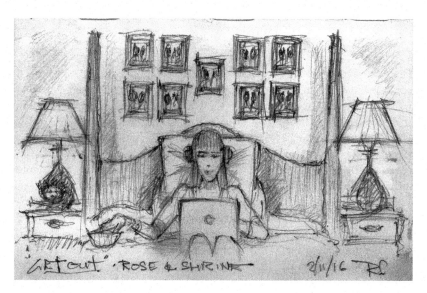

Fig. 3.4 Rusty Smith sketch, Rose's bedroom with shrine of former victims

The fact that Chris is imprisoned in a games room adds another level of cruelty to the proceedings. A room that is allocated for playing in and filled with fun activities has been deliberately ascribed as the room for holding prisoners in. This also connects to the hunting metaphors where the stag has been hunted and killed for the sporting amusement of the family. The message that the lives of others are cheap and at the disposal of the Armitages furthers the sense of callous privilege and entitlement. The room has a surreal quality achieved through the stylised minimal combination of games (table tennis, table football and a darts board), wood panelling and a ceiling made of artificial light reminiscent of a seventies disco floor. Chris is tied to a brown leather chair positioned in the middle of four wooden plinths which each have a table lamp on. Directly in front of him is a stag head mounted on the wall, beneath which an old television set is positioned (circa 1950s). A programme plays which explains the order of the coagula as if it is a perfectly natural procedure, normalising the horrific through the discourse of the everyday.

Everyday objects have been used to create the illusion of normality luring Chris into the trap and he subsequently employs these items in order to escape, ultimately harnessing the tools of his subjugation to free himself; the stuffing from the chair he is tied to, bocce ball from the games room, the stag head, the candle, a knife, a key and a gun are all used against the family.

Conclusion

The Armitage home is a metaphor for the false consciousness promoted by a post-racial America, where the apparently normal surface of everyday life is shattered to reveal covert prejudice. The initially welcoming boundaries of the white home becomes a trap ensnaring and enslaving black visitors who unwittingly enter. The space has hidden depths that conceal the horror beneath the apparently conventional surface. The set decoration enhances the concept through use of items from the past that reverberate and recall the history of slavery. The interior space of the mind is used as a metaphor for the control exerted by dominant ideologies and unconscious internalising of issues. The suburban white home is haunted by ghosts of the colonial past and continues to exclude African Americans on a basis other than slavery. The narrative rewards the characters and the audience for escaping from the house and the neoliberal false consciousness.

NOTES

1. PD Rusty Smith also designed the film *Meet The Parents* (2000).
2. *The Negro Motorist Green Book* was an annual guidebook used by African Americans during the Jim Crow era to navigate segregation while travelling throughout the United States. The book was published by Victor Hugo Green, a New York City mail courier, from 1936 to 1966.
3. According to Bonilla-Silva, 2001, adopting the ideology of colour-blind racism means that African Americans and other people of colour are solely responsible for their social conditions. If people of colour are still poor in the early twenty-first century, it is not because of structural forces and the history of racism; it is their own fault. Consequently, power is maintained through hegemony.
4. 'As a black man, sometimes you can't tell if what you're seeing has underlying bigotry, or it's a normal conversation and you're being paranoid. That dynamic in itself is unsettling. I admit sometimes I see race and racism when it's not there. It's very disorienting to be aware of certain dynamics' (Jordan Peele in Zinoman, *New York Times*, 2017).
5. Jim Crow laws 1890–1940, enforced in 'sundown towns' warned people of colour not to remain in town after sundown.
6. The track played while Chris and Rose drive to the Armitage estate is Swahili song Sikiliza, 'listen to the ancestors. Run. You need to run far (listen to the truth) Brother.'
7. Rusty Smith says, 'The estate had to feel large enough to believe that there could be no escape and capable of sitting on top of a vast undergrounds laboratory and labyrinth of cult history'.
8. Shot on location in Fairhope, Alabama, the house is located in the middle of 18 acres of land, providing the necessary sense of seclusion. The setting was intended as a North-Eastern middle-class suburb.
9. *Doorkijke*, frames within frames that work to both separate and connect two adjacent interior spaces, Ivo Blom (2010, 92).
10. The games room was shot in an abandoned Civil War hospital, which had wood panelling and a renovated seventies ceiling light fixture. Rusty Smith says, 'Once we cleaned up and turned the light on we knew we had the world for our climax' (2021).
11. *Rosemary's Baby* (1968) was one of the inspirations for the film and this scene recalls the horror of realisation that everyone is in on the conspiracy used in the film.
 The conspiracy also recalls *Stepford Wives* (1975) and *The Wicker Man* (1973).
12. The location for Chris's apartment is a loft apartment in downtown Mobile, which the team agreed looked like it could be in New York or Brooklyn.

13. Rusty Smith says the director, dop and he were all fans of Stanley Kubrick and when they found this room while scouting an abandoned hospital agreed this had to be the games room.
14. 'From the beginning of the design process we worked on this illustration, as well as the graphics that would span hundreds of years for the laboratory basement hallway' (PD Rusty Smith, 2021).
15. These may be intended as being the original belonging to the family rather than heirlooms as Smith says, 'One of the backstory components was that the family was part of an ancient cult, seeking immortality for hundreds of years'.

FURTHER READING

Barton, C. E. 2001. *Sites of Memory: Perspectives on Architecture and Race.* New York: Princeton Architectural Press.

Brecht, B. 1964. *Brecht on Theatre: The Development of an Aesthetic.* J. Willett, trans, S. Giles, M. Silberman, and T. Kuhn eds. New York: Hill & Wang Publisher.

Coleman, R. R. M. 2011. *Horror Noire: Blacks in American Horror Films from the 1890s to the Present.* New York: Routledge

Corbin, A. L. 2015. *Cinematic Geographies and Multicultural Spectatorship in America.* New York: Palgrave Macmillan.

Dyer, R. 1997. *White: Essays on Race and Culture.* London: Routledge.

Hooks, B. 1992. 'Representing Whiteness in the Black Imagination.' In *Cultural Studies*, edited by L. Grossberg, C. Nelson, and P. Treichler, 338–346. London: Routledge.

Kracauer, S. 1974. '"Horror in Film," Originally Published as "Das Grauen Im Film".' In *Kino: Essays, Studien, Glossen Zum Film*, edited by K. Witte, 25–27. Frankfurt am Main: Suhrkamp. Translated for me by Eileen Rositzka.

WORKS CITED

Benjamin, W. 1999. *The Arcades Project.* H. Elland and K. Mclaughlin, trans. Cambridge, MA: Belknap Press of Harvard UP.

Benjamin, W. 2008. 'Little History of Photography.' In *The Work of Art in the Age of Its Technological Reproducibility and Other Writings on Media*, E. Jephcott, R. Livingstone, H. Eiland, and others, trans, edited by M. W. Jennings, B. Doherty, and T. Y. Levin, 274–298. Cambridge, MA: Belknap Press of Harvard UP.

Bonilla-Silva, E. 2001. *White Supremacy and Racism in the Post-Civil Rights Era.* Boulder: Lynne Rienner.

Blom, Ivo, 2010, *Frame, Space, Narrative. Doors, Windows and Mobile Framing in the Films of Luchino Visconti*. University of Amsterdam

Butler, B, 2017. 'Jordan Peele Made a Woke Horror Film', *The Washington Post*, February 23.

Desta, Yohana, 2017, 'Jordan Peele's Get Out Almost Had an Impossibly Bleak Ending', *Vanity Fair*, 3 March https://www.vanityfair.com/hollywood/2017/03/jordan-peele-get-out-ending

Freud, 1955, 'The Standard Edition of the Complete Works of Sigmund Freud.' trans. Strachey, J, Hogarth Press, London, 217–256.

Gilroy, Paul, 1987, *There Ain't No Black in the Union Jack*, Routledge

Landsberg, Alison, 2018, 'Horror verité: politics and history in Jordan Peele's *Get Out* (2017)' *Journal of Media & Cultural Studies*, Volume , 32, issue 5, p. 629–642

Morris, W, 2017, 'Jordan Peele's X-Ray Vision' *The New York Times Magazine*. December 20, 2017.

Patton, Elizabeth. 2019, 'Get Out and the legacy of sundown suburbs in post-racial America.' *New Review of Film and Television Studies*, Vol 17, issue 3, p 349–363

Powell, Dionne R. 2020, 'From the Sunken Place to the Shitty Place: The Film Get Out, Psychic emancipation and Modern Race Relations From a Psychodynamic Clinical Perspective.' *The Psychoanalytic Quarterly*, Volume 89, Issue 3, Pages 415–445

Rhodes, John David. 2017, *Spectacle of property: The House in American Film*, University Press.

Smith, Rusty, 2021, Author interview with the production designer of the film.

Zinoman, J. 'Jordan Peele on a Truly Terrifying Monster: Racism.' *New York Times*, February 16, 2017.

Zizek, Slavoj, 1992, *Looking Awry: An introduction to Jacques Lacan through Popular Culture*, Cambridge, MA: MIT Press, 114.

Returning Home: How the Byers' Home in *Stranger Things* (2016—Duffer Brothers, PD Chris Trujillo) Reflects Narrative and Character Interior Landscape

The Byers' home in *Stranger Things* is designed as a transition space, both physically and metaphorically. Situated on the edge of the woods on the outskirts of Hawkins, it is a liminal space between the town, the forest and the Upside Down. Throughout the course of the first season, its small, simple, neutral-coloured interior transforms as Joyce Byers (Winona Ryder) becomes increasingly desperate to communicate with her son and bring him home from another dimension. Although the site of struggle, pain, terror and violence, the Byers' home is also incredibly resilient, like the family it prevails. It is in the house that traditional boundaries are broken and temporary ones created, rupturing and subverting conventional entrance and exit points. At the end of season three, the Byers' home is left behind, its contents packed into boxes, the empty house resonating with self-referential nostalgia for the show's characters and its fans. This poignant departure suggests a family ready to move on, but how do these transitions reflect on the myth of home?

This chapter considers the concept of home in terms of the private domestic environment, the wider sense of community and the metaphorical place of belonging that can result from the repeated viewing of a much loved text. In *Stranger Things*, the home is proven to be a fluid space

© The Author(s), under exclusive license to Springer Nature Switzerland AG 2022
J. Barnwell, *Production Design & the Cinematic Home*,
https://doi.org/10.1007/978-3-030-90449-4_4

where boundaries are repeatedly broken and transgressed, with any separation between interior and exterior exploding through the design to accentuate the malleable nature of borders and frontiers. The protagonists are situated outside of mainstream culture and able to manipulate the arbitrary boundaries of convention reflected in the design where architectural elements are transcended and space and time subverted.

SYNOPSIS

Stranger Things is set in Hawkins, a small town in Indiana where 'nothing really happens'. This all changes when Joyce Byers' son, Will (Noah Schnapp), goes missing, sparking investigations that reveal dangerous Government experiments. The quiet town landscape in its everyday familiarity functions as the backdrop to the supernatural events that subsequently unfold. Following a game of Dungeons and Dragons, Will cycles home and is pursued by a monster. Will is taken to the Upside Down where he manages to survive by hiding in the other world version of his den. A contrast is thus established between the reassuringly familiar small town of Hawkins and the horror of otherness signified by the Upside Down, another dimension, where a beast dwells.

VISUAL CONCEPT

Through viewing the series, and scrutiny of PD Chris Trujillo's designs, the visual concept can be understood as doorways and portals connecting spaces, worlds and ideas. The Upside Down is presented as the nightmare to the American Dream of suburban Hawkins slowly infiltrating the town. However, it could be argued that the two are coexistent expressions of the same mythic place, both facets of the American Dream.[1] The suburban environment has been identified as a 'borderland' space situated both physically and philosophically between the urban and the rural. (Please see Chap. 3 for a discussion of the potential threat of the suburb to racial minorities in *Get Out*.) The subgenre the Suburban Gothic can be seen to focus on tensions arising from the mass suburbanisation of the United States. As Bernice Murphy states the subgenre 'is concerned with exploiting a closely interrelated set of binary oppositions in which the assumptions that lie at the heart of the so called Suburban Dream are inverted/subverted' (2009, 249). As Murphy points out the subgenre often explores the flipside of pro-suburban rhetoric of government and corporate

industry. The Upside Down operates as a dark reflection of the shows nostalgic 'home' of Hawkins threatening to disrupt the dream world of national myth (Mollet 2020, 141). 'By sifting back and forth between the two worlds, *Stranger Things* explores the relationship between the two versions of "home": the darker side of the United States 1980s with its lived realities of toxic masculinity and Reagan's military industrial complex and its nostalgic "Spielbergian" counterpart' (Mollet, 142). Thus the contrast between the two environments enables the complexity of small-town America to be examined.

THE NOSTALGIC RETURN

Cult television can be more or less dated from the mid-sixties on either side of the Atlantic, but when US networks shifted away from simple Nielsen ratings to a more demographic-centred approach nearly 20 years on, the role of niche audiences changed, along with the definition of a cult television text (Angelini and Booy 2004, 22). Cult TV is defined not by any feature shared by the texts themselves, but rather, by the ways in which they are appropriated by specific groups. As such, there is no single quality that characterises a cult text. Instead, cult texts are defined through a process in which they are positioned in opposition to the mainstream (Jancovich and Hunt, 2004, 27). Cult TV audiences recognise themselves as different. The main characters of *Stranger Things* are outside of the mainstream, the geeky kids preferring science over sports and Dungeons and Dragons instead of baseball. Thus the show's protagonists are not the popular kids but the outsiders who get to triumph over the monster *and* mainstream culture, further enhancing the viewing pleasures of a cult audience who can feel perfectly *at home* observing their penchant for endless games of D&D in the Wheeler basement. Inexhaustible revisiting and rereading of a text can be seen as a fundamental aspect of cult consumption, and this attentiveness to the text is one of the qualities that constitutes difference and forms a basis for understanding the nature of the aesthetics of cult TV (Wilcox 2004, 32). The traditional structure of TV shows enables audiences to return weekly to familiar characters, spaces and story threads, replicating the familiarity of feeling *at home*. As Niemeyer states, media can trigger nostalgic emotions and are formative in the aesthetics of the nostalgia world they portray and at the same time serve as a cure for the viewer's longing for a past era (2016, 129). Now, with streaming channels and online binge-watching widely available, audiences can

consume several episodes in one sitting, altering the viewing context. This shift can be seen to further intensify the scrutiny and inexhaustible revisiting associated with cult fan behaviour, with each new season creating another layer of return which allows viewers to 'revel in the development of characters and long complex narrative arcs' (Gwenillian-Jones and Pearson 2004, xvii). It can also serve to deepen the strong sense of community and belonging central to cult texts.[2]

Stranger Things makes available a welcoming community to those holding the core credentials of devotion to the show, which establishes ideas connected to home and a sense of belonging. The notion of home is featured strongly in the narrative, leading to nostalgia for a lost mythic childhood, community and United States. The term nostalgia, partially stemming from *nostos* (return/homecoming) in ancient Greek, refers to the epic hero who, having undergone trials and tribulations, achieves the ultimate level of heroism by successfully returning home. In Homer's *The Odyssey*, Odysseus's drive to return home establishes the notion of nostalgia in narrative. Seventeenth-century Swiss physician Johannes Hofer joined the Greek *nostos* with *algos*, meaning suffering or affliction, as a term originally used to describe the melancholy that stems from the desire to return to one's homeland. However, nostalgia, once regarded as a disorder inhibiting the afflicted from engaging in the present, can now be considered as a more positive tool aiding wellbeing, with nostalgic reminiscence recruiting positive experiences from our past in order to *assist us* in the present (Routledge, 2015, 4–6). Recent research into nostalgia has found it to be beneficial both mentally and physically, thus reversing some of the previously considered negative effects of 'wallowing in the past', or the futile search for a lost 'object' that can never be retrieved. Thus, the positive emotional benefits of remembering a time of belonging can help to produce wellbeing in the present. As cult texts tend to lean heavily on nostalgia, it is important to consider how the site of home and the journey towards it are configured at each stage of the show's development.

Stranger Things can be seen to produce a multi-layered nostalgic experience whereby the viewer may relive the 1980s and experience nostalgia for the period reproduced on screen in a variety of ways. As Ryan Twomey explains: 'For the Duffer Brothers, unlike Milton, Virgil or Homer, nostalgia isn't just a longing for a place you can return to […] through a clever recreation of the decade's aesthetic, *Stranger Things* elicits nostalgia not for a place but for a time' (2018, 41). Audiences can 'return home' through their viewing experience to a recreated past while also

experiencing the benefits of a sense of belonging to a group of individuals who share their love of the show and the feeling of 'being at home' this produces. Much has already been made of *Stranger Things*' countless references to 1980s popular culture, including Dungeons and Dragons, Stephen King novels and films by David Lynch, Stephen Spielberg and Brian DePalma, which the show nostalgically replicates and weaves into a rich tapestry. Kevin Wetmore suggests this love of the 1980s could represent 'a yearning for a perceived simpler time [...] before cell phones and the Internet became prevalent', which he describes as 'manifesting a radical freedom we have lost' (2018, 2). This loss can be recognised and reconfigured through the show where the real and the imagined period is interwoven in such a fashion as to highlight the imperfections of the past. In each season, the home is established as crucial to both character and narrative, as the physical and metaphysical journey to return home is fundamental to the narrative arc and the nostalgic enterprise more widely.

Myths have been cultivated around the home as a safe and secure structure embodying traditional family values. Signalling a yearning for community and something that never truly existed, the mythical place called home is constructed for audiences on the screen (Bronfen, 2001, 50). Screen homes can appear as familiar as our own, especially those we return to regularly in the form of series. In these recognisable spaces, we are reassured by the familiarity, continuing plot lines and a set of characters we know and love. A sense of belonging also comes with the knowledge of genre expectations, character and setting. We feel *at home* in the constructed world around us. These ideas can also be fruitfully subverted where the home is used to trap characters and function as a site of anxiety and disturbance, which is often the case during periods of social and political upheaval or when constructs such as the American nuclear family are questioned. (Please see Chap. 3 where the suburban white home is used to trap characters.)

SUBURBAN DREAMS

Hawkins, Indiana is a classic small American town featuring a main street with the standard collection of exteriors including shops and the Sheriff's office. The production was shot in Atlanta using real locations where much of the architecture fitted with the requisite 1980s period. The low-level buildings create an easy flow between the interior and exterior. The image of quiet suburbia generates nostalgia for traditional family life and a

mythical past that perhaps never truly existed. According to Boym restorative nostalgia emphasises the need to rebuild the lost home but confuses the real with an imagined ideal. Hawkins is established as a typical suburban town in the tradition of a mediated ideal often called suburbia, invoking the aesthetic markers of a suburbia that is both familiar and nostalgic. According to Lacey Smith, this relies on cultural assumptions about the safety of the suburban home and wider environment, thus offering a critique of the dominant ideologies associated with suburbia and our collective cultural connection and nostalgia for the images that sustain those ideals (2018, 215). Through a mediated imaginary place that proliferates on screen rather than by the material inhabited suburbs of everyday life, the suburbia simulacrum acts as a glittering mirage that obfuscates the practical pitfalls of suburbanisation (218). Smith suggests that *Stranger Things* uses the Upside Down as a way to present Hawkins as it truly is— an already infected relic of a nostalgic suburban ideal, a mirage of normality hiding a sinister and dark reality that is always present within it (218). This is a feature of cult texts where the myth of the universal main street is presented as a façade for the disturbing truth lurking just beneath the surface.

However, the protagonists of *Stranger Things* do not belong to the suburban dream, they are outsiders and misfits. As Christine Muller explains: 'By featuring threshold straddling characters challenging established networks and attitudes of authority the series champions misfits, those whose inability to meet prevailing expectations of cultural worth becomes the very resource from which empowerment through solidarity emerges' (2018, 199). It is the kids' outsider status that enables them to triumph in many ways during the course of the narrative, their knowledge of Dungeons and Dragons, CB radio and other uncool geek qualities often turned on their head to create cultural capital where there was none. Their difference, therefore, becomes an ultimate strength. This links with the key characteristics of cult texts in the acceptance of individuals for who they are in an inclusive safe space, that is often situated outside of the mainstream and dominant ideologies. As such, the *Stranger Things* kids are often more closely aligned with the natural landscape than they are with buildings that represent suburban life. For example, Will Byers' affinity with a more natural environment is established through his hidden den in the woods, 'Castle Byers', made out of tree branches. The natural landscape is a key feature of the show, as audiences are repeatedly invited to return to exterior locations such as the woods and the quarry. The natural

Fig. 4.1 The Byers' bungalow is located on the outskirts of town

backdrop is contrast with the Upside Down, which appears to be a nocturnal overgrown forest producing a sticky substance that is slowly infiltrating the town. Trees and woodland are everywhere in Hawkins, mirrored in the Upside Down by sprawling black vegetation. What begins as a beautiful setting becomes poisoned and encroached on by the other world, turning increasingly unsafe as more ruptures occur and the sense of safety and normality is disrupted. This can be read as the collapsing of the illusion of the American Dream in Hawkins to reveal the dark void at the heart of the capitalist construction.

The Byers' home is situated on the edge of the woods on the outskirts of the town, distinct and singular (Fig. 4.1). The family is positioned on the margins of society spatially and socially at the fairy-tale threshold of the forest. The notion of home is heightened in the question of belonging that comes with outsider culture and outsider characters. The cult text welcomes the rejected and marginalised outsider into a community that doesn't conform to societal hierarchies around wealth or social status. The protagonists of the show are all outsiders: as such, they are able to reject the ideology of the suburb and escape its clutches. As Smith observes, it is their designation as 'freaks and outsiders' that allows them to recognise 'the dark underside of suburban life in Hawkins' (2018, 222). Joyce Byers is a single parent who has a low-paid job in the town store where she works long shifts and is often away from home when the children are there alone. Outside of the social norms of suburban motherhood, she rejects

the nuclear family and often refuses to be silenced. Her home reflects the reality of the family income, the cluttered space of the simple bungalow revealing a loving and warm (if chaotic) family life held together by a single working mother. Though lacking luxury, it exudes warmth created from the natural colour palette, soft furnishings and items of family life that ornament the small space. An unpretentious environment that constructs a home through the informal clutter of a lived-in space rather than the formal show home qualities of for example the Wheeler home.

The Byers' home is a pivotal transition point between the two worlds of 'normal' and 'abnormal' during the first and second season. It functions as a liminal space situated between the two environments that increasingly comes to reflect the danger and turmoil of the Upside Down. As Muller suggests, liminality infuses every aspect of the narrative (2018, 202), and through the course of the first season, Joyce's small, simple, neutral-coloured bungalow transforms, as the protagonist becomes increasingly desperate to communicate with her son and bring him home. Furniture is moved around in haphazard fashion, creating a cluttered and chaotic frame bursting with brightly coloured fairy lights. The spatial transformation of the home reflects Joyce's interior landscape while also radically altering for reasons connected to the narrative development. Each time Joyce watches the walls of her home shift and pulse with the danger of the Upside Down, it is suburbia itself that appears to threaten her. The home is a metaphor for her psychological state, which appears fragile as she refuses to give up on the belief that her son is alive and communicating with her from another dimension. As a transition between the two colliding environments of normal and abnormal, the Byers' home and its design are crucial in conveying key themes that reflect the characters' journeys, narrative and wider themes of the show.

In the next section, visual concept analysis will be used to investigate the ways in which the design of the Byers' home in *Stranger Things* conveys and enhances the major themes of the script.

Interpreting the Visual Concept

Space

The Byers' house is a small bungalow consisting of three bedrooms, an open-plan living room, kitchen, bathroom and hallway. The environment is constructed as a fluid space, allowing characters and camera to flow.

Situated on the ground floor, it initially appears simple to navigate, as there are no staircases to create multiple levels or vertical movement. This spatial limitation decreases the possibility of concealment by taking away the potential of anything lurking upstairs or downstairs. This also limits character space, mobility and options suggesting lower status. The family living here is caught within the claustrophobic narrow hallways of a dark and cluttered house (Boudreau, 2018, 167). This space not only functions as accommodation and shelter, it is also a communication device, a trap and a portal to another dimension.

All of the rooms connect on the same level through doorways off the central hallway. Corridors are used by designers to extend physically and prolong visually the transition from one place to another, thus emphasising a journey, a pause or punctuation between two locations. Details of distance, width and material alter our perception of where the character is travelling to and what they might find on arrival. The corridor is a liminal space, connecting one room with another, often granting access to several possible destinations leading off the central corridor. Thus it forms part of a journey to another room, an 'in between' space that extends the journey and builds tension, as 'each step advances but also delays the denouement' (Jacobs 2013, 28). The corridor in the Byers' home is an important aspect of the spatial geography, building suspense and extending screen time as it allows a fluid movement that adds tension and heightens fear and anxiety (Fig. 4.2). The lack of interior space is contrast with the exterior expanse of grass and woodland, which promotes a sense of physical and social isolation. The family's outsider status is echoed in their physical position in the environment.

Notions of home are amplified in the womblike den that Will finds sanctuary in during his time in the Upside Down. The den resembles the one he made in the woods near his home, 'Castle Byers', but its qualities are intensified in the dangerous environment he is now trapped in. The den offers Will protection and shelter in a physical sense, while comforting and sustaining him from giving up in despair. Such is the potency of the meanings attached to a child's den in the collective imagination: a place to have fun, hide, play or retreat in times of trouble. This is private space in a way that the bedroom within the family home is not: disconnected, a little satellite of his own. Cult texts can also be seen to create a uniquely personal space where each viewer builds and customises their own world. In season three Will destroys his den in anger after an argument with his

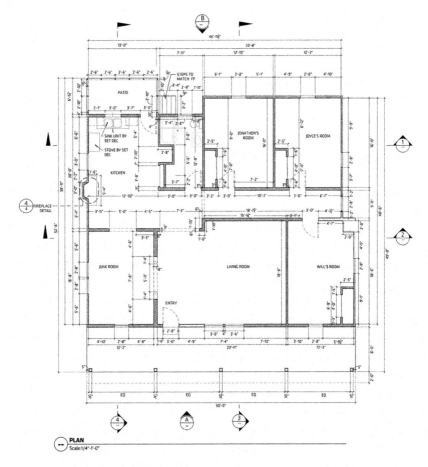

Fig. 4.2 Byers' house floorplan; the central corridor is a key feature enabling movement and tension

friends who seem to be growing up and growing out of games like D&D in favour of girlfriends. This suggests Will too is reluctantly transitioning from childhood by rejecting the magical innocent world that the den signifies.

In and Out

Windows and doorways articulate the boundary between interior and exterior worlds, traditionally connecting the two. Where these are positioned is one of the fundamental building blocks of a design, influencing the way in which characters enter and exit space, but also how they move between the private domestic interior and the public exterior. The Byers' front door leads out to a covered porch that links directly with the exterior landscape. There is also a back door leading into the garden, where the shed is located. However, the apparent connection with the landscape is deliberately withheld in terms of seeing in or out of windows or doorways. The windows initially have curtains obscuring the view outside which is gradually added to with newspapers stuck on the glass to enable Joyce to see the artificial lights more clearly when Will communicates. This creates a physical and symbolic boundary between inside and outside where the rest of the community resides. The house, therefore, stands alone, reflecting the isolation of the family. However, it also works to heighten the connection with the woods and the other world.

The usual transitions and boundaries are broken as the portal between the two worlds ruptures time and space and creates temporary doorways. For example, the monster comes through the Byers' living room wall, creating a breach that Joyce subsequently talks to her son through. However, this is only temporary, and when it reseals, she attempts to break through with an axe. Joyce adapts to the new geography when she hacks through the wall where she had previously glimpsed her son. This action creates a new point of exit/entry but not into the other world as she had hoped. These bold moves indicate her willingness to transgress traditional boundaries and continue the notion that these can be broken and conventional entrance and exit points do not function effectively in this environment. Thus, the visual concept of the design works to make the Byers' home a transitional space between the two worlds, an *in between* functioning as a portal or corridor offering connection. Furthering the notion of liminal space, their home is used as a trap, where Jonathan and Nancy attempt to ensnare the monster.[3] The prominent use of doorways also nods to the use of doors to frame the past as haunted in Gothic texts, serving as warnings of sites of trauma to be avoided and repressed. However, rather than hide the possibility of loss, *Stranger Things* invites the viewer to revel in being haunted by the eighties. Boundary crossing is positively encouraged through the production design, character actions and

underpinning ideology. Thus, the show empowers the audience to enjoy the pleasure of revisiting a period in time that no longer exists while promoting the benefits of being situated outside of it with the positive connotations of perspective, fluidity and insight.

During the third season the importance of doorways and the navigation between interiors, exteriors and worlds continues. The Byers' home is featured very little, instead the Starcourt shopping mall becomes a symbol of the consumer driven ideology of the period, the destruction of the traditional main street and the site concealing the secret Russian base beneath the surface. When working out how to enter the base Robin says, 'There's no way in … if you're using doors'. Air ducts replace the conventional transition points and allow the characters to infiltrate the labyrinth of tunnels that lead to the Russian operation to reopen a doorway into the other world.[4] The dualism of this design articulates the borders between nations, ideologies and the problematic distance between private and public American life.

Light

The lack of daylight in the Byers' home echoes the absence of light in the Upside Down and contrasts with the abundant natural light in the town of Hawkins. Natural light is obscured from windows by newspapers, while artificial light is designed to communicate across the two dimensions, from the Upside Down to the town of Hawkins. Communication between the worlds begins in a cupboard where a ball of lights is found pulsing. Joyce discovers the fairy lights that enable coded communication with her missing son. Gradually she fills the house with brightly coloured fairy lights to better communicate with him. These lights sparkle in the otherwise low-lit home, providing small scraps of hope and information each time they illuminate. Artificial light also comes from an increasing number of table lamps creating dramatic high contrast light and shade. This chiaroscuro reflects the building intensity of the drama. The light and shade in the home becomes more and more apparent, linking with the Gothic tradition of shadows and their connection with the uncanny.[5] Shadows of the past often haunt the present in Gothic texts as a provocation to confront traumatic events. In *Stranger Things*, the shadows have multiple connotations—including the darker side of the American Dream, US government experiments that have resulted in the monster, and the private demons of individual characters. (Please see Chap. 2 for a discussion of flickering light

in relation to the haunting invisible presence of a social underclass in *Parasite* and the return of the repressed (Figs. 4.3 and 4.4.)

Continuing the concept of the Byers' home as a doorway, the fairy lights open up boundaries between the two worlds. The lights form both a connection and a barrier. What we cannot see is as important as what we

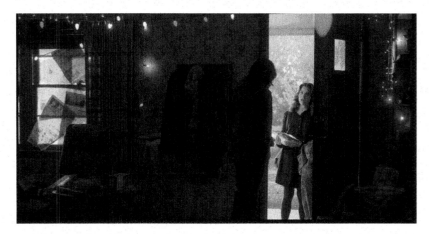

Fig. 4.3 Joyce Byers opens the door to Mrs Wheeler. A small slice of daylight from the exterior contrasts with the lack of natural light inside the home

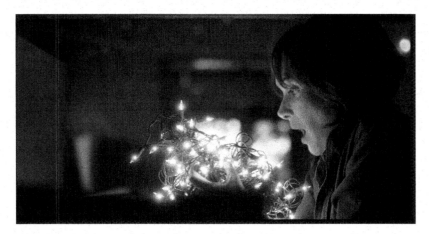

Fig. 4.4 Joyce discovers the flickering fairy lights enable communication with her absent son

can see: fantasy bridges the gap between the two. Like Lacan's conception of the gaze (1998), the lights activate our desire to see more while also being an obstacle to observing all there is to see. The pulsing artificial lights are also reminiscent of the flickering candles of Gothic literature and horror film and are central to the overall aesthetic design of all three seasons.[6] The light reflects character interior landscape, building on the aspects already established through the spatial design and furthering the notion that Joyce Byers has a fragile mental state that can be viewed as both a weakness and a strength. From a cult text point of view this enables her to transgress conventional ways of thinking. The faltering light creates a sense of unease in the traditions of these genres, playing on the fear that the light may fail completely at some point and plunge the characters into darkness and danger, leaving them prey to whatever monsters or ghosts may be lurking there. As an electric life force, the light is a connection to Will, and his mother hangs on every flicker of hope. In this instance, the necessity of light and shade is made apparent. Without the shade or intermittent absence of light there can be no burst of light. In other words, if the light source was continuous, it would not be possible to communicate through it in the same way. Light and shade are essential to both the filmmaking and the storytelling process. Without one, the other cannot exist. This resonates with the binaries found in *Stranger Things*, in particular, the opposition between Hawkins and the Upside Down. Although the Byers' home is not a key feature in season three it is significant in the final episode when empty, the windows now bathe the interior in gorgeous golden sunlight. For example when El lies on the floor reading the letter from Hopper she is lit with natural light from the bedroom window that glows and intensifies the sense of the natural passage of time, tied to Hopper's apparent death and the end of an era. This light is interesting as it does not recall or recreate what we have seen but what we have felt as it conjures a golden time of warmth, love and friendship between the members of the surrogate family.

Colour

The colours of the Byers' home are predominantly neutral in the first instance. A palette of beige and brown perpetuates with highlights of yellow that help lead us into the aesthetic world of their environment, linking

back to nature, wood and the forest. This selection and combination of colours enhances the visual concept already established by the fundamentals of space, in and out, and light. The fluorescent fairy lights add bright unnatural colour to an otherwise natural palette, transforming the home with a display of sparkling artificial colour. Will's bedroom walls are yellow, linking him most strongly with the positive connotations of the colour and echoing the use of bright colour employed in *ET: The Extra Terrestrial* (1982) to differentiate the children's space from the more monochrome adult space. As a child, Will is imbued with the power of magical thought, but instead of this contrasting with the other spaces, it is interwoven throughout. This suggests everyone in the whole household is capable of thinking outside of the narrow boundaries of convention.[7] The bright yellow of sunlight, hope and childhood radiates through the Byers' bungalow, suggesting that in spite of their problems, there is positive energy here. Yellow is featured throughout the home, in the yellow vinyl flowered dining chairs, lamps, throws, curtains and phone. The use of yellow in combination with the natural neutrals furthers the notion that the home is an extension of the woodland. This supports the visual concept in implying that boundaries are operating in an unconventional fashion in this space. The Byers' home is a transitional locale that interlaces with the woods in this world and the Upside Down in the other (Fig. 4.5).

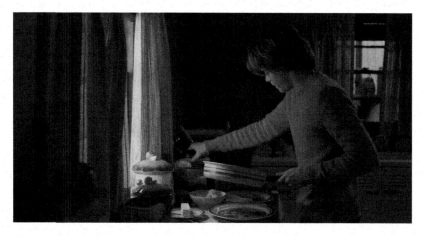

Fig. 4.5 Jonathan Byers surrounded by yellow props and wearing a yellow jumper

The colours introduced into the Byers' home in the second season are the black, blue and purple of the crayon drawings Will creates that ultimately form a map of the tunnels beneath the surface of Hawkins. These dark colours infiltrate the home and occupy the interior space reflecting the monster's penetration and habitation of Will's body. The Byers' home is rarely featured in the third season where the colour palette that predominates is that of the acid neons of the Starcourt shopping mall. This takes the fairy lights of the first season to a new level reflecting the degree to which the monster has succeeded in taking over the town.

Set Decoration

The house is decorated to reflect the limited budget available to Joyce Byers,[8] with busy wallpaper, mismatching pieces of furniture and old sofas covered in throws. Shelving units are crammed full and there are several table lamps, creating a cosy, cluttered atmosphere. However as the narrative progresses, the dressing becomes more chaotic. The telephone is a key action prop in bright attention; grabbing yellow it connects with Will and enables communication from the Upside Down, but it is burnt out, becoming charred and black to reflect the other world. Joyce purchases a replacement phone in beige, which also becomes burnt and destroyed. PD Chris Trujillo sourced the 1980s furniture and props from weekend estate sales in order to create the realistic lived-in setting he wanted. He used the same set for the real world and the Upside Down, which meant continuous redressing: 'There was the added fun of building to accommodate the monster and a mother with an axe tearing the place apart in order to communicate with her son' (Trujillo in Write, 2017).[9] Will's bedroom wall features the iconic poster for the Spielberg film *Jaws*, nostalgically nodding to the period while also referencing the themes of the film. Floral and plant based motif recur around the house, whether in small details such as floral wallpaper prints, the bold dining chairs or the clock with tendrils emanating from it. Organic building materials and furniture all refer us to the forest, to the extent that the space feels part of the forest, further enhancing the notion of the Byers' home as an unconventional boundary between worlds.

CONCLUSION

The Byers' home radically alters for reasons connected to the narrative development but also working to reflect the inner turmoil of Will's mother. In season one a small, simple, neutral-coloured bungalow changes shape and colour as the protagonist becomes increasingly desperate to communicate with her son and bring him home. The spatial transformation reflects Joyce Byers's interior landscape as she unravels it deteriorates. By the time they rescue Will the house has the letters of the alphabet daubed in black paint across the wall, has been set on fire, hacked into with an axe and burst through by a visiting monster. Joyce's destruction of her own home in an effort to find her son indicates her rejection of the confines of mainstream ideology and her symbolic lack of attachment to the domestic trappings of suburbia. The Byers' home is not safe or secure, it is a volatile place of danger where home comforts are gradually dispensed with.

Will remains missing throughout the first season until the final episode when his mother and Chief of police, Hopper (David Harbour) enter the Upside Down and bring him home. Normality appears to have been resumed: when the family is reunited in a restored home, we feel reassured by the resonance of the homecoming in closing the circle of the characters' journey. However, when Will goes to the bathroom and coughs up black matter, the room is temporarily transformed to reflect the other dimension, threatening to consume the life he has fought to return to. The notion that the Upside Down can infiltrate and bleed into the real world has been suggested in many ways throughout the series.

Will's return is nostalgic in the original sense of the term, as he has survived a heroic journey into unchartered lands where a monster lives. The narrative relies heavily on remembering a time and place with fondness. These themes are employed in several layers in *Stranger Things*, the narrative, the 1980s period and the emphasis on home in both the individual sense and the wider community and audience reception. A sense of loss is entwined in the audience's reading of the text as something that no longer exists—the 1980s—thus cannot be physically returned to. However, the state of mind can be returned to temporarily when watching the show. Thus, *Stranger Things* elaborates on and enables a nostalgic return

delivering the audience back in time plus the satisfaction of seeing their hero return home from a perilous journey.

In *Stranger Things*, the fragile and malleable nature of boundaries is visualised through the five tools of space, in and out, light, colour and set decoration. The home is seen to be a fluid space where boundaries are broken and transgressed. The exterior and interior appear dislocated through the lack of views in or out of windows, reinforcing the notion that traditional boundaries don't operate according to expectations. The Byers' home functions as a doorway/boundary to the other world and a continuation of the natural exterior. The home is designed to convey the concept of transitional space through the in and out in particular, as the boundary between interior and exterior is challenged and exploded through the design. The Byers' home is a linking device between the two worlds, indicating the centrality of home to identity and belonging. The importance of nostalgia to Will is tangible as it has fuelled his return. The unconventional outsider status of the Byers empowers them to transgress physical and psychological boundaries and to reinterpret and revise space to enable the rescue of Will. His return temporarily closes the circle that PD Richard Sylbert refers to as signifying safety and security. The home has been rejuvenated since the chaos and the normality of everyday rituals has resumed.

However, it soon becomes apparent that Will's journey is not yet over. In the second season, the Byers' home is again the site of trauma and the key to both environments as its design actively participates in the narrative and forms the problem-solving visual for the series, by reflecting Will's interior landscape quite literally. At the end of season three, their home is abandoned. This poignant departure suggests a family ready to move on and challenge the next boundary that threatens to restrict their growth as they expand outwards into the unknown, ready to find a new home. *Stranger Things* opens up a space constructed like the Byers' home to accommodate the audience, a transitional place with fluid borders that works to connect nostalgia and belonging by creating a portal that we can enter whenever we choose by viewing, reviewing, thinking, talking or writing about the show. This gift gives the audience the positive tools to navigate their televisual way home.

NOTES

1. As Wetmore suggests, they are 'two sides of the same coin' (2018, 224).
2. Please see, Mollet, Tracey, Scott, Lindsey (2021). *Investigating Stranger Things. Upside Down in the World of Mainstream Cult Entertainment*, Palgrave Macmillan, for a full book length exploration of the show in relation to the cult text.
3. The importance of doorways can be seen in the portal of the Government base that leads directly to the Upside Down and eventually enables Joyce and Hopper to rescue Will. Continuing the centrality of doorways at the end of the second season, Eleven closes the door connecting the two worlds, symbolically separating them.
4. Doorways are central to the whole premise of the show in the struggle that exists between the opening and closing of a doorway between two worlds.
5. Ghosts communicating through electricity has long been a trope of the Gothic genre. Flickering lights are a consistent feature throughout season one, from the initial flickering bulb signifying Will's disappearance to the bike headlights and Mike's carport flickering.
6. A partially revealed object or an uncanny entity at the edge of our vision is Lacanian conception of the gaze and a definition of Gothic.
7. Author interview with PD Jim Bissell (2016).
8. Four set decorators worked across the episodes, Jess Royal, Neringa Baciuskaite, Kevin Pierce and Emilija Einoryte.
9. Write, Robin, 2017, *Awards Daily*, Chris Trujillo interview, 'On Set Designing the 80s in Stranger Things'.

FURTHER READING

Abbott, Stacey, 2010 (ed), *The Cult TV Book*, IB Tauris: London.
Andrews, Eleanor, Hockenhull, Stella and Pheasant-Kelly, Fran, 2017. *Spaces of the Cinematic Home. Behind The Screen Door.* Routledge: Oxfordshire.
Boym, Svetlana, 2009. *The Future of Nostalgia*. Basic Books: New York
Eco, Umberto, 1985. *Casablanca: Cult Movies and Intertextual Collage. Travels in Hyperreality*. London Picador: 197–211
Freud, Sigmund, 2003. *The Uncanny*, Penguin: London.
Hofer, Johannes, 2012. 'Dissertation Medica de Nostalgia oder Heimwah (1688) in Helmut Illbuck *Nostalgia: Origins and Ends of an Unenlightened Disease*. Illinois: Northwestern University Press, p. 5
McCann, Ben, 2004. 'A discreet character? Action spaces and architectural specificity in French poetic realist cinema.' *Screen*, 45, no. 4: 375–382.
McCarthy, Kayla, 2019. 'Remember Things: Consumerism, Nostalgia and Geek Culture in Stranger Things.' *The Journal of Popular Culture*, Vol 52, No 3.

Sylbert, Richard, 1989. 'Production Designer is his title. Creating realities is his job.' *American Film* 15, no. 3: 22–26.

Tierney, John, 2013. https://www.nytimes.com/2013/07/09/science/what-is-nostalgia-good-for-quite-a-bit-research-shows.html

WORKS CITED

Angelini, Sergio and Booy, Miles, 2004. In *The Cult TV Book*, ed Stacey Abbott, 22. IB Tauris: London.

Bronfen, Elisabeth, 2001. *Home in Hollywood. The Imaginary Geography of Cinema.* Columbia University Press: New York.

Boudreau, Brenda, 2018. 'Badass Mothers. Challenging Nostalgia' In *Uncovering Stranger Things. Essays on Eighties Nostalgia, Cynicism and Innocence in the Series*, ed Kevin J Wetmore, 164–172. McFarland: North Carolina.

Jacobs, Steven, 2013. *The Wrong House: The Architecture of Alfred Hitchcock.* Rotterdam: NAI Publishers.

Jancovich, Mark and Hunt, Nathan, 2004: 'The Mainstream, Distinction and Cult TV' In *Cult Television.* 27–44. Minneapolis: University of Minnesota Press.

Gwenillian-Jones, Sara and Pearson, Roberta, 2004. *Cult Television.* Minneapolis: University of Minnesota Press.

Lacan, J, 1998. *Four Fundamental Concepts of Psychoanalysis.* New York: WW Norton (95–97)

Mollet, Tracey, 2020. '"I'm going to find my friends…I'm going home": Contingent nostalgia in Netflix's *Stranger Things.*' In *Was It Yesterday?: Nostalgia in Contemporary Film and Television,* edited by Matthew Leggatt, 137–151. Albany: SUNY Press.

Mollet, Tracey, Scott, Lindsey, 2021. *Investigating Stranger Things. Upside Down in the World of Mainstream Cult Entertainment.* Palgrave Macmillan

Muller, Christine, 2018. 'Should I stay or should I go? Stranger Things and the In Between' in *Uncovering Stranger Things. Essays on Eighties Nostalgia, Cynicism and Innocence in the series,* ed Kevin J Wetmore, 195–204. McFarland: North Carolina.

Murphy, Bernice, 2009. *The Suburban Gothic in American Popular Culture.* Palgrave Macmillan

Niemeyer, Katharina, 2016. *Media and Nostalgia. Yearning for the Past, Present and Future.* Palgrave Macmillan.

Routledge, Clay, 2015. *Nostalgia: A psychological resource.* London: Routledge.

Smith, Lacey N. 2018. 'A Nice home at the end of the cul de sac. Hawkins as infected postmodern suburbia.' In *Uncovering Stranger Things. Essays on Eighties Nostalgia, Cynicism and Innocence in the series,* ed Kevin J Wetmore, 215–224. McFarland: North Carolina.

Twomey, Ryan, 2018. 'Competing Nostalgia and Popular Culture. Mad Men and Stranger Things.' In *Uncovering Stranger Things. Essays on Eighties Nostalgia, Cynicism and Innocence in the series*, ed Kevin J Wetmore, 39–48. McFarland: North Carolina.

Wetmore, Kevin J (ed) 2018. *Uncovering Stranger Things. Essays on Eighties Nostalgia, Cynicism and Innocence in the series*. McFarland: North Carolina.

Wilcox, Rhonda V, 2004. 'The Aesthetics of Cult Television' in *The Cult TV Book*, ed Stacey Abbott, 32. IB Tauris: London.

Write, Robin, 2017. Awards Daily, Chris Trujillo interview, 'On Set Designing the 80s in Stranger Things'.

Bridget Jones's Diary (2001, Sharon Maguire, PD Gemma Jackson): A Wild Unconventional Space Bursting with Potential

The space of the single female has not traditionally held the glamorous appeal of the single male. Historically all of the reasons to celebrate the male single space are inverted to commiserations for the female counterpart. Instead of a heritage of exciting bachelor pads there are spinsters to be pitied. Shows like *Sex and the City*, *Girls* and *Fleabag* have done much to redress the balance providing fun, frivolous single homes. However, Bridget Jones preceded these and sets the tone for single women occupying the space between family home and marital home, opening up other possibilities outside of those governed by conventional restrictions.

This chapter draws on conversations with the film's production designer Gemma Jackson who says,

> The first Bridget is the one to talk about as that was the beginning of it all. I was trying to create an environment for a young woman who was struggling, a bit lost, poor, living in London. I mean I think everyone had to agree that it was slightly unusual that a woman of her income was likely to have her own place. I loved the fact we gave her a flat at the top of that pub so she was like a princess at the top of a castle. (Author interview, 2005)

An exterior establishing shot introduces us to Bridget's turret-like home above the Globe pub in Borough Market, South London. A railway

J. Barnwell, *Production Design & the Cinematic Home*, https://doi.org/10.1007/978-3-030-90449-4_5

bridge cuts across at the top and roads on either side create a moat effect; a dynamic composition suggestive of change. Bridget's home is in between the family home she has grown out of and the marital one she hopes to create, a liminal space bursting with possibilities. The eccentric architecture of Bridget's flat maps out her character's hopes, dreams, strengths and weaknesses as surely as any floor plan includes windows and doorways. The design provocatively problematises female identity as something wild and untamed that needs to be organised and controlled.

Film Synopsis

Bridget Jones (Renee Zellweger) is the narrator of her own story, through her diary entries we see the world from her perspective—a 32-year-old single, white woman, working as an assistant in a publishing house. Living in London alone she aims to find a nice boyfriend. She has a lively social life and often arrives late for work with a hangover. Her affair with the boss Daniel Cleaver (Hugh Grant) ends badly when she discovers him with another woman. Bridget responds by finding a job in TV and quitting the publishing house. Mark Darcy (Colin Firth) a childhood neighbour, who is now a barrister, appears throughout the story with increasing frequency. After a big fight between Darcy and Cleaver and some further mishaps Bridget gets her nice boyfriend in Darcy.

The novel *Bridget Jones's Diary* was published in 1996 by Helen Fielding based on her weekly column for *The Independent* newspaper and is one of the first novels linked with the 'chick lit' genre of literature. Academic librarian, Justine Alsop, says that initially this genre would not be considered academic reading. However, in recent years scholars have turned their attention to Fielding and her novels (2007).

The film adaptation was released in 2001, directed by Fielding's friend Sharon Maguire. *Woman's Hour* included Bridget Jones as one of seven women who had most influenced British female culture over the last seven decades. An international success, breaking British box office records and taking $280 million worldwide in theatrical releases. Two further films followed: *Bridget Jones: The Edge of Reason* (2004) and *Bridget Jones's Baby* (2016). This chapter focuses on the first film primarily, referring briefly to the second and third film for further context.

VISUAL CONCEPT

Through discussion with PD Gemma Jackson and analysis of the design a visual concept emerges of multi-faceted female identity, which is echoed throughout the design from the location of Bridget's home, the in and out, space and set decoration in particular. Her character straddles old and new notions and conventions of what it means to be a single woman.

Her home exudes personality, it spills out unrestrained, making visible the different aspects of Bridget's character, including neurosis and the popular culture she has absorbed and regurgitated. The mess and disorganisation is suggestive of the idea that she is out of control and needs to make herself over. Although Bridget's stated intentions are to rehabilitate herself and to change there is the sense that she is actually enjoying her life as it is. It is worth noting that Bridget knows what she wants from the start in spite of confessions of 'sins' and failures Bridget achieves her stated intentions by the close of the film. She is a bridge between old and new femininity, an unthreatening relatable character who explores the territory that feminism has helped carve out.

There is a design contrast established between Bridget and Daniel's homes that highlights differences in male and female singledom. His apartment belongs to the tradition of flash bachelor pad, which is modern, uncluttered and sophisticated reflecting a successful professional.[1] High ceilings, white metal pillars, exposed brickwork and floor to ceiling bookcases. This exaggerates the difference and distance between the two characters as male and female archetypes. The surface appeal of the male space is contrast with the depth of the female. Bridget's home is wildly disorganised in spite of apparent attempts at homemaking; she has better things to do than clean, subverting traditional notions of women around the interior domestic sphere.

AUTHORSHIP

Bridget sets the tone and the premise of the film when she introduces us to the fact that she is starting a diary with the intention of taking control of her life, stating,

It all began on New Year's Day in my thirty second year of being single.

'Writing a diary represents an effort to process experience—to order it and make sense of it, to narrativise it' (Case, 2001, 178). The first person, voice over narration engages the viewer making us feel she may be talking to us directly as part of her circle of friends. However, it can also be disruptive because direct address similar to breaking the fourth wall reminds the audience that what they are watching is a construction.[2] It is Bridget's story and as such the commentary leads the audience through the narrative signposting key issues facing single women at that time in a seemingly effortless fashion. The apparently haphazard accidental style enhances the subject matter and sense of character while deliberately zooming in to Bridget's subjective experience. Bridget has a voice and speaks for herself; throughout the film it is her point of view and experience that is privileged.[3] *Bridget Jones's Diary* promotes identification intimacy and complicity with the protagonist at the same time that is promotes a more active viewing experience. Bridget's voice-overs encourage active spectatorship and identification with Bridget while minimising erotic voyeurism towards her. Firth and Grant enter the film as objects of Bridget's gazes and desires; in both cases she levels the first desiring looks (Ritosky-Winslow, 2006).

Similarly, when adapting the novel for the screen author Helen Fielding worked with Andrew Davies and Richard Curtis on the screenplay, thus maintaining her voice and control in the authorship process.

Screenwriter and educator Helen Jacey states, the gaze and the ideological values of the writer concerning gender will infuse most narrative elements. When writers choose a female protagonist they are confronted with a whole range of choices that require them to consider their own beliefs about women in society and to what extent they want their character to reflect these (2011). As Jacey contends female protagonists can be subjected to far more scrutiny in terms of behaviour, lifestyle, choices, age and physical attractiveness than their male counterparts.[4] This certainly seems the case with Bridget who attracts both love and loathing. In a writing workshop of Jacey's, participants were asked to identify their favourite and least favourite heroines; many named Bridget as least and bristled with anger and hatred towards her as a spineless, weak role model.[5]

According to Fiona Handyside the structure of the film creates an impression of authenticity in that it allows us to see that any 'truth' about female sexuality in cultural discourses such as that produced through the mainstream media is also the result of certain discursive strategies rather than any 'objective reality' (2012). The films draw attention to the pressures of this discourse and indicate the conflict felt by Bridget in relation

to what she thinks she is supposed to do and what she actually wants to do with her body, career and life. The comedy comes from the recognition of these forces and the way society views/represents women who do not conform to convention. Her makeovers are always tongue in cheek: shaving legs, clipping toe nails and scrubbing her buttocks while smoking for example.

Bridget feels under pressure to self-improve, that she is not good enough as she is. This narrative is widespread in forms of mainstream media, in women's magazines, for example which consistently regurgitate the makeover as a means of becoming socially acceptable.[6] Usually these changes involve the consumption of a product or service fuelling the economy. Thus, women's magazines function in the service of capitalism; getting people to buy things they don't need or want. Bridget's home features a shelf full of self-help books advising how she should change but what if she doesn't actually wish to change in the ways that society and the books suggest? Is this apparent failure to remake herself actually an act of resistance to the mainstream pressures to conform?

Kelly Marsh states that Bridget's diary is less an attempt to gain control over her behaviour and perfect herself than it is an attempt to justify herself as she is; Bridget's narrative is not an account of serious self-improvement although she frames it as such. What makes her narrative comic is that it is the confession of an unrepentant sinner with no intention of changing, celebrating the self (2004).

Her diary is full of confusion and apparent failure while attempting to conform to mainstream gender expectations the illusion of the perfect self is problematised. The underpinning narrative suggests rejecting the dream of the perfect self in favour of the joy of imperfection. From a design point of view the film plays along with the genre conventions of a romantic comedy while drawing attention to the inherent problems and contradictions.

LITERARY TRADITION

Bridget is one of a long line of self-deprecating female narrators. Alison Case charts the history of female narrators in literary conventions of eighteenth- and nineteenth-century novels whose self-deprecation is linked to the restricting of their role to that of witness, thus excluding them from the active shaping of narrative form and meaning (Case, 201, 176). Case states that we often think of authenticity in fiction as the opposite of

conventionality, in placing Bridget Jones in the context of the gendered narrative conventions of the eighteenth and nineteenth centuries Case suggests that the authenticity of a fictional voice is in part a textual effect upon literary conventions (2001, 181). Thus, Bridget mirrors the lack of narrative and material agency we have come to expect from fictional women. However, she does this knowingly, deliberately subverting the convention while creating a female role model who is succeeding in writing her own narrative and achieving her aims in spite of, or because of any perceived shortcomings in her personality. Marsh contends, Bridget's voice is authentic because she reminds us that control is a myth. When she returns again and again to the basic idea that she must perfect herself, control her life and secure a mate it results in anxiety and self-flagellation. However, each time she has the opportunity to compare herself to the perfect image she envisions, she likes herself better as she is (Marsh, 2004, 62).[7]

Fielding references Jane Austen for some perspective on popular contemporary ideas around the ideal self.[8] Austen also treats the myth of self-perfection with irony, in Emma for example who finds self-improvement is no substitute for spirit and creativity, openness and fancy (Marsh, 2004, 65). Like Bridget, *Emma* is a much-loved imperfect heroine of British literature, prone to resolutions that she fails to achieve.[9] Case says that part of her appeal is the reassurance that our own failures of control are not only lovable they may be the most lovable thing about us (181).

FEMINISM

However, Bridget has been accused of languishing in her insecurities, failures and mistakes. Mainly these involve dating unsuitable men, weight issues, alcohol and cigarette consumption. Criticism towards the books and films includes frustration that Bridget seems incapable of achieving the goals she sets for herself.[10] Bridget's failure to solve her own issues and reliance on Mark Darcy to metaphorically and literally rescue her are cited as reasons to dismiss the character as weak and pathetic.

The film has been defined by some as post- feminist. Angela McRobbie states,

'Post feminism positively draws on and invokes feminism as that which can be taken into account to suggest the equality has been achieved in order to install a whole repertoire of new meanings which emphasise that it is no longer needed, it is a spent force'. The taken into accountness permits all the more thorough dismantling of feminist politics and the

discrediting of the occasionally voiced need for its renewal (McRobbie, 2004, 255).

Bridget has benefitted from progress made in gender equality and is able to live an independent life in the city. However, these liberties also produce pressures of self-management and the fear that she will remain single and marginalised from mainstream coupledom leads to her fantasising about a white wedding. According to McRobbie, these popular texts normalise post-feminist gender anxieties so as to re-regulate young women by means of the language of personal choice. Carefully defining the parameters of what constitutes liveable lives for young women without the occasion to reinvent feminism. However, the white wedding fantasy may also be understood as drawing attention to the notion of the happily ever after myth that women are often still expected to work with/aim for. Rather than this signalling Bridget's wish to return to the apparent simplicity of traditional gender roles this scene illustrates the contradictory forces single women have to negotiate and draws attention to some of the paradoxes of the post-feminist cultural landscape.

Fiona Handyside contends,

> Although it may seem perverse to argue for any kind of progressive feminist agenda in Bridget Jones, given the novels and especially the films characterisation as quintessentially post-feminist texts with their interest in consumer culture, fashion and beauty, neurotic anxiety about body weight and obsession with heterosexual romance, there is patently a desire to criticise the utter dismissal of the experience of single childless women as worthless, or the complete idealisation of childbirth and motherhood (2012, 45).

Handyside proposes the film implicitly criticises the way women judge each other in ways that replicate the mainstream media, competing and judging each other for example. Instead Bridget shares experience in order to counter hegemonic discourses that shore up patriarchy (and other forms of social inequality). Her solution is a pragmatic and amusing one— she simply forgives herself for her sins and carries on as she pleases (smoking, drinking, eating). As Ritosky-Winslow states, 'Bridget Jones gives women a high profile film role model that works against social pressures regarding a thin body ideal' (2006, 250).

According to Marsh, Bridget's narrative demythologises self-reliance and justifies her choice of a community-based decision-making process where she discusses issues with her friends and considers their different perspectives (2004, 67). This community rather than self-orientated

approach values friends and human connection rather than the individu-
ated self as distinct and separate. Marsh states critics have not recognised
the potential subversiveness of her position. 'These apparently various
shortcomings are really only one: Bridget fails to be a good consumer, fails
to maximise her value. In effect Bridget refuses to play her part in a con-
sumer society and refuses the model of efficient consumer in her personal
life' (2004). This perceived failure to *remake* herself and control her life
can be framed as a rejection of the American dream of a perfected self.
Bridget exemplifies resistance to the conformist power of the dominant
culture, 'the power of conformity, the urge to present oneself as fully in
control can be resisted even as it is acknowledged' (Marsh, 2004, 70).

As a single woman she is perceived as a potential threat, subversive,
unpredictable, thus Bridget's marginal outsider status. The established
couples often appear uncomfortable with her freedom. At a dinner party
where she is the only single guest, she is confronted with the question,
'Why are there so many unmarried women in their thirties?' Although she
wants a boyfriend she does not wish to join the 'smug couples club'.
Within *Bridget Jones's Diary* romance is not in any simple way glorified
over the uncoupled life; Fielding's narrative teases out the process through
which coupledom is ultimately foregrounded as a viable way of overcom-
ing singleness, but not without ambivalence (Taylor, 2012, 73).

Interpreting the Visual Concept

In and Out

We meet Bridget on her way to her parents' house outside of London
somewhere in suburbia. The childhood home frames and helps contextu-
alise where she is from, a detached house conventionally decorated. Her
mother appears to be a bored and unfulfilled housewife tied to gender
conventions that Bridget has temporarily escaped from in the city. It is
worth noting that Bridget's mother applies pressure regarding her single
status inflicting her expectations onto her, creating guilt and inadequacy.

Claude Fischer argues that cities produce subcultural affiliations (1983).
During the 1950s and 1960s single girls in the city were recognised as a
significant subcultural type. Instead of migrating to the city to reject mar-
riage and the script of the housewife Bridget has moved to the city and is
actively searching for her future husband there. Thus, seeing the city as a
vehicle to achieving a traditional family rather than an escape or rejection

of it. Bridget's career seems incidental, a temporary inconvenience to enable her to live in the city and find Mr Right.

US sitcom *Sex and the City*[11] features another self-narrating protagonist, Carrie Bradshaw (Sarah Jessica Parker), living in another city (New York) whose main motivation is finding love. In the show the four friends (Carrie, Miranda, Charlotte and Samantha) are defined through their diverse personalities and distinct apartments that help tell their story. Carrie's extensive wardrobe and walk-in closet are designed to convey the central importance of fashion and image creation to the character. Her apartment works to suggest a desirable and attractive lifestyle, and the exciting glamorous adventures of the inhabitant. Bridget's home stands in contrast to this polished performance; shambolic in comparison reinforcing the notions of imperfection while also suggesting she is more comfortable with her*self* and/or can't be bothered to engage with this level of consumer culture.

Bridget's apartment is located above the Globe pub, in Borough Market, South London. Like much of London, Borough Market is a collision of old and new. An area resonant of Dickensian London also home to a fashionable foodie destination market. The building sits at an intersection, on the corner of two roads with a railway bridge cutting across at the top. The dynamic exterior location of Bridget's home visualises liminality in the position between the tracks and multiple possibilities. The single woman represents potential failure to marry, conjuring the spectre of the spinster[12] who unwittingly remains unmarried. If she lingers too long and the apartment becomes a permanent dwelling, rather than an intermediate base of operations she risks stagnation and death (Robertson Wojcik, 2010, 179). Bridget begins the film articulating this fear as she drunkenly sings *All By Myself* (Jamie McNeal) with gusto, ponders being found alone half eaten by Alsatians and then resolves to rectify the situation. The premise of the film sets up the idea that being single is a problem to be solved in this way (Fig. 5.1).

The space of the single female hasn't traditionally been crafted as an attractive one, unlike iconic male bachelor pads all of the reasons to celebrate the male singledom have been inverted to commiserations for the female counterpart.

PD Gemma Jackson says,

We found that location and it just worked in a number of ways, and I loved the kind of fairytale aspect of it, which you got more of a sense of in the first film than in the second. (Author interview, 2005)

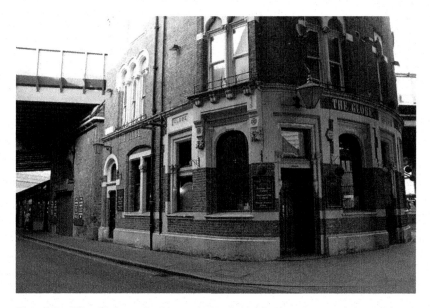

Fig. 5.1 The Globe pub, Borough Market. The location used for Bridget's
apartment exterior

Bridget has to travel up two flights of stairs, wedged between the rail-
way bridge and the pub to gain entry to her apartment. Once inside the
front door she has another small flight of stairs to reach the living space,
which is on one level at the top of the building, the attic angles of which
create interesting spatial possibilities. According to Jackson where the
character is in space and how they are designed to move around that space
is fundamental to her design concept (Fig. 5.2).

> I think very much about how to get people from A to B. How to get people
> to arrive at a good place. That bothers me a lot, how to get them there. I
> think an awful lot about the movement. Movement first, light second.
> (Author interview, 2005)

The attic is often reserved for heroes and heroines in connection with
romantic notions around creativity, escapism and spirituality, characterised
as a secret space concealing forgotten or hidden objects, ideas or people.
It also contains negative connotations of mental instability and imprison-
ment, particularly for women, 'In film and literature the uppermost spaces

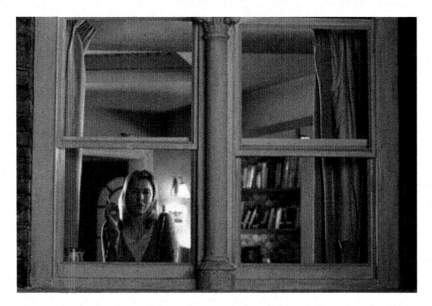

Fig. 5.2 Bridget looking out of the window of her London home. The design plays on the idea of the fairytale princess waiting to be rescued

of the house often have associations with mental illness ... a connection that relates to Charlotte Bronte's novel *Jane Eyre* (1847)' (Pheasant-Kelly, 194) In the case of Bridget both associations integrate in her character where perceived strengths and weaknesses combine to form a woman occupying and owning her own attic. (Chapter 8 sees another attic-dwelling character in the form of Paddington bear.)

The movement Jackson refers to is a key to Bridget's character as she is not patiently waiting in her family home, she is highly active in her quest to find a boyfriend. As Ritosky-Winslow points out she controls the gaze which is another indication of her empowerment. The camera does not objectify her. This is Bridget's story and as such we see events from her point of view. The design of the apartment is dynamic like her as she pushes against the contradictory forces at play in her life. The position of her home between the tracks articulates the push and pull of personal desire, cultural expectation and societal norms.

When Bridget steps out of her front door it is directly into a lively bustling area of London teaming with life, bars, restaurants and market stalls. She lives in a Victorian property (built in 1872) that is characteristic of the

area. Her home is woven into the architecture of the location, like the buildings she integrates into the urban environment and belongs to an 'urban family' (Tom, Shazzer and Jude). This is a social space with porous boundaries, unexpected visitors come and go.

A year has passed and Bridget makes a new diary entry calling herself 'Spinster and lunatic'. Her home looks much the same as it did in the beginning. She is on her way to Paris with her friends when Mark Darcy appears and the two go back inside her flat. While there he sees her diary under a pile of *Hello* magazines and reads rude comments she has written about him. Although he appears to leave the flat offended he is actually purchasing a new diary for Bridget to 'make a new start' with. She runs after him in her underwear and they enjoy a kiss in the middle of the street in the snow. Fluidity of borders is expressed through this ease of movement between the exterior and the interior, Bridget's lack of clothing doesn't inhibit this freedom.[12]

The home has been defined as a shell bearing the impression of its occupant. However, Pamela Robertson Wojcik argues that rather than a shell the apartment [as opposed to the house] is porous and facilitates chance encounters. It is a transient space dependent upon rent and not ownership (2010, 147). Bridget contradicts this notion as an owner not a renter, who continues to occupy the same place for all three films, spanning two decades, suggesting a more permanent connection to her apartment.

On another occasion she is joined by Mark Darcy and her friends for dinner—a social sharing of food indicative of nurture and love in the home. An unexpected visit from love rival Daniel Cleaver disrupts the scene and a big street fight ensues. Interestingly more social occasions/celebrations with food are destroyed when the fight moves inside the neighbouring Italian restaurant.

Bridget is viewed through her window at the top of the building connecting the interior and exterior environments and framing her with the turret-like qualities Jackson refers to. Bridget occupies the border between old and new where she sits between two worlds, on the cusp. The transitional aspects of her home are displayed in the vertical entry and exit points, porous boundaries and connection to the exterior. Conversely, she remains at the same address long term lingering longer than normative models deem healthy in the 'single space' as Robertson Wojcik suggests, instead of stagnation and death she thrives as an independent woman defying the stereotype.

Space

The site between the parental home and marriage has been characterised as a limbo where women wait for love and marriage.[13] A liminal space that always exists in relation to some conception of home as the other, the repressed, the future—the single girl's apartment is not really home but an uncanny space, an interlude that situates the woman between modernity and domesticity (Robertson Wojcik, 2010, 179).

Bridget lives in an apartment or flat rather than a house which sits in opposition to the suburban house that is often the home of families on screen (Bridget's being no exception to this). Having come from 'the site of middle class suburban home as favoured model of family bliss' (Spigel, 1992, 33) Bridget finds an urban apartment for her single London life. We often see single people moving to the city to start a new life or create a new persona. London is a diverse city full of people who have come from somewhere else to reinvent themselves (141).

According to Robertson Wojcik, 'the apartment represents a marginalised dominant that is often represented as subcultural or counter cultural due to its distance from normative ideals'. Robertson Wojcik states that the figure of the single girl in the apartment plot complicates our understanding of the 1950s in relation to women, suburbia, home and domesticity. The career girl's apartment tends to symbolise the woman's potential failure as a mate, because her economic status mark her as potentially castrating and crucially as a virgin or prude (2010, 174).

Bridget lives in a one-bedroom apartment with an open plan living and kitchen area. She is given plenty of space to occupy which is particularly premium in London where studio flats or house shares are the norm for single people. Bridget's relatively spacious home is amplified by the geography of space. Instead of carving the rooms into separate smaller spaces, the central corridor connects across and provides a more holistic sense of her character. Gemma Jackson recalls,

> The way we designed it, was that there was this central hall and there were all these rooms that were satelliting off. You were supposed to be able to look from the living room through to the bedroom etc. and to see her whole world more or less. (Author interview, 2005)

This idea is central to the character as a reflection of her interior world where different facets of her personality are played out. The use of space

helps provide depth in the frame so there is often something to look at beyond the immediate foreground, usually dirty dishes or washing drying on radiators.

Bridget is considered the most highly visible single woman of Western post-feminist media culture (Taylor, 2012, 72). Her character builds on earlier representations of single women who have helped carve out space in an otherwise male or family dominated arena/environment.[14] Her occupation of space and movement around the apartment visualises that she has options and sits at an intersection of possible futures that wouldn't have been open to her in the past. Bridget does not fit the Bohemianism (*Breakfast at Tiffany's*, Audrey Hepburn) or the careerism (*Pillow Talk*, Doris Day) from these earlier incarnations of single women's homes. She occupies a different terrain that has expanded since the 1960s and 1970s single girl spaces discussed by Robertson Wojcik in *The Apartment Plot*. Instead she combines aspects of both of these types into her own configuration (Fig. 5.3).

A key scene in Bridget's home sees her preparing a dinner party for her three friends. The table is set in the centre of the space, the sofa visible behind it and in the foreground she attempts to cook. This creates depth, where we can see beyond and through several frames, while the table in the background is set up with some degree of formality, in the foreground total chaos and disorder reigns. Bridget is splattered with the contents of the food blender her soup turns blue and sauce curdles, articulating the paradox/conflicting ideologies at play in her life and women more widely.

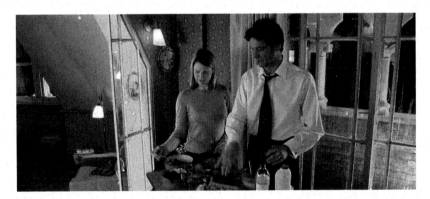

Fig. 5.3 Dinner party preparations, Bridget and Darcy team up to salvage the meal

Light and Colour

The lighting design is tied to the naturalistic style of romantic comedies. There are lots of windows in Bridget's apartment providing an abundance of natural daylight. During evening scenes there are several table lamps, candles and fairy lights used to create a cosy atmosphere. Her bedroom is candle lit and an attractive yet neutral space in comparison to other areas of the flat.

The place is bursting with an array of colours, creating a lively and expressive atmosphere. There is nothing understated or minimal about Bridget's décor.

The sitting room is warm with earthy browns, oranges and reds creating a cosy and lived-in mood. The combination of colours creates a relaxed sense; this is not a carefully curated colour scheme that is working to impress us of the elegance or education of the character, but this is a multi-faceted person with depth, strengths and weaknesses.

Jackson states, 'In the first Bridget the colours were important and a little bit eccentric. Directors are often shy of colour so I just went for aqua colours, which I find very soft. I wanted her to feel relaxed at home' (2005). The combination of colours adds to the busy space which further contrasts with Cleaver's more neutral world of clean white lines and warehouse chic.

The idea that some of the colours and furnishings are inherited rather than of her own choosing is central to the visual concept whereby the character is working with the old and the new as she knits together the strands of her choice.

As the films progress the apartment becomes less colourful, with the most recent film using a neutral palette suggesting she is maturing and growing up. The pruning away of brighter colour and the predominance of neutrals nods to a more coherent design implying she is becoming more organised. This follows the trajectory of her character who is not static and has continued to grow and develop across the course of the books and films.

Set Decoration[15]

Robertson Wojcik identifies Holly Golightly (*Breakfast at Tiffany's*), another single heroine's home as empty and suggests her refusal or inability to furnish the apartment would seem to signify her inability to fashion

a self, her lack of identity (2010,143). In Bridget Jones's case her place is overflowing with often mis-matching furnishings and props indicating an eclectic approach to decorating and perhaps experimentation with a range of personas. Holly Golightly's apartment is neither home nor shell, but a place marker between homes: a stopping place but not a dwelling. Similarly, Bridget's apartment is in between her family home and her hoped-for-future married home. However, it differs in that rather than an empty shell it reflects her complex personality, hopes and dreams. It is also imprinted with past inhabitants, who have left their mark in terms of the colour of paint on the walls, the kitchen and bathroom fixtures and fittings. In a similar sense she has inherited gender identity some of what we see does not represent her and some of it does; a composite.

Her home is imperfect, messy and at times shambolic, reflecting her personality and lifestyle. In the opening scene Bridget is nestled on the sofa in pyjamas, watching the US sitcom *Frasier* on TV. The room is lit from a couple of lamps and the street light coming in through the sky-light, cosy, strewn with books, cushions and blankets. An ashtray and bot-tle of wine sit on the floor beside her. A mixture of patterns and textures collide around the key features of a red sofa, TV and Victorian fireplace. This homely space includes Christmas cards and framed photos of friends and family indicating that although Bridget lives alone she is not an iso-lated character. As we have seen her friendships with Tom, Shazza and Jude (*urban family*) provide community and support.

Bridget is given plenty of props to help tell her story, some of which are remnants from childhood, old board games and dolls for example, illus-trating that this space is in between childhood and adulthood. Although she invests in her home, it is not a priority and she has neither the time nor the finances to improve it.

'The idea was that she'd got this place but she'd only managed to do up a certain amount of it because she hadn't the money.' Jackson says Bridget couldn't afford to paint the bedroom so she ornamented the space with items to help make it her own and feel at home there (2005).

Robertson Wojcik says often the girl's apartment is represented as inex-pensive, inadequate, under furnished, cramped, messy or eccentric. This suggests she is outside of the norm through her unconventional domestic interior. Often a lack of funds is at the root of this style of décor, in con-junction with the fact she is working, thus not at home to engage in domestic chores (2010, 153). In many respects Bridget's home could be characterised in this way as Jackson states,

Fig. 5.4 Bridget lying on sofa surrounded by props and possibilities

We had her in the kitchen doing the cooking and the lovely balcony covered in fag ends and candle stumps. You know there was a feeling that she was trying to make it something but I don't think she spends much money on the home, she spends money on clothes and going out. (Author interview, 2005)

The idea that she is engaging in domestic activities such as cooking is juxtaposed with the mess of discarded items like cigarettes. The detritus of candle stumps also reveals another perspective in opposition to the usual marketing imagery of expensive designer candles as markers of a luxurious lifestyle. Jackson says, that's the sort of thing somebody might give her for Christmas rather than purchasing it herself. The flat is characterised by a lived-in sense of clutter, the haphazard appearance enhances our enjoyment of Bridget. Most homes do not resemble the perfection often represented in media images so there is visual pleasure in recognition of a less polished home. Underwear lies strewn on the floor, evidence of the celebration of imperfection that her character engenders.

Old and new intersect in the selection and combination of set decoration. This visualises the conflict between traditional and contemporary gender options and expectations. The bathroom and kitchen are functional rather than aspirational spaces. Her olive green bathroom is old fashioned and instead of showcasing luxury beauty products and aspiring to glamorous lifestyles popularised in women's magazines on the side of the bath stand some refreshingly realistic budget cleaning items and a kitsch rubber duck. Similarly, the kitchen is cluttered with objects, gadgets, cook books and utensils.

Jackson says, 'We found that great wardrobe for the kitchen, like the side of Audrey Hepburn's hatbox it was glorious and gave the room a great atmosphere'. Unlike her US counterpart (*Sex and the City*) who has a walk-in wardrobe as a central feature of her home Bridget has a recycled wardrobe as a storage solution in her kitchen. This is an effective metaphor for her repurposing and positioning of aspects of femininity and indicative of a refreshing irreverent approach.

When we see Bridget starting the diary as an act of taking control of her life the flat reflects this theme and takes on a more nurtured appearance. It is decorated with a Christmas tree, fairy lights and fresh flowers. Later, when she is preparing for a book launch she is seen vacuuming in her underwear, rollers in her hair trying to read. This image condenses the some of the conventional roles and representations of femininity; the domestic, the sexually attractive and the socially acceptable degree of intelligence. We see Bridget parody this highlighting the multi-faceted complexity of female identity.

After splitting up with Daniel she opens her fridge and is greeted by a solitary piece of mouldy cheese. Retreating to the sofa the flat quickly disintegrates around her again. Empty takeaway boxes, beer and wine bottles are scattered across the floor. She drinks vodka and passes out. Another playful makeover/transformation montage of Bridget in the gym is cut with her throwing items into the bin. The empty vodka bottle is followed by self-help books 'What Men Want', 'How Men Think', packet of cigarettes, chocolate and another book 'How to make men want what they don't think they want'.

New books are subsequently placed on the shelf, 'How to get what you want', 'Life without men' and 'Women who love men are mad'. The prominence of the self-help books visualises and parodies the quest for perfection that women are persistently confronted with. Shortly afterwards she finds a new job, leaves the publishing house and triumphantly confronts Cleaver, humiliating him in front of the whole office—she is assertive and in control. The nurturing of the interior suggests she is looking after herself rather than trying to remake herself. It is not transformed into a designer home it remains lived-in, multi-faceted and imperfect, like her.

CONCLUSION

Bridget Jones's intersectional/multi-faceted status is enhanced through the design of her apartment, which functions as a sanctuary with porous boundaries sitting on the cusp of old and new ideas around gender, love and marriage.

Because the home is such a symbol of family life, examples of single homes seem to signal a lack. The fulfilment of family life is absent replaced by Daniel with the commodities of consumer culture, and by Bridget with the nurturing of the home however haphazard. In contrast to Daniel, Bridget's single status is not considered desirable and her character is actively engaged in trying to change it in pursuit of a boyfriend and ultimately husband. The flat reflects this lack as both a negative and a positive in the mutability of the space, it changes, regenerates, adapts, nothing is stagnant. The plasticity of possible futures is visibly ripe with potential. It engenders the energy of being single and the exciting options for transformation and growth that this allows.

During the concluding sequence Bridget denounces what she has written in her diary to Darcy and rubbishes diaries generally. This could be read as negating much of the film, which has consisted of the narrating of her story through the diary entries. Is she an unreliable narrator or an adept author in control of her own narrative? Again there is a sense then of her dislocated self, trying to undermine her own feelings and perspective. She says, 'everyone knows diaries are full of shit'. This is an interesting reflection on the whole film as an ironic nod to the complexity of neurosis that Bridget has documented/concocted for herself in the diary. By framing herself in this self-deprecating fashion she is able to achieve her aims while sidestepping criticism for being overly confident, ambitious, sexually strident and driven. All to ensure she is allowed to enjoy and gain pleasure from instead of being punished for achieving her aims. According to Ritosky-Winslow,

> The overall experience of *Bridget Jones's Diary* goes well beyond the borders of the film's ostensible storyline, openly inviting viewers to immerse themselves in irony, intertextuality and self-reflexive fun. (206, 237)

The single female space is cluttered, confused and lacks coherence; colourful and characterful with fluffy soft edges. Bridget's home defines her as work in progress. Not settling down, she is continuing her journey,

working out through trial and error what she wants in spite of the distracting noise of mainstream expectations and ideology. Her home is in a state of flux, a dynamic space where she enjoys her own company and that of friends and boyfriends, wallows in self-pity and fights back. As such it doesn't function as the site of her content coupledom but the journey to her continued self-discovery and adventure. Bridget's flat generally mirrors her personal state, veering towards squalor when she is unhappy and appearing more clean and tidy when she is attempting to improve her life. There is no notable transformation at the end, which it could be argued reflects the lack of distance travelled by the character. However, she started the year with the intention of getting a nice boyfriend and a year later has achieved this aim. Both Bridget and her home undergo 'makeovers' during the film but in both instances these are superficial. This has been identified as problematic in suggesting that in post feminism there are no longer fundamental problems for women to tackle. However, it may also be viewed as reassuring to suggest that she is absolutely fine just the way she is. Both makeovers fulfil the function of the 'makeover' in chick lit and rom com while ironically mimicking the genre conventions and remaining fundamentally unchanged. The apartment provides continuity through the three films, she remains embedded in the same locale and has become a part of the fabric of the city.

NOTES

1. The male single space is often seen to be a shrine to consumerism and order, for example *About a Boy* (2002), *American Gigolo* (1980), *Down with Love* (2003), *Pillow Talk* (1959) and *Two Weeks Notice* (2002).
2. More recently in *Fleabag* (*BBC, 2016–2019*) Phoebe Waller Bridge's heroine extends this through addressing the audience directly and breaking the fourth wall. Her character doesn't end up with the 'hot priest' but does end in a much better place than where she started from, in terms of self-esteem and confidence.
3. This is her story however haphazard it may initially appear, Darcy says, 'You tend to let things come out of your mouth without thinking'.
4. *Girls* (2012–2017 HBO, created by and co-starring Lena Dunham) follows the lives of a group of white middle-class women in their 20s in New York City. The show was met with a huge amount of both acclaim and criticism. The criticism is often based on its failure as a feminist text.
5. Soho Theatre, Script Factory, 2010.

6. Naomi Wolf, *The Beauty Myth* (1990). Media emphasis on unrealistic beauty standards trapping women ideologically in an unachievable quest.
7. Candice Carty Williams, author of *Queenie*, said, 'Bridget Jones's Diary is definitely the first place where I understood that women didn't have to be perfect' (BBC2, 2021).
8. The first film references the plot of *Pride and Prejudice*, the second the plot of *Persuasion*.
9. As Byatt's neo-Victorian novel, *Possession* (1991), rejects the myth of the perfected self in favour of the expression of the self in all its imperfection (2004).
10. However it is worth noting that Mark and Bridget admit to liking each other 'just the way they are'.
11. 1998–2004, HBO (Candace Bushnell book adapted for the screen).
12. Although the spectre of the spinster is present in the film, the term singleton signals a new found embrace of singledom according to Taylor, 2012, 73.
13. Exemplified in the seminal novel by Rona Jaffe *The Best of Everything*, 1958.
14. Other notable single women characters in film and TV include *Sex and the Single Girl* (1964), *Breakfast at Tiffany's* (1961), *Pillow Talk* (1959), *Designing Woman* (1957), *Mary Tyler Moore Show* (1970–77), *Rhoda* (1974–78), *Laverne & Shirley* (1976–83), *Single White Female* (1992), *She's Gotta Have It* (1986), *Amélie* (2001), *Friends* (1994–2004), *Sex and the City* (1998–2004), *Down with Love* (2003), *Fleabag* (2016–19) and *I May Destroy You* (2020).
15. The set decorator working with Gemma Jackson was Shirley Lixenberg.

WORKS CITED

Alsop, Justine, 2007, 'Bridget Jones Meets Mr. Darcy: Challenges of Contemporary Fiction', *The Journal of Academic Librarianship*, Volume 33, Issue 5, Pages 581–585

Being Bridget Jones, BBC 2, March 2021. Marking 25 years since the creation of Bridget Jones character.

Case, Alison, 2001, 'Authenticity, Convention and Bridget Jones's Diary' *Narrative*, Ohio State University Press, Vol 19, No 2, p 176–181

Fischer, Claude, 1983, 'Toward a Subcultural Theory of Urbanism.' In *Cities and Urban Living*. Ed Mark Baldassare. New York: Columbia University Press, 84–114.

Handyside, Fiona, 2012, Authenticity, confession and female sexuality: from Bridget to Bitchy, Psychology & Sexuality, 3:1, 41–53, https://doi.org/1 0.1080/19419899.2011.627694

Jackson, Gemma, 2005, author interview.

Marsh, Kelly A. 'Contextualising Bridget Jones.' The John Hopkins University Press. Vol 131. No 1. Winter 2004.

McRobbie, Angela (2004) Post-feminism and popular culture, Feminist Media Studies, 4:3, 255–264, https://doi.org/10.1080/1468077042000309937

Jacey, Helen, 2011, *The Woman in the Story: Writing Memorable Female Characters*, Michael Weise Productions

Ritosky-Winslow, Madelyn, 2006, 'Colin and Rennee and Mark and Bridget: The Intertextual Crowd'. *Quarterly Review of Film and Video*, p 237–256.

Robertson Wojcik, Pamela, 2010, *The Apartment Plot*. Urban Living in American Film and Popular Culture, 1945 to 1975. Duke University Press.

Spigel, Lynn, 1992, *Make Room for TV; Television and the Family Ideal in Postwar America*. Chicago: University of Chicago Press.

Taylor A. (2012) 'Spinsters and Singletons: *Bridget Jones's Diary* and its Cultural Reverberations.' in *Single Women in Popular Culture*. Palgrave Macmillan, London. https://doi.org/10.1057/9780230358607_4

Secret Homes: How Are the Themes of Espionage Reflected in the Construction of Home in *Tinker Tailor Soldier Spy* (2011, Tomas Alfredson, PD Maria Djurkovic)?

This chapter explores the ambiguous role of the home in *Tinker Tailor Soldier Spy* (2011) and the ways in which the design weaves themes of espionage through both public and private environments. The emergence of a labyrinth motif is identified, that visually constructs confusion, where there is a lack of clear division between the interior and exterior. The ways in which these boundaries are transgressed reflect turmoil through the design of space, in and out, light, colour and set decoration.

The notion of home and returning home is fundamental in the film, enhancing character and story through the visual concept of the design. Home in this instance incorporates the additional nuance of country and empire folding in nostalgia for lost myths in the face of uncertainty about the future.

The discussion draws on interviews conducted with the film's production designer Maria Djurkovic and set decorator Tatiana Macdonald, who make clear the extent to which the design of the film is visualising the story. For example, Macdonald elaborates, 'Different directors want different things in relation to the visibility of the set and issues of realism. Tomas [Alfredson] features it as a character in itself, it is very deliberate and it is telling a story' (2015).

Film Synopsis

The adaptation of John Le Carre's 1974 novel is set in 1973 during the Cold War. The protagonist George Smiley (Gary Oldman) comes out of retirement to try and track down a Soviet double agent within the British intelligence agency. The film begins with the head of the agency 'Control' (John Hurt) meeting agent Jim Prideaux (Mark Strong) and sending him to Czechoslovakia to rendezvous with an agent who has agreed to pass on the name of the KGB mole within the British agency. Control explains that he has narrowed down the suspects to five senior agents—Percy Alleline (Tinker), Bill Haydon (Tailor), Roy Bland (Soldier), Ricky Esterhouse (Poorman) and George Smiley (Beggarman). Prideaux is ambushed by the Czech military and is unable to complete the mission. A story featuring betrayal, a changing world and nostalgia for the loss of empire follows the flashbacks of Smiley as he unravels the facts from the fiction.

Visual Concept

Through interviews with the production designer and set decorator and close textual analysis of the film findings indicate the visual concept in *Tinker* is based on a labyrinth.[1] (Please see Chap. 7 for a discussion of the ways in which *Darkest Hour* also employs the labyrinth as a visual concept.) Choices around what is concealed and what is revealed lead us through the narrative like a trail of clues. Production designer Maria Djurkovic working closely with set decorator Tatiana Macdonald finds that character and set decoration are key to the storytelling process, giving her the opportunity to establish themes and create an environment that resonates with the actors.

'Every space that any character inhabits obviously has to be full of clues for that character. Control's crazy messy flat gives us plenty of clues for his state of mind. Dressing any set is hugely important to me, it is crucial to the story telling' (2015, Author interview). Giving clues to character, as Djurkovic says, is even more relevant when spies are central to the story; what is revealed and concealed becomes highly significant in the secret world of espionage.

The Spy Genre

The spy genre typically features themes of betrayal, secrets, lies and the search for truth. These are present in *Tinker* and visualised through the creation of a labyrinth design motif that contains frames within frames working to reveal and conceal the truth. The navigation of the screen space creates pathways of circulation around the quest for knowledge and through the passages, stairs, corridors, doorways and eventual arrival in the enclosed soundproofed box in the centre of 'The Circus' (secret service headquarters).[2] The characters' physical movement and access through these spaces alludes to their metaphorical insight in terms of the various plots, counter plots and the complex search for truth. Spatialisation of story and transition of character echoes the chessboard in Control's home; each player has restrictions and limitations placed on their progression.

This is a secret world the audience does not have access to, largely invisible like the Cold War, a battle of ideas not bullets. Popular notions of spy-craft have been informed by news stories and visualised in famous franchises such as *Bond* and the wider spy genre. A glamorous world where sinister and corrupt antagonists battle with the morally righteous protagonists does not feature in *Tinker*, instead both sides blend together to form the sludgy subdued colours of the ambiguous, mundane and the everyday. The Christmas party is an example of this where a depressingly dingy office space is strewn with tacky decorations, cheap booze and office infidelities. This is a world away from the glamorous spy tropes of well-dressed crowds of beautiful people, drinking elegant cocktails in chic international locations.

Smiley is an unlikely protagonist, grey, plodding and socially awkward. He collects information, putting together through memory/flashbacks the pieces of the puzzle that eventually enable him to unravel the deceit. His pursuit of information is reliant on exchange, remembrance and evaluation of vast amounts of data, termed as 'treasure' or 'gold' by Control. Information is not made visible or presented in a clear transparent fashion, we have to work to put the fragments together, reflecting the process of Smiley's journey.

The Circus functions as a large bureaucracy, a faceless and impersonal machine—the physical manifestation of the labyrinth and the heart of the metaphorical maze of duplicity and deception. Without clear enemies to fight, the agents turn on each other in paranoid and often

counter-productive power struggles. Instead of a monster or Minotaur in the central meeting room there is just a mirrored reflection.[3]

Often the transformation of setting operates to reflect changes in the protagonist, in this instance the temporary office Smiley sets up in the Islay Hotel is the only space seen to change significantly. This is the centre of his undercover operation where he gets lost, before finding his way through the misinformation to finally solve the case. Instead of his home or workplace transforming, he has a liminal space in a hotel room that adds another layer to the already complex geography of space. When Smiley is reinstated in the Circus the only thing that appears changed is his suit.

HOMESICK: SEARCHING FOR THE LOST HOME

In Homer's *The Odyssey*, Odysseus's drive to return home establishes the notion of nostalgia in narrative. Swiss physician Johannes Hofer later attached the Greek *nostos* with *algos*, meaning suffering or affliction as a term to describe the melancholy arising from the desire to return to one's homeland. Although subsequent research has identified benefits attached to nostalgic reminiscence in the instance of *Tinker* the search for a lost home is configured as a futile pursuit. The British empire being sought no longer exists, a crumbling relic that can never be returned to. This stands in contrast to the notion of home constructed in *Darkest Hour* (please see Chap. 7) where the British nation as a place of belonging worth fighting for is set against the fascist threat posed by Germany during the Second World War. In *Tinker* the enemy is not so clearly defined; in this instance the boundaries are blurred making it more difficult to discern who to include and exclude from the national home.

Notions of home are featured strongly in *Tinker*, with the additional nuance of country and empire leading to nostalgia for a lost myth of Englishness. However, homecoming is refused for all characters at some level but none more than Peter, Bill and Jim (Rogers, 2017). Building on the idea that shifting ideologies have rendered the characters metaphorically homeless, many of the agents' homes are not seen at all and remain unknown. The characters who are revealed in their domestic settings appear vulnerable, lonely and isolated. Jim Prideaux lives in a caravan; Connie Sachs doesn't have a home of her own either, instead residing in a bedroom in the Oxford University, hall of residence she is warden of. Peter Guillam is instructed to 'clean up' his home life, which involves

splitting up with his boyfriend. Control's flat is chaotic, confusion reigns as contradictory information spills out across every available surface. Smiley's home is the only one that appears attractive or comfortable. However, beneath the calm and ordered surface it is cold and empty, concealing more than it reveals about his character. Smiley's wife Ann has left him and his loneliness is accentuated through the selection and combination of items in the interiors that gradually reveal clues on closer scrutiny.

Another key setting is the 'witchcraft house', a house set up as a cover for the double agents' activities with Karla and the Soviet Union. In design terms this house is unable to reveal anything of character as it is not an authentic residence. Rather it is a meeting place masquerading as something that it is not, a house pretending to be a home and an example of an uncanny place. Freud's theory of the uncanny may be related to the home as something familiar yet unhomely (unheimlich) (Freud, 1955). Thus the 'witchcraft house' is a façade, an empty shell that functions to enable duplicitous activity. A haunted house containing shadows of the past attached to former national identity. Arguably the other homes featured in the film are also ghost homes, as they are rarely what they appear to be. Smiley's house functions as a shelter and a museum of his relationship with his estranged wife. In this and other instances the home remains enigmatic and anonymous. Control's home stands in contrast as an extreme outpouring, externalising his interior mental state. His residence appears an extension of the office, tomb like, he is buried alive in overwhelming paperwork. The transitory nature of home and possibly national identity is visualised in the caravan Prideaux resides in, which can be attached to a vehicle and towed away at any time with relative ease (Fig. 6.1).

Cultural geographer Doreen Massey reminds us that homes are not fixed identities but are open, contested, multiple and fluid as part of a continual formation and interweaving of social relations, historical shifts and the daily lives of individuals (1994, 12). How does this treatment of the home inform our understanding of espionage in the film? Lonely isolated characters denied a private life reflect shifting dislocated identity and the quest for truth in a morally ambiguous world. The lack of privacy in the home contrasts with the concealed architecture of the Circus, where high security is paramount.

The paradox in the design of *Tinker* is that issues around visibility are also arguably one of the defining features of the work of the PD who is engaged in creating environments that maintain the invisible nature of

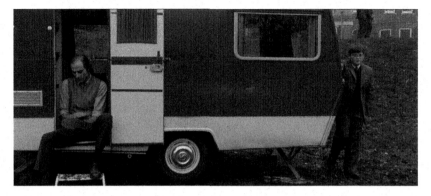

Fig. 6.1 Prideaux's caravan home visualises the shifting and transitory nature of home

their construction. In other words disguising the building of a setting to enable it to function within the codes of classical narrative cinema without drawing attention to itself and weakening the illusion. PDs state their role is to support the story thus to a certain extent complicit in denying their own existence in order to sustain the belief in the screen fiction.

In this chapter we will now consider the five design elements that reflect the themes of espionage explored in the film and how they tie together to form a labyrinth.

Interpreting the Visual Concept

Space

The sordid world of espionage is told in flashbacks, which facilitate our movement through time and space, yet do little to elaborate on story, which remains enigmatic.

The interior settings are often framed by a window or doorway creating the sense that characters are boxed in. The lack of privacy in the homes contrasts with the high security of the secret service organisation (the Circus), which appears impenetrable from the outside—a concealed anonymous exterior that reveals nothing of the nature of business within. The interiors are highly structured following lines and grids, the circulation of space is ordered without fluidity. At the centre of the organisation the

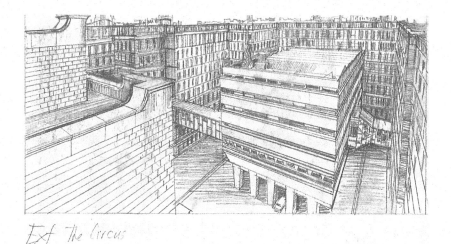

Exf The Circus

Fig. 6.2 Sketch of the Circus exterior, Maria Djurkovic

meeting room is entirely enclosed—a windowless cubicle that contains the characters in compressed space intensifying the quest for truth (Fig. 6.2). The labyrinth of the story is visualised through the navigation of the screen space, which creates pathways of circulation around the quest for knowledge and access to power through the passages, stairs, corridors, doorways and eventual arrival in the closed in soundproof boxes of the Circus or cramped domestic spaces of the agents. Character physical movement and access around and through these spaces alludes to their metaphorical insight in terms of the various plots and counter plots.

The story is told through spatial hierarchies, beginning with Smiley's descent when expelled with Control from the Circus. His journey comes full circle when he is reinstated and is seen ascending the stairways back to power and arriving at the heart of the organisation (and labyrinth) in the central meeting room. This vertical hierarchy is echoed in the horizontal spaces of the film where characters and audience have restricted access to space, rarely glimpsing the whole picture. For example, there are very few wide establishing shots to help orientate, rather we are furnished with partial views that restrict understanding.

An impenetrable fortress with a concealed anonymous interior reveals nothing of the nature of business within. The Circus is a combination of

new and old, a Victorian exterior façade with a concealed contemporary piece of brutalist architecture nested inside. The reassuringly traditional exterior obscures the inner structure containing a soulless unfathomable bureaucracy.

The open plan design of the office spaces hint at the lack of individuality, this is not about human beings but cogs in the machine. The economy of space is distilled in the meeting room at the centre of the building, a no frills functional place, entirely enclosed.

Exterior locations are used economically, cityscapes of London are lacking to the extent that the city remains almost anonymous apart from an occasional red bus moving through frame. Towards the end of the film there is a shot where Big Ben can be seen hazily through a window in the distance. Otherwise, the landmarks and recognisable sights of London are not seen and remain obscure. This is an insular world, hidden from view. Drab and monotonous exterior locations merge into characterless interiors (Deyo, 2017).

Since Smiley has been retired he is now an outsider, and in the perfect position to look in on the secret service. A room in Hotel Islay becomes Smiley's base for his undercover operation, which is soon populated with the files and other paraphernalia recovered from Control's flat. This room slowly transforms to reflect the confusion seen and felt by Control, as Smiley gets deeper into the labyrinth of deceit and double crossing. This temporary place operates as a transition space, bridging work and retirement for Smiley but also somewhere without the baggage of home or office, an opportunity to see more clearly and gain perspective.

In and Out

Windows and doorways articulate the border between interior and exterior, boundaries between which are crossed, breaking down divisions between the private and the public and linking to notions of spying. A theatrical sense of staging is established through these settings, framed from fixed positions characters appear boxed in and compartmentalised. The film traps its protagonists by using transparent layers and intra diegetic frames to divide the screen cinematic space becomes a cage (McNaughton, 2018). The windows do not offer views of the outside world they deliberately contain the characters and audience. Instead, we are recurrently furnished with views looking in on characters through windows observing scenes from the outside. Glass panelling in doors and windows create

depth and allow us to see beyond the immediate foreground, to look in on and observe scenes that appear private—we spy. The use of glass reflects and creates disorientating and deceptive frames within frames that deliberately confuse and obscure the truth. Even the glass in Smiley's spectacles is seen to be out of focus, when he visits the optician for a new pair further accentuating the visual metaphor.

The opening scene of the film is of Control's closed door, as he cautiously opens it to Prideaux and enquires as to whether he has been followed. This introduces the closed nature of the world we are entering.

Conversely, We see through both Smiley and Control's windows, from outside, appearing to provide insight into their private lives but in fact both characters remain enigmatic. The two homes serve as polarities, Smiley's hiding information under the ordered surface, while Control's spews everything out in the open creating an incomprehensible mess.

Although Smiley's windows are hung with nets and curtains, when agent Ricki Tarr visits him the two can be surveilled from the outside unobscured by the nets. The sash design divides the pane into quarters, which effectively compartmentalises space and character. Tarr is situated in the left bottom quarter with Smiley positioned in the right. The glass patio doors behind Tarr suggest he is vulnerable as he is observable from both the front and back of the house. During his visit he reveals information that enables Smiley to edge closer to the truth.

In another scene, Smiley can be viewed exiting his front door through four frames that extend and elongate the transitory space. Corridors and stairways are often used as punctuation points, a moment to pause, reflect, connect two places geographically and two ideas conceptually. Thus, an apparently simple transition point becomes more complex and extends his journey to hint at the layers of story nested within this space. Smiley's ground floor front door creates a solid link between interior and exterior environments suggesting a reliable sense of his character. He is viewed entering and exiting his home situated in an anonymous London street, grounding him visually and psychologically. Nothing is concealed, his portal between personal and public space is clearly visible. In contrast Control's flat is tucked away, above ground level accessed via stairs and the door that links his interior to the hallway is dark and obscured from the exterior. His connection to the outside and the real world is obstructed, suggesting his access to knowledge is also hindered.

Although we are furnished with views into windows these are rarely reversed, in other words the outward view is not provided. The interior is

disconnected from the exterior world, a closed inward-looking organisation that has lost perspective on what it is fighting. On one occasion there is a view of Ricky Tarr looking out of a window but instead of an exterior view this becomes another opportunity to look into more windows and monitor the private lives of others in a shot that references *Rear Window* in style and intention.

In contrast to many of the windows and doorways in the film, the Circus meeting room is without windows and padded with sound insulation foam creating a striking diagonal checked grid pattern, which intensifies the sense of enclosure and sensory deprivation. The grid is further heightened by the reflective surface of the table that dominates the room confining the characters in the infinitely recurring sequence, the moral maze and physical labyrinth played out across the film. The *mise en abyme*, of the meeting room, a room within a room signifies secrecy, paranoia and insularity (McNaughton, 2018).

Meanwhile, in contrast to the restricted character movement the dumb waiter style document transporter glides up and down through the floors of the Circus. The information moves freely.

Light

Dim artificial lighting and a lack of natural light is designed to support the sense that something is missing or lost. Conflicting light sources in Control's home reflect the contradictory and confusing information he is in possession of.

The lighting in the home creates a contrast with much of the light in the work environment. As we can see from Maria Djurkovic's sketches the Circus is filled with overhead lighting, these contribute to the creation of a strong grid like pattern in the workspace composed of rigid lines that further box in characters and promote a sense of order. This is an optical illusion as the attempt to impose a system on the complex business of spying reveals the clever knot at the centre of the story does not follow a reliable pattern—the sense of order, like everything else is actually a misleading illusion. Overlapping squares and rectangles of desks, floor tiles, light fittings and filing cabinets further embellish the labyrinth motif. This compartmentalising of characters communicates the concealment of truths of a personal and political nature (Fig. 6.3).

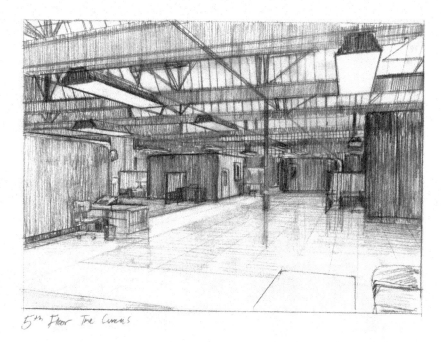

5ᵗʰ Floor The Circus

Fig. 6.3 5th Floor the Circus, pencil sketch Maria Djurkovic

Smiley sits at home in the dark alone, missing his wife—reflected in the lack of illumination. In one of the flashbacks agent Bill Haydon is seated at Smiley's dining table without shoes on, we understand that he has been paying Smiley's wife (Ann) a visit and is in fact having an affair with her. Curtains are open at the patio doors letting light in to the room. The main light source being natural light is used to suggest that some information or truth is being revealed in the scene. Back in the present Smiley sits alone at the same dining table dimly lit by artificial lamps furthering a sense of isolation and lack of clarity.

Later when Ann Smiley returns home the place is bathed in hazy natural light suggesting the restoration of their relationship. Never fully revealed Ann's figure is present in the kitchen as Smiley enters the front door, the view from the entrance hall and into the kitchen is lit more warmly signifying the homecoming. Framed in a painterly fashion, the right half of the screen is filled with the staircase while the left includes the hallway leading to the kitchen where a figure we understand to be Ann

sits. Through the kitchen doorframe the composition draws the eye to a square of light coming from the kitchen window, resuming daylight to Smiley's home. This return appears to close the loop in terms of character journey. The domestic interior is briefly transformed into a potentially comforting space. The empty shell that has been Smiley's home shifts with Ann's return, signalled by the replacement of dim artificial lighting with natural light. The audience remains at a distance from this reunion we continue to observe as uninvited guests on the scene.

The lighting design in Control's home is more dramatic and expressive in contrast with that of Smiley's which reflects the difference between their characters and vision of the truth. Control is seen sitting in front of a window that doesn't illuminate the room, while practical lamps appear randomly positioned, sculpting dramatic light and shade, creating conflicting shadows emanating from several sources rather than a single motivated light. This conveys the conflicting supplies of information Control is attempting to piece together and his resulting confusion.

Colour

Smiley blends in to his environment in understated costume and style characterised by his ubiquitous beige raincoat. The subdued colour palette reinforces notions of loss; in the personal story Smiley's wife is absent and in terms of the wider narrative perspective, the truth and morality are in question as the investigation seeks to uncover the identity of the enemy within. Post-imperial decline tinges every frame with a nostalgic longing for lost national identity and value system.

The colours chosen for *Tinker* evoke the 1970s but without the usual browns and oranges often relied on for that period. The palette is not only monochrome as it may seem on first impression—it features desaturated reds, teal and mustard. The aesthetic world of the film is articulated through the palette employed. Set decorator Tatiana Macdonald says the colour springs up very quickly from Djurkovic's research with dirty pink used liberally to evoke betrayal and the sordid world of espionage.

Djurkovic considers colour one of her most useful tools in achieving the desired mood on screen.

Sketching and location scouting are the first steps in finding the visual language for the film. Colours always come from the research, I tend to play with a restricted colour palette and make sure that it leads us into the aesthetic world of that film. (Author interview, 2015)

In the flashback featuring Bill Haydon the Oriental rug stands out as a sickly green against the subdued sage walls. The colour of bile is often used to indicate moral transgression and it is in this scene that it becomes evident that Haydon is having an affair with Ann Smiley.

Set Decoration

Set in 1973 the representation of period is another strand of style that forms part of the visual story, for example finding the balance between an easily recognisable screen version of the period and a poetic realism that captures the spirit of the times as understood from our contemporary perspective. Set in a time when smoking at home and at work was acceptable provides an opportunity to add texture to the dressing, an atmospheric haze and a tacky nicotine tinged quality pervade.

In the secret service building overlapping squares and rectangles of desks, floor tiles, light fittings, filing cabinets and so forth create grids that further embellish the labyrinth motif established through the design of space, in and out, light and colour. The meeting room features a highly reflective table adding to the pattern and further disorientating spatially through texture, pattern, position and choice of materials.

The Smiley's sitting room evokes an ordered world, with well-upholstered furniture and ornamentation. Dressing such as a piano, books, framed paintings on the wall, curtains with swagging all suggest a settled middle-class comfortable dwelling (Fig. 6.4). Moving upstairs into more intimate terrain the bedroom is comfortable and cave like with soft furnishings, more paintings and bedside tables adorned with lights. The dressing table appears to be covered in George's estranged wife's cosmetics, further clues to her presence in the narrative while being visually absent from the frame.[4] As we have seen Smiley's home reveals little of his personality and functions to maintain his anonymity. It does make apparent Ann's preferences and the fact she is responsible for decorating choices in their home. A clear example of this is the painting George studies on the wall—a gift to Ann from Bill Haydon. This is a crucial clue to the larger narrative, in clear view but not necessarily understood. The relationship between George, Bill and Ann is pivotal to the plot.

Thus, much of George Smiley's interior landscape remains unknown; in spite of his home becoming familiar to the audience he continues to be enigmatic, the design works to maintain his lack of exposure. The relationship and power balance with his wife is pivotal to understanding George's

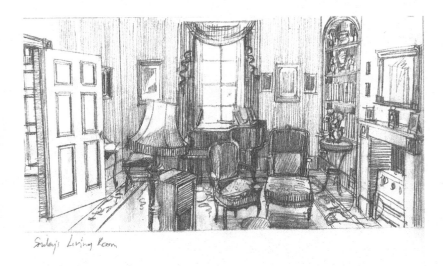

Fig. 6.4 Sketch of Smiley's living room, Maria Djurkovic

character and the story. She is absent for most of the film but her presence is felt in an interior dominated by her choices.

Set decorator Tatiana Macdonald studies the script and voraciously researches other source material to gain insight about the period and the sort of objects the characters would have around them. She thinks about the philosophy of the story carefully to inform decisions about the subsequent selection, combination and position of these. An example of Macdonald's work can be seen in Control's home where lots of fragments of information are revealed but in such disarray that it adds to the confusion and lack of clarity over the identity of the mole.

Under the surface of the apparent organisation in the Circus disorganisation and hysteria are visualised in Control's private space—a messy, unappealing nocturnal world. Crammed interiors are often read as reflecting a character who is stuck in the past and haunted by demons. In fact, 'John Hurt said that he didn't realise how mad Control was until he saw where he lived' (Maria Djurkovic, 2015), indicating the impact of production design on the actors and their subsequent performance. Tatiana Macdonald states,

> I like putting in obstacles—you don't want to treat it like a stage set and put everything around the outside, you want things that you can shoot past and through, so I tend to dress the set for visual interest and practically how that set would have been dressed according to period. I think if they have to

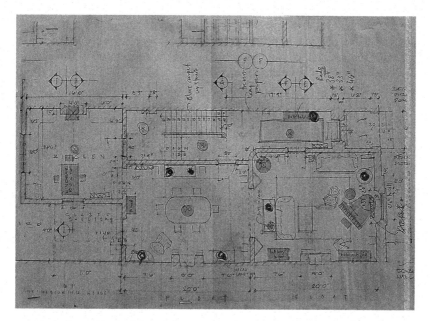

Fig. 6.5 Dressing plan of Smiley's living room, Tatiana Macdonald

navigate things it can make the scene so much more interesting as well, otherwise the actors are just rattling around in a box. (author interview, 2015) (Fig. 6.5)

Macdonald says she prefers to source items rather than have them made because they have the patina and history of real objects that can add texture and atmosphere to the setting.

It is a small hand prop, a lighter engraved from Smiley's wife to him that reveals information about Smiley to the Russian agent Karla. This detail exposes his wife as his weakness to the Russians who subsequently use this to their advantage. His wife's affair is choreographed deliberately to exploit this perceived weakness in an attempt to distract Smiley from uncovering the identity of the double agent. In spite of this Smiley discovers Haydon to be the double agent and he is handed over to the authorities. Once revealed Haydon confesses to Smiley,

Karla said you were good the one we had to worry about. But you had a blind spot. And if I was known to be Anna's lover, you wouldn't be able to see me straight. And he was right up to a point.

Contrast is established between the domestic settings of Smiley and Control, a homely space and an uncanny one. Control's space is overflowing with material in his quest to uncover the mole's identity, his interior landscape is reflected in the confusion that surrounds him, lost in the labyrinth of deception.

Thus, although Smiley remains enigmatic without anything distinct or revealing in his home, clues to his personality and the mystery lie in clear view. The key to the case relates to Ann, but this like so much of the design although in plain sight is not obvious to the audience or the characters. Thus, we engage in the journey attempting to put together pieces of the puzzle without comprehending the relevance of clues until the end. In spite of uncovering the truth about the double agent, Smiley remains lost in the labyrinth of the secret service returning to the very heart in the form of the meeting room at the end of the film. He appears inextricably woven into the fabric of the organisation, stuck in the past, in his continued quest for a home that no longer exists.

Clues to George Smiley's character are present in his domestic interior if we look closely. Although initially it seems there is little to go on, the presence of certain details and the absence of others help us gain a sense of who he is and what motivates him. It is established that Smiley's wife, Ann, has left him and his loneliness is accentuated through the production design of the home, where her impact continues to resonate. There is an empty quality created throughout the space evoking a feeling that something is missing. This void is partially visualised through Smiley's pursuit of information which is reliant on exchange, remembrance and evaluation of vast amounts of data. The commodification of which takes the form of 'treasure' or 'gold' as Control terms it.

CONCLUSION

Thus, the production design of the domestic space is full of clues to aid our understanding of character and narrative in this complex and often obtuse film.

The exterior of the Circus presents an anonymous façade, concealing and containing the secrets and lies within. Similarly the narrative withholds information, which is not made visible or presented in a clear transparent fashion; we have to work to put the fragments together, reflecting the process of Smiley's journey as the protagonist. Boundaries and transition points are used to tell the visual story and contrast private and public space.

In the beginning of the film contrast is established between the two key domestic settings of Smiley and Control—a homely space and an uncanny one. As discussed Smiley's home is defined by the absence of his wife, there is an empty quality achieved reflecting the sense that something is missing. Control's space on the other hand is overflowing with 'stuff', he is consumed by his search to uncover the identity of the mole. An extreme example of someone taking their work home, Control's interior is occupied by his job, paperwork, files and books surround him in a chaotic and deranged hoarder fashion. The set decoration echoes his inner torment consumed by his job he has lost perspective and balance, confused and disorientated he has no idea who to trust and is lost in the labyrinth of lies.

In contrast there is little evidence in Smiley's domestic space of work or clues in terms of what his job entails. His comfortable home reveals even less about him when we understand that his absent wife has decorated and that this space is more a reflection of her character than his. This supports the central notion of Smiley as a blank canvas who is relentless in his search for information.

The transformation of Smiley's home is briefly glimpsed at the end of the film when Ann, his wife, has returned. Never fully revealed her figure is present in the kitchen as Smiley enters the front door, the view down the entrance hall into the kitchen is lit more warmly now signifying the relief engendered by the homecoming. The circle is closed, the return home is temporarily satisfied in a narrative sense, although Smiley has not left home, his wife's absence has rendered it unhomely. The empty shell Smiley has been inhabiting is transformed into a home on her return.

The themes of espionage including surveillance, betrayal, secrets and lies are explored through the design of the film. From the anonymous façade of the Circus, the boundaries and transition points used to contrast private and public space, through to the selection and combination of set decoration every detail builds and reinforces the visual concept of the labyrinth.

Notes

1. Labyrinthian structures evocative connotations have been employed in literature and art, including the intriguing work of artists Maurits Cornelis Escher and Giovanni Battista Piranesi in particular. Film references include *Pans Labyrinth (2006)*, *Inception (2010)*, *Labyrinth (1986)* and *The Shining (1980)*.

2. Originally Le Carrè's location for the fictional Secret Service headquarters was Cambridge Circus.
3. In the form of the highly reflective glass table that dominates the meeting room at the heart of the Circus.
4. A cluttered dressing table covered in the belongings of someone no longer present is also a key feature of the Bates home in *Psycho*, where the display of the dead mother's possessions foreshadows the discovery of her corpse in the rocking chair.

Works Cited

Alfredson, Tomas (2011) 'DVD Commentary', *Tinker Tailor Soldier Spy* [DVD], StudioCanal.

Brunsdon, Charlotte (2007), *London in Cinema: The Cinematic City since 1945*, London: BFI.

D'Arcy, Geraint (2014) 'Essentially another man's woman: Information and Gender in the Novel and Adaptations of John Le Carre's Tinker Tailor Soldier Spy.' 275–290. *Adaptation*, Vol No. 3, Sep 2014.

Deyo, Nathaniel (2017), 'Opening Choices: Tinker Tailor Soldier Spy: Significantly ordinary', *Movie: A Journal of Film Criticism*, 7, pp.4–9.

Djurkovic, Maria, 2015, Author interview.

Durgnat, Raymond (1983) 'Art for Film's Sake.' In *American Film*, 8, 7.

Freud 1955, 'The Complete Psychological Works: Standard Edition. Vol 17. London: Hogarth, 219–252.

Jacobs, Steven (2013) *The Wrong House: The Architecture of Alfred Hitchcock.* Rotterdam. NAI Publishers.

Macdonald, Tatiana, 2015, Author interview.

Massey, Doreen, 1994, *Space, Place and Gender.* University of Minnesota Press.

McNaughton, Douglas, *(2018)* Cold War Spaces: *Tinker Tailor Soldier Spy* in television and cinema. *Journal of British Cinema and Television*, 15 (3). ISSN 1743–4521

Rogers, Randal (2017) 'Into a Wilderness of Mirrors: Tinker Tailor Soldier Spy and Queer Nostalgia.' *Queer Studies in Media & Popular Culture*, 2: 2, pp 183–97.

Sylbert, Richard (1989) 'Production Designer is his title. Creating realities is his job.' *American Film* 15, no. 3.

Finding Your Way Through the Maze: Navigating the Public and Private Spaces of Downing Street in *Darkest Hour* (2017 Joe Wright, PD Sarah Greenwood)

The film is set in 1940 during a turning point in the Second World War. Downing Street is a crucial environment in the film that reflects Winston Churchill's (Gary Oldman) private and public persona effectively. As one of the most famous addresses in the world, Downing Street contains the twin functions of headquarters of the British government offices and private home of the Prime Minister and, thus, contains the potential for architectural anomalies at every turn. PD Sarah Greenwood used the real exterior combined with built interiors to convey the sense of struggle and lack of clarity during the tense period in British history portrayed in the film.

> We are all in it together. Spatially it feels like it could go on forever so it's the principal of a maze. (Greenwood, 2018)

It is the low-tech, low-spec austerity on the surface of the design that makes the lack of resources abundantly clear. A crumbling surface is underpinned by a maze of underground activity in the form of the War Rooms. Greenwood says spatially the idea was to convey a shabby exterior befitting of Britain's underdog status at the time while below the observable surface there are solid foundations. The whole nerve centre of the map room in the bunker is held together through tenuous means that

© The Author(s), under exclusive license to Springer Nature Switzerland AG 2022
J. Barnwell, *Production Design & the Cinematic Home*,
https://doi.org/10.1007/978-3-030-90449-4_7

appear fragile accentuated in the design through haphazard, mismatching dressing enhancing the already disorientating chaotic architectural space.

The Prime Minister's home is recruited to communicate wider notions around nation, belonging and democracy. Downing Street does not stand apart from the other settings in the film blending as it does with the dreary lack lustre looking London of the period. Functional stripped back to the bone interiors in need of repair hint at failure. In spite of the uninspiring appearance and peeling paintwork the sense that we are all in it together is echoed repeatedly in the design.

The domestic interior of Winston Churchill blends with both the public government interiors and the other spaces of the film. As such it functions as an in-between space where the joining of public and private worlds indicates a democratic flow in spite of existing hierarchical structures. This stands in deliberate contrast to the fascist ideology that is being fought against. The maze ultimately leads us to the democratic space at the centre of wartime Britain and reflects the strong sense of unity at the core of the story.

FILM SYNOPSIS

The story begins in May 1940, when three million German troops reach the Belgian border. The British parliament has lost faith in Conservative Prime Minister, Neville Chamberlain (Ronald Pickup) and Churchill (Gary Oldman), steps in as the only acceptable candidate. However, there are a lot of doubts around him and his past failures in the Gallipoli campaign in the First World War. His approach is deemed too aggressive after the appeasement policies of Chamberlain. Will Britain go to war or agree to negotiate with Hitler? When Churchill lacks the support of the Houses of Parliament his wife, Clementine Churchill (Kristin Scott Thomas), and his secretary, Elizabeth Layton (Lily James), sustain him through the darkness and self-doubt.

VISUAL CONCEPT

As the screenwriter Anthony McCarten explains, one of the central ideas of the film is that words have the power to unite and help change the world.

> It was truly the case that in those dark days of 1940, when Britain stood alone before a monstrous enemy, Winston mobilised the English language and sent it into battle. This isn't merely a pretty metaphor. Words were really

all he had back then. But if you are to be left with only one thing to fight with, then—the lesson must be—you could do a lot worse. (McCarten, 2018)

How does this idea translate to the visual storytelling of the film? PD Sarah Greenwood says,

> You have to find a different way in to every film. The whole feel of it was very low key and interestingly that was as a point of contrast to *Valkyrie* (2008) and *Downfall* (2004) the visual opposite of what we were doing. Both of those films represented Hitler and the Reich as this sharp, hard immaculate organised machine. Whereas, everything about what we were doing was chaotic and underground. (Author interview, 2018)

The visual concept plays with the maze or labyrinth[1] to suggest danger and impending doom while subverting this to identify the deep roots of democracy that inform the British people and their way of life. The prominence of home as both a real and imagined place is drawn on as a source of comfort and safety. The design uses space to define ways of thinking and unite disparate groups in the shared aim of defeating the Germans. I will now outline the ways in which the visual concept of the labyrinth connects with the concept of home, the hero's journey and underpins the visual storytelling in the design of the film.

The labyrinth is a key to the visual concept in the film in that the underground passages lead to and from Churchill's home and visualise his internal/metaphorical journey, working through the problems in his path allowing him to find his purpose. The motif of a labyrinth has cultural potency through history and is often used to represent a character's search for their spiritual path by removing them from the usual indicators of time and space. According to the Greek myth *Theseus and the Minotaur*, a labyrinth was created to contain a half man, half bull creature. King Minos ordered seven boys and seven girls be sent into the labyrinth every seven years until Theseus volunteers to kill the monster, which he does with the help of Ariadne (Minos's daughter) who gives him a ball of thread to navigate the passages with and returns safely.

The labyrinth is often used as a symbol of change and transformation, travelling a spiritual path alone to enable a character's interior journey with the exterior world. Carl Jung identified the labyrinth as a symbol of the joining of the inner self and the external world resulting from venturing into the darkness and emerging. According to Jung this represents the

journey of the self to wholeness; on the way to the unknown centre facing the danger of losing the way and death, transformation takes place and the return home. This is where demons are faced and our dark repressed selves (1990). Churchill spends most of the film lost in the darkness facing his fears, alone and without allies. His journey results in growth and new resolve through unity and a common sense of purpose with the British people. (Unlike George Smiley in Chap. 6 Churchill does not remain lost in the labyrinth but emerges transformed.)

Labyrinthian structures evocative connotations have been employed in literature and art, including the intriguing work of artists Maurits Cornelis Escher and Giovanni Battista Piranesi in particular. Film references include *Pans Labyrinth* (2006), *Inception* (2010), *Labyrinth* (1986) and *The Shining* (1980).

THE HERO'S JOURNEY

Churchill doesn't travel very far physically in the film he remains in London but his internal journey is visualised through the subterranean tunnels he uses to travel between Downing Street and the War Rooms.[2] It is also while underground on the tube that he talks to the general public and undergoes personal growth as a result. This arguably helps him find his way and set his resolve in spite of political opposition.

One of the most fundamental mythic narratives, the hero's quest and return home is exemplified in Homer's *Odyssey*, where Odysseus's quest takes him on an epic journey through foreign lands where he faces many trials before ultimately succeeding in returning home transformed. Joseph Campbell famously identified the 12 steps of the hero's journey as a recurring myth through the history of human storytelling (Campbell, 1972).

The hero quest is not limited to the discovery of a Holy Grail like object but also involves finding oneself and finding a home in the universe. The home that is sought is simultaneously the literal home from which the hero sets out and the terminus of the personal growth he or she undergoes during the journey back. The hero's quest then is a double quest that often requires a journey home not only to the place from whence the hero departed but to a state of being or consciousness that was within the hero's heart all along (Mackey Kallis, 2010, 1).

Churchill leaves his home in Chartwell to take up office as Prime Minister in 10 Downing Street. Thus, his journey begins but the personal

growth comes through struggle in the face of huge adversity in the form of not only the Nazi threat but the majority of MPs who do not believe in his political approach. Establishing him as an isolated and unpopular character who faces possible defeat at home and abroad it is his physical journey on public transport that enables a metaphysical transformation to take place.

Churchill spends much of the film underground in the War Rooms and it is while underground that he experiences a turning point. The dark subterranean world of the film suggests answers are to be found beneath the surface. Before embarking on the public underground train for the first time Churchill asks a little girl for advice about which line to travel on standing in front of the famous colour-coded train map there appears to be clarity and a form of navigation.[3] This is a major deviation for him, which results in listening to others and feeling unified with the people/nation.

Downing Street

10 Downing Street has been the home to British Prime Ministers since 1735.[4] It has three overlapping functions; the official residence of the PM, their office and place to entertain guests according to the official Gov.uk website. A place for politics and entertainment, however we do not see Churchill entertain there the only socialising is with his family when they toast his appointment as PM.

Sarah Greenwood says they were lucky enough to use the real location exterior reminding us that unlike many of the homes in film and television drama Downing Street is a real place that is familiar around the world as the home of the British PM. As such the understated exterior Georgian terrace conjures culturally and historically significant moments in international politics and has become iconic; the distinctive black door with lion head door knocker regularly features in photographs and television press announcements. Media representation means that we recognise the exterior and the entrance hallway as recurring aspects of the location. However, beyond the entrance hallway remains mysterious and open to filmic interpretation.[5] When working with any location filmmakers must begin with the real place and adapt it according to practical, technical and aesthetic needs.

Downing Street then functions as a familiar character in ways we have come to understand as visual shorthand, similar to the use of familiar cities and landmarks (such as Buckingham Palace, Tower Bridge and Trafalgar

Square). Each new incarnation of the place increases the sense of knowing, familiarity and expectation. For example, the location performs a different role in *Love Actually* (2003) where Downing Street is bright, light, colourful and upbeat. There is no war looming and romance and comedy are integral to this Prime Minister's (Hugh Grant) narrative.

Margaret Thatcher stated that Number 10 is 'above all, a home—and it is a house of history' (Jones 1985, 184). Elevating the status of Number 10 to that of a national symbol, Thatcher hinted at the complex position the building holds in the discourse of public and private space. Allowing the BBC to film in both the offices and the residence for a two-part documentary, *No. 10 Downing Street* and *Living Above the Shop*, as well as a book, *Number 10 Downing Street: The Story of a House*, Thatcher highlighted the fact that behind the plain façade there was an attractive interior that reflected British history (Morrison, 2010).

HOME AS NATION

Chamberlain implores the King (Ben Mendelsohn), 'We must strive for peace so that every son and daughter can emerge from this war with something recognisable as home'.

The home referred to suggests the British way of life that is at stake, not just the physical place but the identity and character of the residents. The notion of home is a key concept in the film in terms of the British nation as a place of belonging worth fighting for. A patriotic Britain, battling for the belief in democracy and against a fascist bully, defending national boundaries, identity and values. Meanwhile, other boundaries are in transition as European nations during the war are invaded, annexed and borders shifted forcefully. Home is often used to refer to nation imbued with positive connotations such as a shared community, identity, place of belonging, cohesion and security. The metaphor of nation as home was used to help unify the people during the war. According to Gannon and Pillai, Britain's long and illustrious history lends credence to the cultural metaphor [of the house] and the heroic manner in which the British people rallied in the Second World War when the nation was bombed and heavily damaged tends to reinforce it (2010).

> We shape our dwellings and afterwards our dwellings shape us. (Churchill speech on rebuilding the house, 28 Oct 1944)

According to Davies, the home when linked to a region or nation is often defined exclusively with a rejection of those who allegedly do not belong or were not invited (2015). Margaret Thatcher subsequently drew on the national significance of home. Built on a foundation of inclusions and exclusions, interior and exterior, home is 'the desired place that is fought for and established as the exclusive domain of the few' (George 1999, 9). This ties into notions that became popular in the nineteenth century about the exclusive nature of the personal home.

The difference or demarcation between us and them is visualised through the design, whereby as Greenwood says *we are all in it together*. The *we* being the British nation in the face of the German outsiders/ intruders. During the Second World War the working class became 'The People' whose interests were synonymous with those of Britain itself. Termed 'The People's War', the working classes were frequently featured in fact and fiction where they were deployed as central protagonists with the aim of disregarding societal differences (Hockenhull, 2016, 35).

The British nation is characterised as the underdog but the roots of democracy run deeper than the shiny, sleek ideology of the Nazis (visualised in films such as *Valkyrie* and *Downfall*). The Germans attempt to remake and perfect themselves, while the British embrace imperfections.

HOME VERSUS OTHER

As Henriette Steiner states, 'In modern, Western culture, the idea of the home as a closed container, sharply separated from the world outside, prevails' (2017, 74). However, for Walter Benjamin writing about nineteenth-century Paris, the bourgeois separation of work and living spaces are evidence of the increasing desire for individuation. A perpetuation of the self that the nineteenth century expressed including the use of first names, portrait visiting cards, individual burials (Steiner and Veel, 2017, 74). Thus we are reminded that this demarcation between work and home is a relatively recent one. The emphasis on the need for separation between home and other in what thinkers like Baudrillard and Adorno refer to as the modern bourgeois domestic setting is a highly construed binary understanding of home versus other (Steiner 2010).

Doreen Massey reminds us that homes are not fixed entities but are open, contested, multiple and fluid as part of a continual formation and interweaving of social relations, historical shifts and the daily lives of

individuals (1994, 12). This flux is evident in *Darkest Hour* in relation to both national and personal borders.

There appear to be few boundaries between Churchill's public and private life (or work/home life) as his unusual working pattern sees business conducted from bedrooms, bathrooms and toilets. The lack of distinction between the interior and exterior while on one level is part of the job description and indicative of someone dedicated to their work, it is also visually reflecting Churchill's approach. He does not conform, he is unpopular, unconventional and outside of the mainstream. These qualities allow him to breach traditional boundaries and explore alternative ways of navigating space, ideas and the world. His problem-solving approach is mapped out through his spatial relations in the film, like words these are not bound by apparent physical restrictions. In fact, watching the film is like watching a mind map expand before our eyes.

The five key tools used to enhance these concepts in the film will now be explored.

Interpreting the Visual Concept

Space

In the face of the decline of Empire and World War an imaginative space opened for a change of meaning for the home and domestic interior, whereby a neo-Romantic sensibility came to the fore. The photographer Bill Brandt captured this in his series of photos, *The English at Home*, 1936; *A Night in London*, 1938; and *Camera in London*, 1948 (Aynsley and Grant 2006, 213). Sarah Greenwood says the crew all followed these photos as a visual reference for the film which guided choices around the atmosphere subsequently created. The gritty exterior façade of Downing Street connects to this notion; however, the understated surface conceals hidden depth.

> It is much larger than it appears from the exterior. The hall with the chequered floor immediately behind the front door lets on to a warren of rooms and staircases. It was joined to a more spacious, elegant building behind it in the eighteenth century. No 10 has also spread to the left of the front door and has taken over much of number 12 Downing Street, which is accessed by a corridor that runs through 11 Downing Street—the official residence of the Chancellor of the Exchequer. (gov.uk)

In the film we do not see into all of the rooms of the house (reputedly over 100) and never really get a sense of how the different spaces connect.

Beyond the familiar hallway and cabinet room the majority of rooms remain mysterious thus there is plenty of possibility for invention. Particularly when we consider the renowned Tardis like qualities of the place. The recurring interiors featured within Downing Street are the hallway, the staircase, the sitting/drawing room, Churchill's bedroom, office and the cabinet room. In addition, there is a spare room in the attic where a pivotal scene takes place between Churchill and King George VI.

The bedroom, arguably the most private space of all is particularly significant in reflecting Churchill's interior landscape as it is not a shared bedroom with his wife making this even more personal. He is often seen in his single bed working or eating.

The spaces Churchill occupies tend to be small, cramped and singular. His separation made clear through physical boundaries of brick and glass. These intimate settings build a sense of vulnerability that becomes both his weakness and his strength. Churchill's private space such as toilets are particularly small and constricted reflecting the notion that he has very few options available, he is hemmed in to tight corners that often seem to cut off and isolate. These small dark enclosed rooms without views in or out of windows tend to feature a single light source, suggesting hope and a possible route out of the darkness.

In contrast Churchill's office and the cabinet room in Downing Street are spacious. However, the ample space in these settings also works to accentuate his isolation as he is often seen on his own or with a single collaborator, his secretary, Elizabeth Layton. Conversely the film opens with his predecessor Chamberlain occupying the same space surrounded by his supporters. Interestingly the interior appears to be completely different in terms of lighting, decoration and atmosphere, reiterating the sense that the interior landscape of each character is reflected in the exterior space they occupy. The once warm inviting social space of Chamberlain's Downing Street is transformed with Churchill's occupancy into an empty dark void mirroring his isolation, self-doubt and lack of confidantes.

A new room is featured at a pivotal point when the King comes to see Churchill in his home and offer his support in resisting Hitler. Previously Churchill and the King have conducted weekly meetings in Buckingham Palace; a cold formal affair where the two appear as uncomfortable in each other's company as they are with each other's approach/sensibility. The fact that this time the King enters Churchill's domestic interior is significant. The meeting doesn't take place in the office or work space but in an apparently disused spare room that is situated upstairs in the attic[6] and

looks particularly shabby and unsuitable for visitors. The spare room provides space and previously unexplored territory for the King and Churchill to form a new alliance in. There is no façade in this intimate space without the furniture of formality that an office would provide. Both men meeting on more neutral ground enables them to see past their differences and find a point they agree on: they do not want to give up without a fight (Fig. 7.1).

Churchill's home is transitional as is the situation for a new Prime Minister, who must leave their residence and make 10 Downing Street their temporary home in the knowledge that down the line they will need to vacate the property for the next head of government. The temporary and transitory sense of home then is part of the job description, thus making 10 Downing Street a liminal space, somewhere familiar around the world and potentially unhomely as a result. Can somewhere as iconic as the home of the British Prime Minister ever really feel like home? According to John David Rhodes when property instability is made visible and

Fig. 7.1 Set photo of the spare room, courtesy of Sarah Greenwood. The shambolic space provides an opportunity for fresh perspective and an informal place for a stronger alliance to spring from

apparent in this way we are forced to confront the tenuous relationship between public and private as well as the tenuousness of all property relations (Rhodes, 2017, 18).

Freud's theory of the uncanny has been related to the home as something familiar yet 'un-homely' (unheimlich) 'that class of the frightening which leads back to what is known of old and long familiar' (Freud, 1955, 219). For the audience Downing Street is familiar yet each new fictional representation adds nuance and new dimensions to our sense of this well-known location. (Please see Chap. 4 for a discussion of the uncanny home in *Stranger Things* as a familiar feature of the gothic and horror genres.) Thus, Downing Street functions as both Churchill's temporary home, the home of democracy and the home of the British nation.

The War Rooms operate as an extension to his home connected through underground tunnels. Although the War Rooms are also a real location, now functioning as a museum, the filmmakers chose to design and build their own version, constructed for the film to create a subterranean labyrinth with low ceilings that accentuate the sense of claustrophobia. Beige brick walls in gloss paint and long hallways that appear infinite help tell the story according to PD Sarah Greenwood who says,

Telling the story for me it's about finding the best solutions, sometimes it's a build sometimes it isn't. The War Rooms was a set build, the real space is very linear and that wasn't going to work for us. What we wanted was for it to feel like a maze with the different heights and claustrophobia and compression. Spatially it feels like it could go on forever so it's the principal of a maze. You could open the door on the sound stages and interlock them so that's what we did.[7] (Author interview, 2018)

Greenwood created a mishmash of beams that supported the floor above and used different types of brick in the build to indicate the renovations and additional layers to the building over time (Fig. 7.2).

In and Out

The connection between the interior and exterior is deliberately designed to suggest and enhance narrative and character detail. The thresholds between these two distinct environments can be used to convey concept and influence the way characters enter and exit space.[8] Churchill's home before the move to Downing Street at Chartwell is also a well-known

Fig. 7.2 Set photo of the War Rooms interior, courtesy of Sarah Greenwood

location (National Trust) established as an attractive big country house surrounded by grounds and gardens. Stairways feature strongly as his new assistant Elizabeth Layton journeys up and down them attempting to accommodate his demands, they are often dark or shady with some glimmers of daylight through nets.

The greenery and vegetation vanishes when Churchill becomes PM and arrives outside the austere, unwelcoming façade of 10 Downing Street. Entering the famous black door into the recognisable chequered black and white hallway removals people carry a large framed painting (seen earlier in Chartwell) up the stairway lined with black and white photos of previous PMs. Unlike the arrival to an empty new home that most people experience when moving house the PM is greeted by the former inhabitants in the form of a gallery of portraits. The physical presence of these pictures is another unheimlich aspect of Downing Street, a property that visibly insists on reminding the occupants that this is not their forever home. '[S]paces are always on the cusp of being emptied of one set of

human contents and awaiting the arrival of the next' (Rhodes, 2020, 18) (Fig. 7.3).

The front door of 10 Downing Street leads out into the familiar exterior, the public face of the PM. However, Churchill is often seen exiting and entering the building via other less conspicuous routes. For example, using a lift from inside Downing Street he journeys through underground tunnels to the War Room bunker. The lift cubicle is a tight space with a single light source that transports him vertically into the depth of darkness and back up again. Thus, his *in and out* is often unconventional in that he does not enter and exit his property through the front door but prefers to travel by more secretive means.

There are no views in or out of the windows, which further enhances the insular sense of the home. Thus, there is a distinct boundary between the exterior and the interior. Churchill is rarely situated in exterior locations, he spends the majority of the film inside, frequently underground, in squashed, compressed spaces. His journeys often take him through

Fig. 7.3 Set photo of 10 Downing Street entrance hall, courtesy of Sarah Greenwood

tunnels, which are geographically disorientating. He occupies secret spaces often concealed from public view where he can move between interiors linked by subterranean corridors unobserved, circumnavigating the need to step outside of his front door. Corridors extend physically and prolong visually the transition from one place to another; they can be utilised to emphasise a journey, a pause or punctuation between distinct places, building suspense and highlighting temporal and spatial aspects of the journey. In this instance they are an in-between space enabling his safe passage between the War Rooms and Downing Street unseen. The tunnels he uses amplify the sense of enclosure, danger and need for secrecy during this time of international conflict. Churchill's unconventional use of boundaries and transitions can be seen as partially in response to the threat of war and need for necessary precautions, while also visualising his unique perspective and intense internal conflict.

The underground passages that lead to and from Downing Street further intensify the notion of the labyrinth within the design. Often underground spaces such as cellars and basements engender Gothic sensibilities of entombment, abjection or uncanniness (Andrews et al. 2016, 8). (Please see Chaps. 2 and 3 for basements that imprison characters.) However, in this instance the protagonist appears at home beneath the surface. Uterine metaphors abound in theoretical analyses of film spaces, especially those with negative connotations (Pheasant-Kelly 2013, 18). However, in this instance the underground passages hold more positive associations and may be seen to help birth Churchill's plans, nurturing and sheltering him from the outside world.

If the home is his interior conscious mind the labyrinth beneath may be his unconscious. Zizek's discussion of the house in *Psycho* considers the three different levels as corresponding to the id, ego and superego, whereby the basement is the id, the ground floor the ego and the attic the superego (2006). Using this analogy the id may be a repository of primal drives that may also hold the answers to problems that appear unsolvable on other levels. Thus, the underground spaces of *Darkest Hour* could be viewed as Churchill's hidden place of unconscious primitive instinct. Equally Michel Foucault states that internal spaces consist of perception, memories, dreams and emotions. Thus, we find Churchill located in interior spaces that reflect his inner journey, which is where he must go into the darkness to return with a solution. This spatialises his metaphorical journey which is emphasised by his often solitary state.

Similarly, boundaries between work and home life appear non-existent illustrated through scenes of him working in the bath, bedroom and toilet. Working from home is a fluid state often resulting in blurred boundaries[9] and this state is rendered architecturally through the paradoxical notion of the PM's residence. Churchill pushes this notion still further through the distinct use of places of rest, relaxation and recuperation.

When Churchill ventures outside he usually travels by car, being driven along the London streets he is separated from the people who throng the way. He is seen looking through the glass of the window which conveys the barrier between himself and the people/interior and exterior worlds. This divide is broken through when he suddenly jumps out of the car and decides to take the tube instead to the Houses of Parliament. Churchill goes down in the crowded lift (not alone this time) to the underground platform. Travelling along shiny white tiled tube tunnels where overhead lighting leads the way, he steps into a public train carriage, where he encounters popular opinion in relation to the war, Nazis and Hitler. Reviews at the time considered this highly improbable and contested the effectiveness of the scene. However, in terms of visual storytelling it makes sense as he breaks out of his particular spatial confines and into a new physical and psychological realm where he is able to connect with people in a way that has not been possible in his war cabinet. As the story of the film revolves around democracy versus dictatorship Churchill's connection to others transcends hierarchical structures as he finds support in the people rather than other members of parliament.

The breaking through boundaries and divisions reflects the sense of inclusion in the sense of home as nation and nation as home. National unity is visualised through Churchill's utilisation of public and private space.

Light

As might be expected in a film entitled *Darkest Hour* very little daylight features; the lack of which is a recurring motif from the beginning to the end. Churchill is first glimpsed in his bedroom curtains closed in darkness, he proceeds to light a cigar and illuminate the scene. The search for light in order to spark up his cigar becomes a helpful thread in the gloom leading him on his journey on the London Underground. The light is used to guide Churchill through the dark labyrinth of uncertainty. The artificial lights that line the underground tunnels and the ceiling of the War Rooms

create a thread or breadcrumb trail of hope and a possible way out from defeat and despair.

Once installed in Downing Street there are many windows but no views out of them, the lighting is diffused by netted windows. Churchill is often seen in darkness except for a single light source. For example, sitting at his office desk with the light from a solitary table lamp, reflecting on the shiny stretch of the long meeting table, or reading the paper with a single light bulb overhead.

In the closing scene Churchill enters the Houses of Parliament which are now bathed in ample daylight from huge windows. His rallying speech is well lit in response to the new strength and determination he has found through both his new understanding with the King and the exchange with everyday people in the London Underground. The light suggests a way out of the darkness; however, when he subsequently exits the doors close behind him and it is dark again. The film closes as it began in the dark, closing the chapter and making clear further struggles lie ahead.

Set Decoration and Colour

The colour palette for the film is tied to period accuracy and mood with dull, dusty and dark colours. Two occasions when the colours shift are scenes featuring two key people in Churchill's life. His wife, Clementine, and secretary, Elizabeth Layton, both support and encourage him in the face of despair. Layton sits in front of an arched window, framed by cool monochrome light colours. Later she perches on the stairs with an unusually bright orange wall taking dictation while Churchill is in the bath. Layton appears to ground him through her flexible and resilient approach. Similarly, Mrs Churchill is characterised as a calming influence balancing Churchill's volatile nature. She is surrounded by delicate, pale, elegant colours of grey, blue, cream and silver.

The first glimpses inside Downing Street are while Chamberlain is Prime Minister; the environment appears elegant and attractive. His inner circle of MPs create a convivial social scene, decanters of alcohol, candlelight and other after dinner accoutrement adorns the table they are seated around. A huge chandelier glistens overhead. This scene is cut to an egg cracking into a pan and a large fry up breakfast tray is prepared including the unusual addition of whiskey and champagne. The tray is taken in to Churchill's pre-Downing street bedroom in his Chartwell residence.

The architect and interior designer Robert Mallet-Stevens wrote of set design, 'The décor ought to present the character even before he or she appears—to indicate the character's social situation, tastes, habits, ways of life, personality' (1927). This is true of the breakfast scene where we are introduced to Churchill through his stomach. He is a man of indulgent tastes; the fried breakfast accompanied by champagne and whiskey are arranged on a tray and deposited on his bed every morning. We understand his social situation, habits, tastes, way of life and personality all captured in this simple, articulate piece of set decoration.[10]

Churchill's bedroom as a reflection of his interior landscape looks busy, cosy and confused. This room is stuffed full, creating the sense of a hoarder's den. The single wooden bed and bedroom rather than shared with his wife maintains his individual rather than shared domestic space. The piles of paperwork, books, typewriter and other work-related paraphernalia indicate a workaholic who not only brings his work home but brings it to bed. The head of the bed is encased by overflowing book shelves reflecting the busy mind beneath. The room also holds indications of comfort and homeliness in the form of upholstered armchairs, a marmalade cat, dusty green patterned wallpaper (on ceiling), framed pictures covering the pale green panelled walls, a fireplace framed by a mirror and plaster busts.

Downstairs we meet Mrs Clemmie Churchill and a sense of calm and order permeates. An oil painting of two girls Singer Sargent in style (the implication being it could be of two of their four daughters), painted in 1910, is hanging in one of the rooms.[11] This features again in a later scene when the Churchills move into Downing Street it is seen being carried up the stairs. The idea that the Prime Minister is moving in key pieces from his home in Chartwell reminds us that Downing Street must be remade with each new leader. An interesting combination of old and new whereby certain old furniture remains and is joined by the personal belongings of the newcomer. The place transforms to reflect Churchill's interior, mirroring his Chartwell bedroom; the breakfast tray contents and routine remain unchanged but for a silver tray—always seen from above. Unaltered as Prime Minister, his new home reflects his personality and inner psychology.

In other respects the ground floor work spaces (his office and the cabinet room) look colder and emptier than during Chamberlain's office. These appear simple and uncluttered decorated with essential work furnishings such as desks and lamps contrasting with the overstuffed bedroom, suggesting that the office is another façade, this is not where the real thinking/working takes place for Churchill. The cabinet room is

dominated by a long meeting table that is notable by the fact it is empty of people and meetings.

Conversely the War Rooms are cramped and crammed full of people. These were a group of basement offices in Whitehall that became the secret centre of operations during the Second World War: a tangle of corridors, a typist pool full of mismatching furniture and coloured phones visualise the makeshift nature of the space (Fig. 7.4). Sarah Greenwood says the War Rooms themselves were an incredible reference for the design of the film,

> The whole nerve centre of the map room in the bunker was held together with string and pins. I love the idea that from that tiny room we were running the operation. We won the war compared to this massive German machine that was represented in *Valkyrie* and *Downfall*. When you visit the war rooms they talk about carpet, people brought carpet from home and chairs it's just an absolute shambles. It was a subterranean world that they lived in. (Author interview, 2018)

Fig. 7.4 Props and dressing in the War Rooms set build, courtesy of Sarah Greenwood

Elizabeth Layton's work space echoes Churchill's isolation. In spite of being situated in the War Rooms she is shown to her own little office where she works in the cramped space with a single light overhead, hemmed in to the dark, cold makeshift room where nails are visible in the wall panels behind her desk.

Buckingham Palace, like Downing Street, is another real location with a wealth of history, representation and connotation.[12] The palace is a visual shorthand for the British monarchy and the distinctive model of governance. As Greenwood says it is used to indicate that we are all in it together, the hierarchy are not removed from the struggle or pain endured by the people. When Churchill visits King George VI at the Palace a contrast is created through the size and space of the meeting room. Lots of lamps create shadows mixed with some daylight peeping through the shuttered windows. A lengthy corridor leading to the meeting room appears infinite echoing the distance that exists between the two men. However, this too is a multifunctional building, like Downing Street it is a home and a place of work.

Later in Downing Street the previously unseen shabby spare room with peeling wallpaper and misplaced furniture becomes the impromptu meeting space for Churchill and the King. The distressed shutters are closed and a single light bulb illuminates the dusty space. The sense that he has sought refuge in this room, which appears disused suggests he is occupying new space in his search for solutions.

CONCLUSION

The design of the film visualises underpinning notions of the script through the use of space, in and out, light, colour and set decoration the concepts of home, the hero's journey and the labyrinth are woven. The maze is a metaphor for the political and physical obstacles Churchill has to navigate.

This home is multi-faceted, as it is simultaneously a private dwelling place and public building and workspace. Themes of transition, duality, doorways and passages looking forward and backward at the same time accentuate Churchill's quest has taken him away from his home and into the dark labyrinth where he has been largely alone. He finds what was in his heart all along in the form of a decision to fight the Nazi's and go to war as a nation.

While there are few boundaries between Churchill's work and home life there is a division between his interior and exterior environments. He ruptures this when he leaves the car pushing through his elite bubble to travel on public transport connecting with 'the people' and discovering what they (rather than the politicians) think and feel. This physical breakthrough reflects the importance of uniting as a nation in the face of the external threat, reinforcing the message 'we are all in it together' and enabling him to find his way home.[13]

Notes

1. A maze and a labyrinth differ in design. A labyrinth has a single continuous path leading to the centre. A maze can have multiple paths that do not all lead to the centre. However these terms are often used interchangeably.
2. Churchill's War Rooms, secret underground headquarters where Winston Churchill lived and worked during the Second World War, Clive Steps, King Charles Street, London, SW1A 2AQ now a museum, which became fully operational in 1939 a week before Britain declared war on Germany. In 1984 they opened to the public as a museum.
3. The importance of maps as navigational aids is visualised in the London Underground scene and the Map Room within the War Rooms.
4. The Georgian cul-de-sac of plain brick-terraced houses was originally built on the instruction of Sir George Downing, Member of Parliament. Most of the exterior shape and features were created by William Kent in 1735. The Georgian front door and the blackened brick bays are the work of Kenton Couse completed in 1775.
 During the 1950s the house was completely renovated. At this point it was discovered that the black façade was actually yellow and had become black from centuries of severe pollution. The newly cleaned yellow bricks were painted black to match their previous appearance.
5. The interior has been created for film and TV including *Love Actually* (2003), *The Iron Lady* (2011), *The Ghost* (2010), *Salmon Fishing in the Yemen* (2011), *The Crown* (2016–), *Bright Young Things* (2003), *Yes, Prime Minister* (1986–1987) and *Churchill's Secret* (2016).
6. Churchill appears to be hiding out in the derelict room which reflects his state of mind. In *Sherlock Holmes* (by Sir Arthur Conan Doyle) a man's brain is compared to an empty attic which may function as a virtual retreat.
7. 'Built on two stages in Ealing studios. Joe [Wright] likes to shoot 360 degrees and he likes to shoot on the move so the opening shot when you get introduced to the space you know the journey that's going to take. You predict that and you know you come down these stairs here, we can track

through there they can walk through these doors and double back on yourself. And then it develops in this case with Joe and DP Bruno Delbonnel or Seamus there are masses of conversations that go on and its constantly evolving.' Sarah Greenwood.

8. See Chap. 4, Barnwell, J, 2017 *Production Design for Screen* for further discussion.

9. Since the events around the pandemic in 2020 the blurring of work and home life has fresh resonance with many people finding themselves working from home and having to renegotiate physical and psychological space as a result.

10. The set decorator Katie Spencer is long-term collaborator with Sarah Greenwood and they have developed a close working relationship across films that span three decades.

11. The painting was hired from Farley's prop hire.

12. 'When we did Buckingham Palace we shot that in an empty house, Lancaster House in Yorkshire which is down at heel and not been painted for 70 years so it was perfect for what we felt Buckingham Palace should look like at that time. It's not out on its own in a sort of gilded existence. We are all in it together. So with the furnishing instead of using beautiful gold damask we chose one ten shades down from that so everything had this dowdy air, even royalty.' Sarah Greenwood, PD.

13. Unlike Smiley in *Tinker* who remains lost in the labyrinth, in Chap. 6.

Works Cited

Andrews, E, Hockenhull, S, Pheasant-Kelly, F, 2016, *Spaces of the Cinematic Home. Behind the Screen Door*. London, Routledge.

Aynsley, J, Grant, Charlotte 2006, *Imagined Interiors. Representing the Domestic Interior Since The Renaissance*. V & A Publications.

Campbell, Joseph, 1972, *The Hero With A Thousand Faces*, Princeton, NJ, Princeton University Press.

Davies, Margaret, 12 Feb 2015, 'Home and State: Reflections on metaphor and practice.' *Griffith Law Review*, Taylor and Francis, p 153–175

Freud, Sigmund, 1955, 'The Uncanny', in *Infantile Neurosis and Other Works: The Standard Edition of the Complete Psychological Works of Sigmund Freud*, vol 17, The Hogarth Press and the Institute of Psycho-Analysis, 217–256.

Gannon, Martin, Pillai, Rajnandini, 2010, 'The Traditional British House', in *Understanding Global Cultures: Metaphorical Journeys Through 29 Nations*, Sage Publications

George, R. M. 1999, '*The Politics of Home: Postcolonial Relocations and Twentieth Century Fiction*.' University of California Press.

Greenwood, Sarah, 2018, Author interview.

Hockenhull, S, 2016, 'Peas, Parsnips and Patriotism. Images of the garden in the Second World War.' in *Spaces of the Cinematic Home. Behind the Screen Door.* London, Routledge.

Jones, C, 1985, *Number 10 Downing Street: The story of a House.* London, BBC

Jung, Carl, 1990, *The Archetypes and The Collective Unconscious.* Princeton University Press

Mackey Kallis, Susan, 2010, *The hero and the perennial journey home in American film.* University of Pennsylvania Press

Mallet-Stevens, Robert, 1927, *L'Art cinematographique*, Paris, Felix Alcan.

Massey, Doreen, 1994, *Space, Place and Gender.* London: Polity

McCarten, Anthony, screenwriter of Darkest Hour, 2 Jan 2018, 'How Churchill's words shed light in his darkest hour.' https://www.penguin.co.uk/articles/2018/anthony-mccarten-darkest-hour.html

Morrison K.A. (2010) 'There's No Place like Home: Margaret Thatcher at Number 10 Downing Street.' In: Hadley L., Ho E. (eds) *Thatcher & After*, pp 115–133. Palgrave Macmillan, London. https://doi.org/10.1057/9780230283169_6

Pheasant-Kelly, F, 2013, *Abject Spaces in American Cinema*, London and New York. I B Tauris

Rhodes, John David, 2017, 'Prop and Property' *Places Journal*, December.

Rhodes, John David, 2020, 'Temporary Accommodation: Joanna Hogg's Cinema of Dispossession.' *Film Quarterly*, University of California Press, Vol 73 (3), p.12–20. https://www.gov.uk/government/history/10-downing-street

Steiner, H, 2010, 'On the unhomely home: Porous and Permeable Interiors from Kierkegaard to Adorno.' *Interiors* 1-2: 133–147, Taylor & Francis.

Steiner, Henriette, and Veel, Kristin, 2017, 'I've Changed my mind I don't want to go home.' *Home Cultures. The Journal of Architecture, Design and Domestic Space.* Vol 14, issue 1, p. 73–94

Zizek, Slavoj, 2006, '*The Perverts Guide to Cinema*', Dir Sophie Fiennes.

The Hero's Journey: The Quest for Home in *Paddington 2* (2017, Dir. Paul King, PD Gary Williamson)

This chapter explores the role of the Browns' house and the prison in the representation of home in the film *Paddington 2* (2017). The prison is a key setting in the film, which playfully stitches together popular notions of the real and imagined prison and turns into a community where friendship, food and flowers blossom. It effectively forms a transition space linking Paddington's journey away from home and back again. The Browns' house, Paddington's family home, is established as a warm and welcoming environment, which Paddington is forcibly removed from when he is wrongly sent to prison. On arrival, the prison appears to be a classic harsh and hostile place of incarceration where Paddington is intimidated and alone. However, Paddington's presence is slowly seen to transform the place into a warm and inviting world full of friendship and hope. The design is crucial in conveying key themes in the script that reflect Paddington's character and the positive impact he has on people's lives. The changes we see taking place in the home and prison are metaphors that convey the visual concept at the heart of the film design.

Traditional ideas and images of the prison are turned on their head as the place of incarceration becomes a candy pink-striped world of high teas and bunting. The environment reflects the camaraderie between Paddington and the people he befriends inside. They form an escape plan and Paddington eventually closes the narrative circle by returning home.

J. Barnwell, *Production Design & the Cinematic Home*, https://doi.org/10.1007/978-3-030-90449-4_8

Order appears to have been restored as thespian antagonist, Phoenix Buchanan (Hugh Grant), is sent to prison in his place. However, not only has the prison remained a cosy reflection of Paddington's character it now incorporates the high camp theatricality of its new inhabitant, complete with a closing musical number that sees Buchanan singing and performing to rapturous applause from the inmates. The design functions to reflect these changes physically while also visualising the underpinning concepts at work in the narrative.

The notion of home is particularly poignant in a wider sense, as Paddington can be understood as an outsider story, having migrated from Peru and made London his home, while also being an anthropomorphic bear interacting with humans. The film contains messages of tolerance towards difference and diversity, particularly in that Paddington's marginal status is foregrounded and his differences identified as strengths through the course of the narrative.

Film Synopsis

Paddington Bear lives with the Brown family in Windsor Gardens, where he is a popular member of the community. He wishes to find a special present for his Aunt Lucy's 100th birthday and sets his sights on a pop-up book in Mr Gruber's Antique shop. Paddington takes on a series of jobs to save money to buy the book but it is stolen from the shop and Paddington is falsely accused of the theft and sent to prison. The family set about finding the real thief, their thespian neighbour Phoenix Buchanan. In spite of making friends in prison, Paddington escapes in a bid to clear his name. Buchanan is eventually charged with the crime, Paddington is pardoned and Aunt Lucy is brought to London for her birthday.

Visual Concept

Through analysis of the film and insights gleaned from discussion with the films PD Gary Williamson, I propose that the visual concept in *Paddington 2* is based on the quest for home. This visual concept is realised through the kindness and warmth exuded by Paddington, transforming whichever setting he inhabits. As seen in Windsor Gardens and subsequently the prison where he is incarcerated, Paddington's personality is transformative in terms of the characters and the environments he is in close contact with.

This operates on a narrative level and is reflected and enhanced through the design.

PD Richard Sylbert (1989, 22) highlights the importance of returning home in narrative structure. 'There is something satisfying about getting back home. It satisfies the mind and it closes the circle.'

Paddington's positive influence in Windsor Gardens is made clear prior to his prison sentence, thus leaving a tangible absence when he is gone as the world he has created in Windsor Gardens disintegrates into a negative, less hopeful place.

PD Gary Williamson says one of the underlying ideas was prior to Paddington's arrival the Browns are a dysfunctional family, 'When we go into the dolls' house in the beginning everyone is in separate rooms, doing separate things and not relating to each other. So, when the bear comes into the house he brings the family together' (2021).

Meanwhile, inside prison Paddington the outsider becomes an insider finding friendship and camaraderie amongst an unlikely bunch of characters. He and his marmalade help create cohesion that is reflected in the design transformation. Although Paddington is desperate to return home, his presence succeeds in transforming the prison into a more attractive and homely environment. The notion of home is cultivated to the extent that a banner proclaiming 'Prison Sweet Prison' becomes a feature of the communal space. The visual concept enhances themes in the original books, that wherever Paddington goes he spreads love, warmth and good manners. Williamson found the illustrations by Peggy Fortnum in the books to be a key source of research and inspiration in designing the film.

Often the transformation of setting operates to reflect changes in the protagonist but in this instance the transition is a reflection of the entire prison population. Rather than Paddington changing while in prison, he effects change in others, which is visualised in the design transformation of the shared spaces.

The transition taking place is particularly effective due to the popular conception of prison as a brutal and archaic system. The stereotype of a cold unforgiving environment is used to visualise and convey the dramatic shift that occurs. For this to work, the prison is established initially through the use of design that conjures notions of enclosure, punishment and abandonment when Paddington first arrives. The Victorian architecture underpins a sense of severity and the loss of hope attached to being banished to a place out of sight and forgotten by society. This is a key idea that is returned to several times in the narrative, whereby Paddington insists

the Browns will not forget him while he is in prison. The other people in prison warn him that slowly the visitors become less frequent until they will eventually stop.

He carries his idea of home from Peru and the way he has been brought up by Aunt Lucy and Uncle Pastuzo, to believe he will be welcomed and find a good home in London. The city becomes an imagined idyllic place until Paddington arrives to a cold inhospitable London that echoes the experience of migrants invited to make the UK their home during the 1950s but on arrival were made to feel unwelcome (termed the *Windrush Generation* after the ship, *Empire Windrush* that brought one of the first groups of West Indians to the UK in 1948). Paddington's dreams are destabilised until finding a loving home with the Browns. His sense of identity is configured through his formative years and his new home in Windsor Gardens creating a positive allegory of migration and interracial harmony. The landmarks of London that feature in the pop-up book create a wider sense of home in terms of city and nation. PD Williamson says that London was very important right from the beginning, with the choice of landmarks creating an exciting vibrant evocation of place.

Ultimately, Paddington himself is the catalyst for the transformation and reformation of the environment in Windsor Gardens and the prison.[1]

THE PRISON ON SCREEN

Prison architecture reflects the intensity of ideas and emotions concerned with crime and punishment, the discourse surrounding them being inescapable in physical form. The relative levels of mental health and humanity of the times can be measured by the degree to which inequality and fear have inflected the design and build; buildings always speak of the period and purpose of their making. Cinematic representation extends these notions by repeating and perpetuating them in popular culture.[2]

Thus, prisons look like *Shawshank Redemption* (1994), *The Green Mile* (1999), *Porridge* (1974–77), *Midnight Express* (1978), *Cool Hand Luke* (1967) and *Escape from Alcatraz* (1979), particularly as the invisible nature of real prison interiors allows room for speculation. As PD Stuart Craig says, the designer's job is to distil, simplify and make the meaning of a setting absolutely clear (Author Interview, 2000). Designers are not concerned with producing museum-like accuracy but rather with the creation of an emotional truth in support of character, narrative and genre. Screen representations provide the audience with access to an

environment that is not open to the public and as such becomes an imaginary rather than a real place. Thus, despite Foucault's genealogical account of the disappearance of the ancient regime's spectacle of punishment, of gallows and guillotine, visual spectacle persists in cinematic representations of crime and punishment (1975).

Cinematic space plays on the ways attics, basements and bedrooms hold different roles in our daily imaginary lives. The physical realm and abstract notions of space cannot be disconnected from our memories, dreams, fears, desires and everyday existence (Jacobs, 2013, 10). These notions are amplified when it comes to a limited use of settings or a confined space such as the prison. Prisons, like hotels, museums, theatres and public transport for example are transitional and contain a diverse milieu.

Notions of confinement are exaggerated through the use of small spaces and fragmented geography of space, while also promoting the alienation and intimidation of the environment through lofty ceilings and extended walkways. Often presented as a stark, frightening, unstable world with the threat of violence and psychological torment, the confined setting creates a physical and symbolic boundary between inside and out where themes of resistance to authority are often played out by individuals who have lost their liberty and access to physical space.

Films featuring prisons often include an intense sense of identification and empathy between viewer and the person in prison (Kehrwald, 2017, 4). The genre-defining film *The Big House* (1930) established key innovations in the genre including particular character types, iconic settings and situations such as riots and escape attempts—consistently portraying the prisoner as victim to powerful external forces beyond their control. These conventions hold true in *Paddington 2*, where the audience is in no doubt that he is innocent (a popular theme in prison narratives) and that a gross injustice has been committed.[3]

Paddington 2 is a comedy and as such takes great pleasure in playing with and subverting popular perceptions of prisons and the cinematic representation of people in prison. For the comedy to work, the familiar image of a prison and the stereotypes that conjures must be established on the screen in order for the turnaround transformation to function effectively. Thus, the design of the prison is deliberately familiar using the conventions an audience expects to see—the prison of the imagination and of popular representation is cold, brutal, intimidating and alienating comprised of unyielding metals and lacking any soft textures or materials.

Redemption is a popular trope for prison and this process is heightened in the transformation of the people in prison and the environment that subsequently takes place. The reform of character stands in contrast to the abandonment notion, prison as the instrument of positive change enabling a return to society. Thus, the film references ideological discourse around crime, punishment and the role of incarceration in society. Cultural myths around prison are incorporated in the design and assist in the narrative and character development of the film. The prison setting often amplifies a correlation between violence and masculinity, employing aspects such as fights, torture and intimidation as central to the narrative and character development.

Paddington arrives to a classic display of stereotypical masculinity, where he is initially threatened and intimidated by archetypal tough characters who rebuff his attempts to make friends. The sense of physical violence breaking out is later referred to in the dining hall scene, when Paddington confronts Nuckles the cook and the prison guard radios first for medical assistance in preparation for imminent violence and then the priest in preparation for death. The use of parody identifies the tensions in the representation of masculinity, both recycling and problematising them. PD Williamson says, the brief for this from the director Paul King was 'little bear, big prison' and his research took him around the UK recceing empty prisons, which informed his eventual design.

Paddington is initially lost in this all male environment having been brought up by his Aunt Lucy in Peru and now nurtured by the Brown family, which includes three influential feisty women, Mrs Brown (Sally Hawkins), Judy Brown (Madeleine Harris) and Mrs Bird (Julie Walters) the housekeeper.

Paddington reverses the usual representation of hierarchy in prison—his power doesn't come from any of the conventional channels, for example where violence results in status. Instead his strength lies in the ability to encourage the potential for bonding and camaraderie amongst the inhabitants of the prison—a disparate group thrown together regardless of background, class and culture.

Nurturing the hidden or forgotten talents of his fellow prisoners Paddington uses food to bring people together emotionally. The preparation and sharing of recipes motivates the engagement and enjoyment of the other characters to collaborate, creating a positive environment psychologically. The emotional impact of which is realised in the design, through the transformation of the shared spaces, for example the sparse dining hall becomes the attractive and inviting *Aunt Lucy's Tearoom*.

Paddington's presence assists in modernising representations of masculinity by using food preparation and baking specifically, to create a new and more positive sense of identity and community in the prison. Later, this notion is extended further with the arrival of Phoenix Buchanan, whose presence transforms the prison into a theatrical space, delivering a hopeful message of the potential to reform the people inside.

The five design elements that reflect the visual concept will now be examined.

INTERPRETING THE VISUAL CONCEPT

Space

Paddington tells Aunt Lucy, 'I really feel at home in Windsor Gardens' and reiterates 'You sent me to London to find a home and its worked out beautifully' (Fig. 8.1).

The setting of 32 Windsor Gardens is situated in Notting Hill,[4] in West London which had a large community of Caribbean immigrants during the 1950s (Paddington was initially written in 1958). Although much changed since then the area continues to be racially diverse today.

The Victorian house consists of three storeys, with hallway, kitchen/diner and living room on the ground floor. The family bedrooms and bathroom are upstairs on the second floor and Paddington's bedroom occupies the attic space. Williamson says, 'Paddington ends up in the attic because it's the only room they've got left and he is a bear', reminding us of the practicalities involved regarding where particular characters may be

Fig. 8.1 32 Windsor Gardens exterior location, featuring a mansard attic with circular window

located. Protagonists are often situated in the attic space, with romantic notions around creativity (artists garret) and spirituality; it holds the potential to be surprising, magical and transformative. Above the main living space it has also been a place concealing secrets and suggestive of hidden, forgotten or marginal ideas, belongings and people (Fig. 8.2). The attic is also where Phoenix Buchanan hides his costumes and dastardly plans to steal the book and find the treasure. His covert operation and personas are tucked away out of sight until Mr and Mrs Brown uncover the secret door. (Please see Chap. 5 for a discussion of Bridget Jones who is another attic dweller.)

The ground floor kitchen and living room are connected through a large archway creating a fluid social space forming the beating heart of family life. Paddington is established as belonging and being at home here making his expulsion more of a dramatic upheaval.

The prison architecture conjures the classic model of the Victorian prison, which exaggerates notions of confinement. Lofty intimidating ceilings, long alienating walkways and cramped individual cells all work to convey the stereotype of the prison environment. When Paddington first enters the prison it seems stuck in the past, forgotten, with an imposing scale and ornate gatehouses representing the power and authority of the state. This is intensified from Paddington's perspective, as he is smaller than the humans in prison everything is amplified from his point of view. The vertical hierarchy and levels within the space reflect the expectations of power and authority imposed in a prison environment. The scale dwarfs

Fig. 8.2 Paddington's warm and inviting attic bedroom

its inhabitants and suggests the insignificance of the individual in the face of a large dehumanising building with an equally alienating underpinning ideological structure. The collision of private and public space that engenders a prison setting establishes a tension. Private space is limited to the functional cubicle-like cells, overshadowed in scale by the communal spaces, reinforcing the idea of loss of individuality and liberty and the sense that once inside everyone becomes part of the prison machine. Loss of liberty can be seen in the limiting and control of individual space in this way.

Although prison is necessarily a closed architecture, the building is seen in full through the use of a scale model in the warden's office that replicates its geography in miniature. This is later referenced as a slice through, which is opened up and used as a technique to show the four prisoners simultaneously escaping from their uniform cells. The cut-through slice of the building echoes that of the Browns' family home and reminds the audience of the universal nature of people wherever they are. This technique allows us to view the whole of the interior space of the building, including the individual cells, the warden's office and the communal areas in one frame. Thus, providing a privileged view of the whole building and increasing the sense of magnitude of the escape plan from such a complex and imposing structure.

In and Out

Windsor Gardens is an attractive Victorian crescent of sugared almond houses. The columned bold green doorway[5] opens into a hallway and unusual spiral staircase. The curvilinear organic shape of the stairs is entwined with a mural of a blossoming cherry tree, hinting at the magical childlike qualities that thread through the house and the stories. The house is part of a community, the connection to the exterior is made visible through windows and open doorways, whereby the street is an extension of the home.

In contrast, the nature of a prison is crucially defined by the border between the interior and exterior and the lack of liberty to move between these. Windows and doors articulate the boundary between interior and exterior worlds and this is all the more poignant in *Paddington 2*. The windows and doorways do not offer views of the outside world, they deliberately contain, us the audience, within the prison.

The main portcullis doorway is only seen once, when Paddington first enters. The intimidating scale of the architecture, signalling the power of authority and pressure to conform, is exaggerated further by the framing from above. The exterior is glimpsed when Paddington first arrives but is seen again only once more until his escape. Paddington climbs up to his small, arched prison cell window to write a letter to his Aunt Lucy and it is at this point that the vast and intimidating exterior is revealed— a gothic nightmare fortress that reinforces his exclusion from the outside world.

The arched window in his cell echoes the round window of his attic bedroom in Windsor Gardens, connecting Paddington to his home and accentuating the contrast between the cosy comfort there and the austerity of his current setting. The prison warden's office doesn't provide exterior views, behind his desk is a huge clock face emphasising classic notions attached to prison and serving or *doing time*.

Prison is a liminal space; an in between where prisoners wait until the point where they can be released and return to society. The term 'inside' that is often used as a popular euphemism for prison makes this sense quite clear. The separation between the prison and the rest of society is crucial in the design and the notion of escape ties into this. Windows have the characteristic prison bars on them, reinforcing the disconnection from the outside world and the prisoners' absence, invisibility and insignificance. This is a self-contained space, hidden, concealing and separating the people within from the exterior, which supports one of the themes of the film—once inside people will be forgotten by the outside. The cramped visiting cubicle accentuates the notion of spatial confinement and isolation, with Paddington firmly positioned on the inside and the Browns on the other side of the glass partition.

Within the prison, three levels of walkways transport prisoners from individual cells to inhospitable communal areas. Corridors are used by designers to extend physically and prolong visually the transition from one place to another, and emphasise a journey, a pause or punctuation between two places. Details of distance, width, material and so forth alter our perception of where the character is travelling and what they might find on arrival. Corridors can build suspense and play with notions of time and space (Barnwell, 2017, 114). The doorways to the individual cells are closed as might be expected in a prison, however communication takes place through the plumbing in the walls without the need to be face to

face. This hints at the way space may be manipulated in unconventional ways as illustrated in the escape scene.

The escape does not just involve corridors and staircases but extensive machinery that features cogs that require Paddington to squeeze himself through impossibly tight spaces. This transition is a physically difficult enterprise that accentuates the drama and tension involved in the break-out. The length of the clock tower and the machinery within it extend the possibility of the eventual getaway. Not using the traditional exit point of doorways or even windows makes this a 'great escape' as they transcend architectural boundaries moving through space inventively to achieve their freedom.[6] This speaks of their empowerment physically and mentally as they occupy space unintended for them and manipulate the architectural structure to enable their emancipation. Having been spatially confined by the prison structure, makes their transgression all the more thrilling. The notion of time is physically and metaphorically extended through the use of the clock mechanism. The transition through the clock takes time to undertake and it is achieved through a timekeeping device. The psychological passage from imprisonment to freedom is unconventional and daring. Time and space are crucial elements of any design and in this instance have resonance with key notions entwined with prison. Time is something the characters have forfeited while incarcerated but are able to adapt their punishment into an instrument of escape.

The tunnels and tight spaces they have to navigate to reach the roof intensify the tension, enclosure and confinement to a claustrophobic level. The condensed space of the clock tower eventually brings them out on the rooftop with its expansive city skyline, from where their makeshift hot air balloon can lift off. The escapees have made the clock tower an *action space*; a device that enables the movement of character through the décor (McCann, 2004, 375).

Light

32 Windsor Gardens is well lit with large windows in the kitchen/diner and a partially glass back door allowing plenty of natural daylight. There are several artificial light sources in the form of characterful table lamps, wall features and fairy lights crafting a bright inviting and colourful environment.

In the prison although characters are very much boxed into their private cells, there is abundant light that comes from arched windows in the two communal prison spaces: the atrium and the dining hall. There is lots of natural daylight provided from these windows, which interestingly creates a positive ambience, intentionally bucking the archetypal notions of prison design. Ultimately the film is a comedy and although there is a need to create a sense of threat and isolation the edges are softened by key design choices such as this use of natural daylight.

Once the prison has been transformed by Paddington's arrival additional lighting appears in the form of paper lanterns and strings of hanging lights, creating a cosy inviting environment that echoes the lighting in Paddington's attic bedroom in Windsor Gardens.

There is very little shade in the film. When Paddington first goes to help Nuckles McGinty in the kitchen it is dark but gradually as the marmalade making progresses day breaks and the kitchen is flooded with natural daylight. Significantly when Paddington thinks he has been forgotten by the Browns because they miss a visiting day, his world becomes darker and he succumbs to despair. It is at this low point that he agrees to join the escape group (Fig. 8.3).

The warden's office is bathed in light that emanates from the clock face positioned behind his desk. This light has an opaque quality as the clock connects the interior and exterior, while also featuring artificial lighting.

Fig. 8.3 The dimly lit dining hall prior to the marmalade making

Colour

The exterior and the interior of Windsor Gardens is awash with colour. The pretty pastels of the outside become bold, bright primary colours within the house. PD Williamson has said that they gave each of the character's a colour motif whereby Mrs Brown and Jonathan are red and Judy and Mr Brown are blue connecting to Paddington's iconic blue duffle coat and red hat. In the kitchen/diner yellow and blue create an exciting fun atmosphere.

Although a very useful way of communicating the visual concept, many filmmakers prefer to use colour subtly and with caution as PD Stuart Craig says:

> The safest thing is to eliminate colour, the more limited the palette the more effective. It allows the lighting to work. The colours that are used should be motivated by the psychology of the scene. (Author interview, 2008)

Williamson agrees that the colours should come from the emotion of the scene:

> It's a children's film so we wanted it to look exciting and I'm not frightened of colours. The colours came from the characters. (2021)

The selection and combination of colours are carefully considered and help lead us into the aesthetic world of the film. The palette in *Paddington 2* is designed to highlight the colour red, which is significant in relation to Paddington's character reflected in his red hat. He is strongly linked to Mrs Brown through her costume choices and the decoration of the family home which both feature prominent use of red.[7] The colour red is bold and is sometimes used to connote fear, death and disease. However, in this instance the red is a joyful one bursting with warmth and connects the Browns as a family. Red also stands out and can be used to indicate subversion and lack of conformity, challenging the status quo.[8]

There is initially an absence of red in the prison environment. The key colours are cold grey, blue, green and white in the first instance. One red sock initiates the change in colour palette in the prison, which is responsible for turning the uniform of the entire population from grey and white-stripes to pink and brown. The next stage involves a confrontation with Nuckles the cook when Paddington squirts red ketchup across his

white apron. This action results in Paddington and Nuckles joining forces to make marmalade for the breakfast. Once tasted, the previously hostile prison population softens and become involved making other tasty treats. It is through this sharing of food that the place transforms to reflect an inviting and nurturing environment reminiscent of an opulent tea room such as in the Ritz.[9] During the transformation pastel colours gradually fill the kitchen and dining hall and eventually bright red bunches of chillies adorn the kitchen.

The changes are evident outside of the kitchen and dining hall too; the once sterile grey walkways are now populated with vibrant flower boxes, strings of bunting, fairy lights and a large hand stitched 'Prison Sweet Prison' banner in bright red font. Meanwhile Windsor Gardens seems a colder, more hostile place; the colour sapped out of it, without Paddington's charming vibrancy.

The use of colour mirrors the impact Paddington has on the prison, which he infects with his warmth and kindness that gradually radiates through the communal spaces. The colour in Paddington's individual cell remains cold, as a reflection of his inner-sadness and wish to return home to the Browns.

Set Decoration

Initially a design contrast is established between the comfort and warmth of eclectic clutter that fills the Browns' home and the cold sparse prison fixtures.

The filmmakers wanted to be true to the era Paddington was written in (*A Bear Called Paddington,* by Michael Bond was first published in 1958), while making a contemporary film. They made a conscious decision to have no mobile phones or computers[10]; the home includes vintage items of furniture and dressing that nod to the 1950s, combined with up-to-date features creating a lived-in feel that exudes a welcoming warmth. 'The aim was to create a heightened reality', says Williamson, 'a place where a talking bear would feel right at home but also one that felt new and exciting. We are looking through Paddington's eyes' (Drummond, 2015). Set decorator Cathy Cosgrove worked closely with Williamson to achieve this carefully curated blend of props and décor.[11]

Mary and Henry's bedroom uses a vibrant Chinoiserie style for the bed and wallpaper with flower head lamps organically climbing the wall, echoing the blossom tree mural in the hallway. This home is full of life, love and

warmth. Although attractive and comfortable it is also cluttered with the hallway for example overflowing with discarded shoes, coats and bags. 'The house is a reflection of the characters in it. My job is to try and bring that out with the sets', says Williamson. 'Artwork features prominently throughout the Browns' home (Mrs. Brown's character is an artist) and much of the art used was borrowed from artist friends, or created for the film. Some of it is hung at deliberately kooky angles to drive home the idea of family and fun' (Drummond, 2015).

Inside each prison cell are identical, metal-framed single beds, a desk and chair. The two key communal spaces of the atrium and the dining hall consist of entirely functional items. In the dining hall a symmetrical arrangement of long rectangular tables and bench seats flank each side of the room.

The scene references many cinematic prison canteens where row upon row of uniform people lose their individuality and are objectified as prisoners without distinction. The experience is dehumanising as all individual characteristics are replaced with a homogenous body of criminals—part of the machine. However, in this instance it is on a smaller scale, which hints at the possible makeover to come (Fig. 8.4).

The creativity of the kitchen becomes redemptive in this example. Once the cake making is in operation the dining hall benches are replaced with round tables covered in gingham-checked tablecloths in pink, green and blue, while the bench seats are replaced with individual chairs. Bunting is strung up and above the doorway and a sign is painted in pink 'Welcome to Aunt Lucy's tea rooms'. Potted plants and tea trolleys stacked with cakes and sweet goodies decorate the hall. Meanwhile, the walkways of the

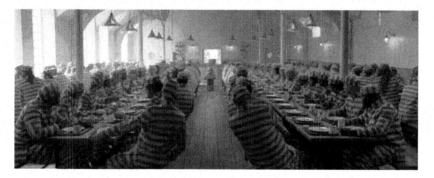

Fig. 8.4 Prison dining hall before the transformation

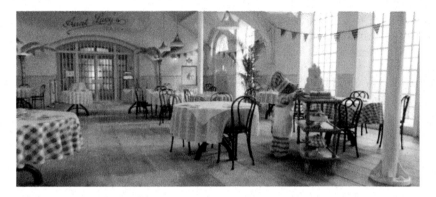

Fig. 8.5 The prison dining hall after it has been transformed into 'Aunt Lucy's Tearoom'

main atrium are lined with flower filled window boxes, bunting, strings of lanterns and welcoming hand stitched banner (Fig. 8.5).

A hopeful and redemptive quality is indicated by the fact that when Paddington is freed the prison doesn't return to the way it looked before his arrival. Instead, the positive changes actually continue with a theatrical makeover reflecting the new resident, actor Phoenix Buchanan. The trajectory of change continues to foreground the strong community and friendship that was forged through the preparation and sharing of food and now through music and dance. For example, the prison uniforms are still pink and have been customised to add flared trousers. Phoenix's name appears in lights in the atrium accompanied by spotlights, and pastel-coloured umbrellas as props for an extravagant musical show stopper.[12]

CONCLUSION

Paddington changes the uniform, the attitudes, the diet, the environment and the futures of the other prison inhabitants. The design helps tell that story through the vocabulary of the visual concept. The discussion, has indicated the ways in which the characters, narrative and themes of a script may be enhanced through the deliberate use of space, in and out, light, colour and set decoration.

The boundary between interior and exterior is reinforced through the design, accentuating the division between the prison space and the outside world. The prison setting forms a linking device between Paddington leaving and returning home. This enables the importance of his home to be

reiterated and re-established; he belongs there in spite of having come from somewhere else (Peru). Windsor Gardens is now his home and he is a welcome and valued member of the community (Smith, 2006).

As Foucault asserts, the prison's mechanism of control derives from the routinisation of time, space and activity with the aim of producing docile bodies (1975). The prison does not appear to hold any reformative potential—when Paddington arrives it is a liminal space of incarceration and deprivation.[13] It is Paddington who introduces a therapeutic element to the environment, which as we have seen improves the physical setting, reflecting the positive psychological impact of his presence. During the end credits, we see that his co-escapees have all gone on to turn their lives around to the benefit of themselves and society. In *Paddington 2*, the prison characters become energised, having been institutionalised they begin to regenerate. Paddington dissents from the narrative expectations of the prison environment he is placed in. This is reflective of some modern approaches to prison design that attempt to create calmer atmospheres and employ art and cooking therapeutically as forms of rejuvenation, fostering a sense of community.[14] The unconventional use of space, in order to escape, breaks the rules of spatial navigation and subverts the intended function of the clock into a way out of captivity.

Paddington uses the prison of popular myth as a vehicle for change, his unconventional outsider status enables him to transgress physical and psychological boundaries and to reinterpret and revise space to more closely reflect his belief systems.

The contrast that is initially established between Windsor Gardens and the prison is reversed when the prison evolves to reflect Paddington's interior landscape.

Helping others is key to Paddington's character; we witness the effect his absence in Windsor Gardens has on the residents there. One by one, their lives are shown to be less sweet—grumpy, selfish, sad elements creep into their characters. This provides contrast to the positive effect Paddington is having on the prison population and environment.

Paddington does eventually return home to Windsor Gardens, closing the circle that Richard Sylbert refers to, his home interior has not changed since he left it, signifying a return to safety and security. The reassuringly static setting highlights the importance of his journey and a sense of relief that he is now safe and sound is well deserved. Paddington wakes up snug in his own little bed surrounded by the Browns in a scene that echoes Dorothy's return in *The Wizard of Oz*. Paddington carries his internal concept of home wherever he goes fortifying and enabling his quest to return home successfully.

NOTES

1. Paddington is an animated bear, which had implications for the shooting schedule in terms of extending the length of time a set remained dressed before striking. However, Williamson says although created in CG Paddington is there all the time in the form of stand-ins for eyeline matches and so on. 'He was always there by not being there.'
2. *The Palgrave Handbook of Incarceration in Popular Culture,* 2020 (ed. Harmes, Marcus, Meredith, Barbara) examines the representation of the prison from a broad range of perspectives.
3. Paddington's sentencing may be read as the scapegoating of an outsider. As Rene Girard (1972) states, the potential violence of a community directed towards an *other* rather than on itself.
4. The exterior location used for the Browns' home is actually in Chalcot Crescent in Primrose Hill. The interior of the Brown family home is a three-story house built on a set in Elstree Studios for the first one and Leavesden and Pinewood studios for *Paddington 2.*
5. Following the green door in the original books, illustrated by Peggy Fortnum.
6. A similarly audacious use of space can be seen in the film *Die Hard,* with John Maclean's continual rupturing of space to create new exit and entry points.
7. Williamson says the red wallpaper in the Browns' bedroom was hand painted by a scenic artist to include swans, pelicans and birds flying.
8. Red is also used to signify the theatrical world of Mr Gruber's antique shop, the circus and Phoenix Buchanan's secret attic. See Bellantoni, P (2005) Chapter 1 for a discussion of the colour red in a range of films.
9. Buchanan's agent (Joanna Lumley) goes to the famous 5 star London hotel, The Ritz to meet a Broadway producer.
10. The phone is tethered in the hall which is not what would happen today. The kids would have phones and there would be laptops and iPads all over the place and we didn't want that (Gary Williamson, 2021).
11. Williamson says he and set decorator Cathy Cosgrove, 'We'll talk about it, go through books and colours and then she goes out and we'll take photos and do a show and tell for props with the director. So, everything an actor holds the director has seen and approved before we shoot' (Author interview, 2021).
12. Referencing the musical genre in general and films such as *Singing in the Rain* and the *Umbrellas of Cherbourg* in particular.
13. *Architectural Digest,* Slade, Rachel, 30 April, 2018.
 It just took one night inside a U.S. jail to move Frank Gehry to run a Spring 2017 semester course at Yale exploring the design of prison facilities. He encouraged his students to rethink incarceration as an opportunity

for rehabilitation rather than punishment and took them to Northern Europe and Scandinavia, where prisons look and perform more like college campuses than fortresses.

14. Samson, Lindsay, 28 Mar 2018, Design INDABA. Each cell features long vertical windows to maximise the light that enters, and its green surroundings are easily viewed in common areas ('the opportunity to follow seasonal changes helps to clarify the passage of time for the inmates', explains prison warden Are Høidal). Safety glass is utilised so that bars can be avoided; and shared living and food-preparation spaces are included to encourage cooperation between inmates. The primary goal of the space is to rehabilitate, a radical aim when the vast majority of the world's prison systems are more focused on doling out punishment.

FURTHER READING

Bentham, Jeremy. 1787. *The Works of Jeremy Bentham Volume 4*: edited by John Bowring. Edinburgh: William Tait.

Fairweather, Leslie. 1961. 'Prison Architecture in England', *The British Journal of Criminology*, Volume 1, Issue 4, 1, Pages 339–361.

Wilkinson, Tom. 2018. 'Typology: Prison', *The Architectural Review*, June issue on Power and Justice.

WORKS CITED

Barnwell, J. 2017. *Production Design for Screen: Visual Storytelling in Film and Television*. London: Bloomsbury.

Bellantoni, Patti. 2005. *If It's Purple Someone's Gonna Die: The Power of Colour in Visual Storytelling*, 5–39. Burlington: Focal Press.

Bond, Michael, 1958, *A Bear Called Paddington*, London, Collins

Craig, Stuart, 2000. Author interview.

Craig, Stuart, 2008. Author interview.

Drummond, Gillian. 2015. 'A Style Called Paddington.' *3StoryMagazine*. http://3storymagazine.com/style-tips-paddington-bear/.

Foucault, Michel. 1975. *Discipline and Punish: The Birth of the Prison*. London, UK: Penguin Books.

Girard, Rene. 1972. *Violence and the Sacred*. Baltimore, MD: John Hopkins University Press.

Harmes, Marcus, Meredith, Barbara (eds) 2020, *The Palgrave Handbook of Incarceration in Popular Culture*, Palgrave Macmillan

Jacobs, Steven. 2013. *The Wrong House: The Architecture of Alfred Hitchcock*. Rotterdam: NAI Publishers.

Kehrwald, Kevin. 2017. *Prison Movies: Cinema Behind Bars*. New York: Columbia University Press.

McCann, Benn. 2004. 'A Discreet Character? Action Spaces and Architectural Specificity in French Poetic Realist Cinema.' *Screen* 45, no. 4: 375–382.

Smith, Angela. 2006. 'Paddington Bear: A Case Study in Immigration and Otherness.' *Children's Literature in Education* 37, no. 1: 35–50.

Sylbert, Richard. 1989. 'Production Designer Is His Title: Creating Realities Is His Job.' *American Film* 15, no. 3: 22–26.

Williamson, Gary, 2021. Author interview.

Index[1]

[1] Note: Page numbers followed by 'n' refer to notes.